Health
and
Safety

A Breakdown

Emily Witt

Pantheon Books, New York

Copyright © 2024 by Emily Witt

All rights reserved. Published in the United States by Pantheon Books, a division of Penguin Random House LLC, New York, and distributed in Canada by Penguin Random House Canada Limited, Toronto.

Pantheon Books and colophon are registered trademarks of Penguin Random House LLC.

Portions of this book originally appeared, in different form, in *The New Yorker*.

Library of Congress Cataloging-in-Publication Data
Names: Witt, Emily, 1981– author.
Title: Health and safety : a breakdown / Emily Witt.
Description: First edition. | New York : Pantheon Books, [2024]
Identifiers: LCCN 2023058010 (print) | LCCN 2023058011 (ebook) |
ISBN 9780593317648 (hardcover) | ISBN 9780593317655 (ebook)
Subjects: LCSH: Witt, Emily, 1981– | Man-woman relationships—
United States. | Single women—United States—Social conditions—
21st century. | United States—Social conditions—21st century. |
Civilization, Modern—21st century.
Classification: LCC HQ801 .W773 2024 (print) | LCC HQ801 (ebook) |
DDC 306.70973—dc23/eng/20240206
LC record available at https://lccn.loc.gov/2023058010
LC ebook record available at https://lccn.loc.gov/2023058011

www.pantheonbooks.com

Front-of-jacket photograph by Luis Nieto Dickens
Back-of-jacket photograph by Alina Oswald/Alamy
Jacket design by Linda Huang

Printed in the United States of America
First Edition

9 8 7 6 5 4 3 2 1

For Emily Brochin

Part I

I

I REMEMBER A DATE: THE FIRST OF JULY, 2016. THAT AFTERNOON I came home after a few days on Fire Island, back to Brooklyn, to the brick building off the intersection of Myrtle and Broadway. The air was humid and the streets smelled of trash. The steel door of my apartment fell shut. The bed, the table, and the chairs were all where I had left them. I had a suntan that I wanted to show to someone, but there was no one to see it. I lived alone.

The apartment was a studio. It had brick walls, exposed pipes, and wood floors marked with paint. It had my teakettle, my pots and pans, and a table that was also my desk. It had my solitude. The studio was on the third floor, in a corner of the building. I had moved here a few months before, in winter, when the heat blew from a giant vent like a desert wind. Now it was summer, and the city's noise poured in through windows that were taller than I was. On one side they looked out on a white-painted warehouse next door, and in the afternoon the room would illuminate with flashbulbs from a photo studio there. On the other side I had a view of rooftops and a redbrick housing complex on Bushwick Avenue. In the evenings, the complex's walls would turn pink for an hour in the setting sun. The unencumbered sky rose up above it, impervious to the city and everything humans had ruined below. Pigeons and seagulls flapped in slow orbits. The

jets flew north to LaGuardia in a steady, unceasing line. The colors of dusk would make a gradient of orange and lavender, the rooftops would turn gray and dowdy, and my private domain, my apartment, would be bathed in soft evening light.

The day before, lying on the beach on Fire Island, I had been looking out at the Atlantic Ocean and wondering what would happen next. Maybe I would be invited to a party. Maybe a relative would die. Maybe an unexpected writing assignment would arrive. Maybe there would be another mass shooting. Maybe something would happen that would indicate the arrival of a new historical epoch, a sign that we were living in an era of meaning and purpose that would be remembered for many decades to come.

I lay in sunlight that had traveled through the vacuum of space. I sensed I was on the cusp of a change. I pictured each cycle of life—friendships, relationships, phases of experience—as an arc that emerged from a horizontal line. At any point along the line, a tangle of arcs hovered above like the ribbed vault of a cathedral. Some curves were in the process of rising, and some in the process of falling.

2

I HAD MET ANDREW ON A COLD EVENING IN LATE APRIL. THAT NIGHT, I had given a lecture in Brooklyn for a series of talks called IRL Club. In his invitation, the organizer had described IRL Club as "a casual evening of slideshow presentations by cool people 'from the internet.'" The theme of the evening was "altered consciousness." The other presenters included the author Tao Lin, who was writing his book *Trip*, about psychedelic drugs, and a woman who spoke about autonomous sensory meridian responses, the bodily sensations some people experience when watching women with long nails pressing buttons on cash registers, or hearing crinkling paper. The speaking fee was $150.

The event was held in a warehouse event space near the polluted Gowanus Canal. In preparation for my lecture about altered consciousness, I had made a digital slideshow on Google Slides. I titled my speech "How I Think About Drugs," which I typed out in twenty-four-point black Arial font. I arrived early, then waited in the wings offstage, drinking a beer and watching Tao give his lecture, "Specific Effects of Psychedelic Drugs on Me." The effects included "advertisement for a Don DeLillo reading showing his face seemed like a powerful non sequitur" (psilocybin mushrooms); "said incoherent things about Harry Potter then passed out" (cannabis);

"realized I'd convinced myself while unconscious to go to the beach" (salvia); "alien occupation" (mushrooms again); and "sobbing" (cannabis, ingested, baked in an oven). After DMT ("my life a vague myth"), it was my turn.

I began "How I Think About Drugs" with a slide showing an advertisement for an antidepressant. In the ad, a smiling blond woman in a pink shirt poses with a beach behind her, as if she were out at sea on a boat. "I'm ready to experience life," reads the text floating next to her head. I hadn't tried very many drugs before the age of thirty, I explained, referencing the ad, because of my commitment to this single drug, the antidepressant called Wellbutrin.

I took Wellbutrin (I said, continuing) from 2003 to 2004, and then again from 2006 to 2012. I started taking it the year after I graduated from college because I wanted to be as decisive and active as those I perceived to be more successful than me. Wellbutrin had an amphetamine-like effect. It confirmed my love of stimulants. On Wellbutrin, my hands shook slightly. I slept less, I ate less. The chemical in Wellbutrin, bupropion, is also used to help people quit smoking. It deactivates the part of the mind that craves small sources of chemical solace in the middle of the afternoon. My sweet tooth disappeared. The pill made me skinny, impatient, quick to anger, productive, multiorgasmic. The drug seemed to raise my heart rate. It made my body weak in a way that was unfamiliar. It made me dizzy. It made my ears ring. Its effect on me was immediate and tangible. I stopped crying on the subway. I could get out of bed in the morning. I could get all the same things done that the people around me were getting done. I turned forms in on time. I wrote emails. I made decisions.

I avoided other drugs in the seven years that I took Wellbutrin, I explained in my lecture, because I worried about interactions, but also because I had little interest in them. I switched to a slide with

a collage made of photographs I had found on the internet: images of a 1960s-era hippie; a 1990s-era candy raver; Nancy Reagan; Hunter S. Thompson; a hemp necklace; Ewan McGregor crawling out of a toilet in the movie *Trainspotting;* an antidrug ad that read "Ecstasy Today; Agony Tomorrow"; psychedelic art by Alex Grey; and other images meant to convey the myriad negative impressions of drugs I had received as a young person, all of them specific to my generation. Drugs, I explained, were incompatible with my ideas of success, good health, and the clear exercise of reason. The druggiest kids I knew in high school had in fact ended up living out the nightmares that the propaganda had promised, and spent their late twenties and early thirties cleaning the bathroom in Goodwill, stuck in halfway houses, and trying to regain custody of their children. I knew all this because of Facebook, where they testified on their anniversaries of getting sober. Addiction could generate a war within a person, a struggle of life and death, a storm of trauma and debasement, but one we had been taught to see as self-imposed. This could happen even to a person with every advantage in life, who has the good fortune to live without fear of poverty, hunger, fascism, bombs, drone warfare, or an especially dysfunctional family. In avoiding drugs, I thought I was avoiding that kind of self-generated squalor.

Not taking drugs was easy (I continued, squinting out into the darkness of the audience but unable to discern any faces) because I had not been the kind of young person to whom anyone offered drugs. Had they offered, I would have taken them, but my friends were like me, bookish and obedient, exploring their maladjustment through literature, music, art, and film, and not shifts in consciousness, sexual adventure, or alternative living arrangements. My chemical experiences as a college student in the early 2000s were limited to nicotine, alcohol, caffeine, and cannabis. Once, a boyfriend in college had given me a little peach-colored triangle of the amphetamine

Dexedrine. I nibbled off corners of the pill in the computer lab and wrote a play, taking breaks only to go to the water fountain for my dry mouth. Dexedrine induced a euphoric trance state of production, but in the days after I took it, I found I wanted to die with more intensity than usual.

I switched slides again, to one where I had arranged a list of drugs according to a grid. I explained how I unconsciously categorized psychoactive substances according to the distinctions set out by the federal government in the early 1970s. The category I thought of as "drugs" correlated exactly with the government's definition of a federally banned Schedule I substance. Heroin, cocaine, LSD, MDMA, and cannabis were drugs. Then I had a category that I called "sort-of drugs," which meant off-label use of pharmaceutical painkillers, antianxiety medications, and amphetamines like Dexedrine and Adderall. Unlike drugs, a person could casually use sort-of drugs without a sense of impropriety or loss of reputation. Republicans, moms, and other people who expressed concern and disapproval about cocaine would readily take a Xanax on a bad day without moral qualms. The problem with the sort-of drugs category was that its pills were considered safer than "drugs" even when they were more dangerous. As an example, I reminded the audience of the failure of millions of Americans, including many doctors, to understand that opioid painkillers interacted with the human body in the same way as heroin. Unlike drugs, pills were cute; they rattled in their little amber canisters like candy, and there was something childlike about the way adults received their diagnoses of pain, anxiety, depression, and deficit of attention. We filled our prescriptions for sort-of drugs with a bustling sense of importance and authority, and altering our brain chemistry was done with a veneer of officiousness and responsibility.

My drug-taking habits, I explained, did not change until I stopped

taking Wellbutrin, which happened after I sold my first book and quit my newspaper job. I became a freelancer, which meant I could be depressed without a boss commenting on my bad attitude. I stopped taking the pills during a stay in San Francisco in 2012, around the time of my thirty-first birthday. I didn't notice any symptoms of withdrawal. San Francisco helped, with its bracing fog and scenic vistas. I would run from the Mission up to the Panhandle and back, and my body became strong again. Six months passed and I didn't notice the absence of the antidepressant at all, except that I needed to sleep more.

No longer taking Wellbutrin made me less scared to try other drugs, but as is usually the case, my sudden personal interest in them was the channeling of a broader social change, as the drugs also became easier to find, after a period in which they had been less available. The first decade of the millennium had coincided with an "acid drought" in parts of the United States. First the Grateful Dead had stopped touring in 1995, ending a network of distribution. Then there had been a major federal bust at an acid lab in Kansas in the year 2000. Surveys that monitored drug use and discussion documented a marked decline in people using LSD. The price went up, and it became scarce. In 2002, Joe Biden, then a senator, introduced the Reducing Americans' Vulnerability to Ecstasy, or RAVE, Act, which held promoters liable for drug use at their parties and hastened the decline of the network of underground raves that had expanded around the country in the 1990s. In my twenties, when I lived in New York, in Little Rock, and in Miami, the most available drug had always been cocaine (or, at least, speed sold as cocaine), never psychedelics or MDMA or ketamine. This was also the decade when hundreds of thousands of people became addicted to prescription opioids and methamphetamine, and consequently when drug overdoses became a leading cause of accidental death in America. A genera-

tion raised on televised "this is your brain on drugs" propaganda, cautionary tales of 1960s acid casualties, and Red Hot Chili Peppers songs about heroin had no warning system in place for OxyContin dispensed by a physician. Perhaps this is a subjective opinion, but the 2000s were not a time of psychedelic experimentation—the dominant drug reference in pop music was cough syrup.

But by the second decade of the new century, you could buy and sell psychedelics and MDMA on the dark web, and Kanye started rapping about parties melting like Dalí, and Rihanna began singing about diamonds in the sky. Psychiatric researchers were beginning to recategorize them into the less stigmatized category of "medicine," as potential treatments for depression, post-traumatic stress disorder, and even as a possible treatment for addiction to other drugs. White, upper-middle-class professionals began to accept that psychedelics could in fact be compatible with their notions of capitalist success and would not harm the career or social prospects of people who were otherwise dedicated to conformity. In 2012, newly freed from Wellbutrin, I heard someone on National Public Radio talking about tripping on mushrooms; I read an Oliver Sacks article in *The New Yorker* where he recounted his many psychedelic experiences. "Many people experiment with drugs, hallucinogenic and otherwise, in their teenage or college years," wrote Sacks. "I did not try them until I was thirty and a neurology resident." This was interesting to me.

In November of 2012, six months after I quit Wellbutrin, a friend asked if I wanted to smoke DMT. I was traveling with this friend to Rhode Island. The weather was cold, and outside the window of a high-ceilinged room lit with Christmas lights and candles the trees were stark and bare in the darkness. The friends we were visiting had a trio of especially active cats, who followed us into every room and congregated on its highest perches. The DMT we had was the waxy orange kind. We weighed out a dose on a piece of aluminum foil and

took turns freebasing it with a glass pipe. I sat on a mat on the floor. My friend held the lighter and pipe for me so I could focus on vacuuming up as much of the smoke as I could. I inhaled an acrid vapor that smelled like burning plastic. I have trouble smoking anything, and struggled to hold the substance in my lungs. It hurt my throat, and my respiratory system fought to expel it. I suppressed coughing, exhaled, lay back on the mat, and covered my eyes with a scarf. The pain in my throat grew in dimension into a vast underground cavern inlaid with geodic crystals. The act of swallowing echoed with the steady drip of a stalactite. A buzzing drone filled the room and my vision tightened into geometric patterns of purple and green. I failed to get enough smoke in my lungs to "break through." DMT has a reputation for producing ornate filigree palaces, praying mantises, and titanium space elves. Some people describe a tear in the fabric of the universe. I just saw some patterns that faintly buzzed in the marker colors of my childhood—the "bold" jewel-toned spectrum that Crayola started selling in the early 1990s. But that this cognitive experience could be generated by the interaction of my brain with a chemical found in plants amazed me. I understood that the human mind had evolved to access this realm. That our biology enabled us to trip could not be an accident. I wanted to understand more.

So, I explained to the audience, altered consciousness became a course of study. In 2013 I decided to try as many psychedelic drugs as possible. I would tell this to my friends as a joke, except it wasn't a joke. It took time to figure out how to even find the drugs, and it was already July of that year when I tried my next psychedelic, ayahuasca, which was trendy in 2013. A friend added me to a Facebook group called "Love Is the Medicine." I met a man named Juan at a coffee shop in Park Slope, I gave him some cash, and three days later I went to the Catskills for a "ceremony."

The neoshamanic ayahuasca scenes of the twenty-first century

were the culmination of centuries of colonization and syncretism, followed by decades of hippie modernism, jet travel, the internet. They were a symptom of a mindset that saw the whole world's cultures, gods, and horticulture as a kind of buffet from which the missing object might be found.

The oral mythologies of ayahuasca tell of a plant-child born of impregnation through the eye and umbilical cords that became vines. In the deep history of the Americas, humans discovered—perhaps by observing the animals and what they ate, or in some interpretations, by communication from the plants themselves—that if they boiled an Amazonian vine together with the leaves of certain plants and then drank that concoction, the vine would suppress a stomach enzyme that otherwise inhibits the psychoactive properties of the DMT in the leaves. The first European invaders saw the brew as sorcery, but by the nineteenth century, botany and anthropology had become part of the rhetorical strategy of imperialism, and studies were done. People like William S. Burroughs and Allen Ginsberg started visiting Peru looking for ayahuasca in the 1950s, and the Amazonian city of Iquitos became one of those nodes, like Bali or Rishikesh, where outsiders could dabble in other people's religions and reformat them to the capacious American tradition of self-help. Of the varied traditions of ayahuasca used among Amazonian peoples, where the plant had many names and methods of ingestion, the Shipibo tradition of the Peruvian Amazon was the one that was extracted and reformatted for a global consumer class. By the 1990s the American tourists were bringing their shamanic mentors back to the United States and touring them around New Age circles. By the 2010s, when I went to the Catskills, it was all more or less a codified system, and, after a successful Supreme Court case brought by the União do Vegetal, an American branch of a Brazilian church that used ayahuasca as a Christian sacrament, a legal gray area. The urban ayahuasca circles that met in

yoga studios and retreat centers in Brooklyn and upstate New York were criticized for "bio-prospecting" and "commodification of the sacred," but their advantage was that they were semipublic, which allowed for an uninitiated person like me to find a psychedelic experience without having access to an underground subculture of music, religion, or parties. As was the case with most corrupt practices, you could perform your misgivings or you could just consume.

On the July week in 2013 when I had my first prolonged psychedelic experience, New York was in the middle of a heat wave, and in the seventy-two hours between my meeting with Juan and the ceremony I spent a lot of time alone, wandering from air-conditioned library to library, eating watermelon, rice, and vegetables. It is common with the Shipibo tradition of ayahuasca to follow a diet of bland, low-sodium food in advance of the ceremony. I followed these restrictions. Caffeine was prohibited, but I allowed myself a single serving of green tea each day. I didn't have an air conditioner in the small, one-windowed room I was renting at the time. My sleeping was erratic from the heat and I would lie awake until dawn, falling asleep at first light and then waking late feeling stunned.

On the day of the ceremony, a Friday, I woke around eleven. I lay for several minutes facedown in bed, experiencing the weather. The heat was oppressive, into the nineties by midmorning and expected to reach one hundred by the afternoon. When I forced myself awake, walking was like pushing through a thick soup, the air tangible and yellow, my mind clouded by torpor. I had been told to take it easy that day, so I did. As instructed, I ingested only juices and raw fruits and vegetables. I avoided salt. I went to the air-conditioned library and finished writing an essay. Then I returned home. I packed my sleeping bag and a towel to lay down beneath it. I knew we would be outside, and I worried about bugs, but it was too warm to put on long sleeves and pants, so I packed them for later. I brought herbal

bug spray, walnuts, and dried fruit. I was lightheaded and calm, but I was having difficulty concentrating. I spent an anxious and sweaty few minutes in my room trying to find my MetroCard. Despite the heat, I took care to make sure my room would be empty and clean when I returned. I organized and put away my books, papers, and clothes. I made the bed with clean white sheets. I left my apartment without telling anyone where I was going or that I would be gone for the night.

I had scheduled to meet my ride in Clinton Hill, and waited for her in a small patch of shade near a man selling shoes and clothes on the sidewalk. My driver arrived wearing a lavender backpack, and carrying a tote from a French clothing brand and a paper shopping bag containing two pillows. We walked together to her hatchback. She was in her midtwenties. This was to be her third ceremony. Her first one, she told me, had helped her instigate a series of important changes in her life. The ayahuasca had helped guide her toward quitting her job in finance, applying to graduate school, and focusing on her study of Pilates. We drove first to Williamsburg and picked up two other people, both in their midtwenties, each carrying their backpacks and sleeping bags, and then we drove to the rendezvous point upstate. I was happy to be going to the ceremony with these cool young people. They talked about Freerotation, the members-only electronic music festival that took place on the grounds of a stately home in Wales; their recent vacations to Croatia and Puerto Rico; of friends who had taken jobs waiting tables at raw vegan restaurants; the surfing lessons they were taking at Rockaway Beach; Pilates; bicycling; the elite private high schools two of them had attended; and the political philosophers they had most enjoyed reading in college. They mentioned an electronic music website called Resident Advisor and I put a note in my phone to remember it. It was rush hour, the traffic was bad, but we arrived at the rendezvous point, a shop called the

Crystal Connection, at the scheduled time around dusk. From there we caravanned to the land that would be the site of the ceremony. We were told to travel in silence. The silence was a relief.

We drove through the darkness, descending eventually down a narrow dirt track through a forest and ending at a farmhouse outside of which were parked a dozen or so cars. In front of the house, a group of people were gathered around a bonfire in conversation. They ignored us. We picked up our sleeping bags and pillows and lined up single file in front of a barn. As we approached the entrance to the barn, a woman dressed in white greeted each of us. Exhaling in short bursts, she performed a ritual over us with burning sage and a fan made of feathers, wafting smoke and fluttering the fan along our outstretched arms, directing us to lift one foot and then the other. Then we passed through the barn, one by one, into the garden in back. A man with a headlamp approached and led me to my place in the circle of seated people forming around a second bonfire. I laid down my towel next to a plastic pail, took off my shoes, and covered myself with insect repellent. The night was sticky and still, the fire uncomfortably warm. A half moon rose to the east and the cicadas buzzed around us.

The participants settled in for the night, unrolling yoga mats and unpacking sleeping bags, towels, and blankets. One woman unfolded a portable cot. Then the ceremony began. We introduced ourselves; then the man who would be our shaman gave a long, somewhat rambling speech. He was a white person, not from Peru, although he explained that he had studied in Iquitos. He gave me the impression of someone who had been lost, perhaps to addiction. He had the mild fanaticism of a convert. He appeared to have embraced the concept of the "personal pantheon," and freely remixed sacred traditions into his discourse. The pseudoreligious sermon possibly included some aphorisms from Alcoholics Anonymous. Mosquitoes bit my ankles.

I was hot and irritated as I followed a prayer to the four corners, and a prayer thanking our mothers and fathers, and then a prayer where we repeated the words "Hello, I'm sorry, I love you, please forgive me." We touched the ground with a hearty exhale then lifted our arms to the sky. We did a breathing exercise that we were told could be repeated to calm us later, if we found we needed calming. As the night deepened, a damp settled over us. I could smell citronella oil. I was lightheaded and inattentive from hunger. I was very tired.

After a final prayer, the shaman began dispensing the ayahuasca. One by one, the twenty or so members of the circle walked up and knelt before him. I watched the fire, trying to regulate my grumpiness by reminding myself how excited I was to be there, and my turn seemed to arrive quickly. I was dizzy as I stood up, walked to the shaman, and knelt before him in the dirt. First he administered a bitter sort of tea that was strong but clear and refreshing. This was followed by a sweet tincture from an eyedropper. Then he asked if I wanted to try rapé, a powdered tobacco. I nodded. "Don't breathe in through your nose," he said, then blew the powder into my left nostril through a straw. This hurt a lot. My eyes watered. I braced myself again for the pain and he blew the tobacco snuff into my right nostril. Then he administered the tiny cup of ayahuasca, murmuring some words over it. He held out the cup and I drank it. It tasted primordial, of swamp decay and mottled leaves. I swallowed it and suppressed a wave of nausea. I stood and walked back to my place in the circle, my nostrils smarting. I felt faint and nearly fell over. Once back in my seat, I tried to clean the dirt from my legs. The tobacco had sharpened my vision and my hunger had disappeared. The campfire's flames were brighter and clearer. I was more alert. I waited.

For a long time nothing happened. I was aware only of my own discomfort, of feeling vaguely ill. The shaman and other helpers sang tuneless songs. They whirled airfoils to produce a vibrato, they

played drums, they broadcast "I Only Have Eyes for You" performed by the Flamingos from a tinny digital speaker. Around me, people were silent; some sitting up, some lying down. I took out a wet wipe and tried to clean the dirt off my legs. Then I changed from my skirt into my pants and a long-sleeve shirt. I thought, Maybe it's not going to work. Then a woman halfway around the circle threw up into her pail with what I thought was a quick turnaround, because she had been one of the last to drink. It's not working, I decided. I was very tired. I had not slept well for days. I lay down with my head on my sleeping bag. At least I can sleep, I thought.

Perhaps I drifted off, perhaps not, but the change came as an abrupt shift. Suddenly the dark motions of sight behind my closed eyes organized themselves into tight patterns. Earlier that summer I had traveled to Portugal, and what my mind now produced replicated the azulejo tiles that patterned the facades and sidewalks of Lisbon. My vision assembled itself into stable, interlocking pixilated patterns of violet and green. The patterns were familiar from my DMT trip, but where before I had merely stood at a threshold, I was now trying to pass through it. More palpably, something shuddered inside me. Something was trying to hatch through the shell of my body. The cicadas called it out.

People with experience drinking ayahuasca had spoken of the medicine manifesting itself as an entity, a female, whom they referred to as *abuela*, or grandmother. Allen Ginsberg gendered it as male: "This great creature being bisexual and the lover of all in an extremely personal way." I experienced the ayahuasca as a coherent and feminine entity. I had allowed a being to enter my body. It was not a possession, just as the purging was not an exorcism. She had, I understood, a system of revelation unique to my own limitations of consciousness. She was amused by my inhibitions, and revealed the paucity in my patterns of thought. I could converse with her. That this being had a

physical process of settling herself inside me felt correct: the urge I had to vomit was her settlement pattern.

I sat up and opened my eyes. Another shudder went through me, but my awareness of my body had otherwise vanished. My senses were flooding, brimming over beyond my physical outlines. I opened my eyes and looked at my surroundings. The grass before me, the bonfire, the black silhouettes of the trees overhead, the stars and the half moon hanging low in the sky. The grass had thickened and intensified and was traced into ornate patterns. The trees had flattened into lace. The stars quivered and the fire bled out into the darkness around it. The cicadas were now rending the air, tearing it into patterns. I dry-heaved over my bucket, a sharp physical sensation that forced all the dissolved particles of my being to gather once again.

The next time I could claim awareness of the passage of time would be as the sky began to turn gray with dawn. When I closed my eyes, I was borne along in a rapid slideshow of observations. The impression was of being pulled, running, through a series of rooms. As soon as I was close to grasping what surrounded me, a shudder would again rip through me and I would return to the world of human senses. When my eyes were closed, the ayahuasqueros' music was the organizing principle around which everything cohered. Without it, everything would fall apart. I hated the vomiting, which drew me out of the exquisite realm taking shape in my mind with every wave of sickness. It seemed that the plant was punishing me, but finally the nausea subsided and I was left to watch the show unfurling in my mind.

The images were dazzling but did not exist long enough to be recorded in memory, for that was the point, to cut them off before they would become constrained by the limitations of understanding. I can only recollect the vaguest impressions: feeling like a child, the

experience of doors opening and closing, of running up and down stairs, of flying buttresses and astrological maps laid ornately over a white sky. To properly hold these impressions would be to diminish, categorize, and encapsulate them, and the purpose of the visions—I was aware they had a purpose—was to reveal what was lost in the usual process of mental recording. This was a place outside of words, yet it made me aware of certain linguistic habits. I was suddenly conscious, for instance, of what I can only describe as a "women's magazine voice," a constant running narrative about how to be a more efficient, cleaner, healthier, more beautiful, undemanding, and more domestically competent human. I could ignore the voice, was the suggestion.

In what I later thought of as a second phase, my thoughts began to slow and I was allowed finally to comprehend the images passing before me. The visual chaos subsided. Having showed me the process by which my thoughts initiated, and the clutter and distraction, now the entity was slowing the pace to tell me what to do. It was as if the initial phase had been a roulette wheel going through my memories, and having surveyed what was there, now prepared to dispense lessons. I experienced a deliberate reticence from the entity that allowed me to draw slow connections.

A series of people passed before me. It was not the people I thought of the most. Not, for instance, the ex-boyfriend I had thought about almost constantly for the past two years, or anyone in my family, or any of the friends I saw on a regular basis. One person appeared whom I had last seen in Mozambique in 2008, but there he was, with a lesson. The lessons from these encounters amounted to the following: I should not withhold my affection from the people around me; I should not withhold my love from them; I should not be scared of presenting myself to them; I should be decisive, not insecure; I should

not fear telling people I loved them and that, with the people in question, I would be rewarded for breaking down formalities by richer, truer friendships and relationships.

The birds began singing. As the sky lightened, my vision was still affected by the ayahuasca but the pace of everything had slowed further. An extreme peace settled over me, characterized by overwhelming gratitude and a singular happiness. These ersatz shamans were geniuses. They had given all this to us and I loved them. I sat up in my sleeping bag and tried to record my thoughts in a notebook. In the morning we spoke around the circle, we ate breakfast, and then we returned to the city. I showered and went to sleep. I was happy I'd cleaned my room and that I had no obligations for the day. The heat wave had broken.

I did not tell the audience about these epiphanies in the lecture I was giving almost three years later. They were too personal. Also, I'd met someone at that ayahuasca ceremony. For the past two and a half years Matt had been my boyfriend, and now he was sitting in the audience and watching me. Instead, I said that like many people who have just tried psychedelics for the first time I became a zealot in the immediate aftermath. I followed ayahuasca with every drug I could find, mostly the classics: LSD, MDMA, mushrooms, ketamine. As I worked on my first book, about sexuality, I was already planning to write a book about drugs. My bookshelves filled up with literature published by New Age imprints. I read the canon: *Be Here Now, The Electric Kool-Aid Acid Test, The Doors of Perception, The Varieties of Religious Experience, PiHKAL.* I read self-published books and esoteric novels, like William Craddock's forgotten LSD bildungsroman *Be Not Content* and Krystle Cole's *Lysergic,* an account of the LSD bust in Kansas, which happened in an underground missile silo. I listened to the lectures of Terence McKenna. I read the correspondence between William Burroughs and Allen Ginsberg about

trying yage, or ayahuasca. I knew it was an unfortunate intellectual detour. Falling in was one of the greatest risks of adult life, not much discussed—falling in to conspiracy, fanaticism, religion, and embarrassing beliefs, as life continued on and the weight of it broke people left and right. Some people hinted that my new hobby was a dead end. Of all the courses of study a person of means and intelligence could undertake, or causes to which I could devote myself in the prime of life, this one was silly, and put me in contact with dissipated people who believed in things that weren't real. Nevertheless, I listened with genuine interest to the theories about the primitive computing power of crystals, and to McKenna's predictions of the eschaton. In 2013, I went to Burning Man for the first time; I went to Horizons, a conference on psychedelics held at Judson Memorial Church in Manhattan; I wrote about the drug website Erowid for *The New Yorker*.

These were middle-class entry points, and like most conformist strivers who also did drugs I convinced myself of an idea of responsible drug use. My experiments were confined to one or two a month, so that I could consider each new substance in its distinct identity. I never mixed substances. Except for the group ceremonies, I preferred to experiment in solitude and in a quiet place so that I could discern the effect of a drug in a controlled setting. I didn't understand the point of being on a psychedelic at a bar or party, but also that was something I thought I heard Terence McKenna say. If you wanted to talk to people, I thought at the time, you shouldn't need more than a cocktail. I took drugs, I would tell people, for introspection, which was a self-righteous posture, as if the way I went about it was somehow more noble than people who got high to have fun. These pretenses made me think of myself as rule-abiding and prudent, and allowed me to differentiate my drug use from the kind I had been taught to think of as reckless and unhealthy. I avoided opiates because I didn't want to develop a dependency or die. As for cocaine, I began

to think of it as an unspiritual drug, a drug that offered no surprises, a drug for assholes. The thing was, I was the one being an asshole, with my smug little adventures in cultural appropriation that I used to process my banal emotions. I concluded my lecture with the lesson that I now knew: thinking of drugs as "good" or "bad" was unhelpful; there are only more or less dangerous drugs. I said I now tried to avoid "pharmacochauvinism," or judging one high as more spiritual or intellectual than another. I talked about the idea (stopping short of any statement that might be construed as advocacy, since I was uncertain) of "cognitive freedom": the right to alter one's consciousness as one chooses. I averted my eyes from the white beam of the projector and decided to end things there, sensing the attention of the audience beginning to wander.

3

AFTER THE LECTURES ENDED, WE ALL WENT TO A NAUTICAL-THEMED bar on Third Avenue. I walked over the Gowanus with Matt, my boyfriend. Whenever I went near the Gowanus I thought of the minke whale that once swam into it. "Frolicking Visitor Delights Hearts, Then Dies," the headline in the *Times* had read.

Matt sold mushrooms, worked as an attendant at a studio that rented sensory deprivation tanks by the hour, and had the jaw, torso, and height of a male model. He had noticed me at that first ayahuasca ceremony and found an excuse to get my number from the organizer. Our first date was at a fading health food restaurant in the East Village called Quintessence that served only raw, organic, vegan, gluten-free, and soy-free food and where I ate a bowl of squash soup, which set the hippie tone of the time we spent together. When I met him, Matt was almost a decade into an intensive pursuit of self-help. This pursuit was so completist that it often made me wonder if the best thing that Matt could do to help himself might be to pause his obsession with his personal health and wellness. A year or so into our relationship, however, I thought we could put some of his experiences to use by collaborating on a book called *Self-Help*. He would provide the stories, and I would write them. The outline of *Self-Help* had chapters for each of Matt's experiments, which included masculin-

ity groups, colonics, acupuncture, cupping, moxibustion, vipassana meditation, orgasmic meditation, neurolinguistic programming, eye movement desensitization and reprocessing, a gluten-free diet, sweat lodges, yoga, colloidal silver, cognitive behavioral therapy, chiropractic treatments, the full encyclopedia of psychedelic drugs, and other "modalities," many of which I had never heard of. Whenever Matt was feeling off, he would attribute the problem to, say, having ingested too much maca powder, or having consumed a nightshade. But this "work," as he called it, had given him a talent for calming himself. He rarely drank alcohol and avoided caffeine. He had an uncanny physical intuition that, early in our relationship, made for fun sex on a mattress that had been magnetized to restore and detoxify the body. He was at his most eloquent when describing the flavor profile and nutritional content of a persimmon. In the end I wrote only two chapters of *Self-Help*. One chapter told the story of an oracle in Mount Shasta who had approached Matt in a coffee shop and then declared him to be the reincarnation of an ascended master named El Moyra, who occupied the sixth dimension. ("Excuse me," she had said, when she addressed him for the first time. "Your guides are telling my guides I need to talk to you.") The other chapter recounted Matt's five encounters with ghosts.

We would often trip-sit for each other. One night Matt bought salvia, which was legal, from a head shop on Saint Mark's Place in the East Village and we smoked it together, producing a receding angular dissociation I thought of as "triangle world" and uncontrollable laughter. On another day he drove us in his grandmother's Toyota Camry to a peyote ceremony in Pennsylvania organized by the Native American Church. He told me that, as a woman, I should wear a long skirt out of respect for a tradition that had begun in the nineteenth century, when the Plains Indians developed the rituals of a pan-tribal spiritual resistance to colonization. On the way out of

town he pulled over outside a thrift store so I could run in and buy one. We arrived at a tipi in a muddy field next to a farmhouse. The ceremony began after dark. I put the skirt on over my jeans and went into the tipi. Fifteen or so people sat in a circle around a fire. After a ritual, the peyote buttons were passed around in a bowl. The buttons were fresh, not dried, and seemed to have just been washed. I ate conservatively, maybe three. They were crunchy and bitter, like the world's worst-tasting cucumber. We spent the night passing around the drug and singing. The white woman next to me sang a song about Jesus and seemed to have developed a syncretic religion involving peyote ceremonies, sweat lodges (which she said she also attended regularly), and Jesus.

It was an uncomfortable night. The damp seeped into my clothes. The fire burned and I smelled like a pile of wet ashes at the end of the ceremony. I did not have a visual response but I also had not had the urge to fall asleep. Sometimes, when a psychedelic didn't quite take hold, what I experienced instead was a deep misanthropy. I spent most of the night longing to escape the tipi and go home, increasingly uncomfortable with the religious nature of the ceremony and the sense that I was violating a space where I did not belong. In the morning I was angry at Matt for having brought us there. He fed me hard-boiled eggs and almonds, trying to take the edge off.

At the time of the lecture in the warehouse near the Gowanus Canal, we had been sleeping together for more than two years but didn't live together and never would. That night I wanted to avoid his thoughts about my lecture, which would have been disappointing. We were not intellectually aligned. He had spent most of that spring in Colorado studying a kind of bodywork focused on connective tissue called Rolfing and we had not missed each other. I was as lonely in the relationship as I would have been if I were single, but stayed under the belief that I didn't get to choose who loved me, that life was

a process of accepting whatever love I was offered, and what Matt had offered without qualification was love. But what had lasted without my love, in return, was now entering a phase of mutual disdain: I no longer wanted to have sex with him, and he was beginning to hate me for it. He came to the lecture and the after party to support me, but at the bar we ignored each other.

The interior design of the bar was dated to the years, 2010 or so, when people in Brooklyn dressed like lumberjacks and tools hung from the walls of the places where they drank old-fashioneds. As we walked in, I noticed a man standing at the wooden bar drinking a beer. He stood out because he was tall and had unkempt, shoulder-length blondish hair. He was standing next to, or rather towering over, a journalist I knew, so I had an excuse to approach him as I went to order a beer. He introduced himself; his name was Andrew. He held his beer in one hand and an unlit cigarette in another, perpetually on the verge of going outside to smoke. He wore a T-shirt with a black-and-white picture of an old Sony Discman on it, except that the logo had been edited to read "Discwoman." I said hello to the journalist I knew, then turned to Andrew and asked him about the T-shirt. He explained that it was a feminist DJ collective based in New York. We talked about the techno scene in Bushwick, about Sustain-Release, the rave that took place every September in the Catskills, and Bush-wick A/V, the seedy after-hours warehouse party that would start on Sunday at four in the morning after the bars closed. Some of these parties were hard to find because they were not held in legal venues and used secret ticketing links that were passed among friends or sent to email lists. Andrew offered to send things along as they came up, and we exchanged numbers. I did this turning slightly toward the bar, hoping Matt was absorbed in conversation and wouldn't notice. Andrew complimented my lecture, which embarrassed me, so I asked

him what he did and he told me he was a computer programmer and a music producer. He worked with my journalist friend, who was nodding politely, at an internet media company.

In the weeks after we met, I sent him a few text messages, all of them businesslike, where I would ask if he knew of any parties going on, and he would forward links to parties I never went to. Then, in late May, I was sent to France on an improbable assignment for the *New York Times* style magazine where my job was to hike through the Maritime Alps as Simone de Beauvoir had done every summer for years. Magazines often had to draw on the past to recall writers who could command cults of personality, in this case by literally following in the footsteps of bygone intellectuals, in a fury of longing for a time when writing was synonymous with celebrity and style, as opposed to now, when it was associated with obscurity and financial precarity. I was several days into my journey, alone in the single room of a French hostel in the forest, watching the mist rise off the pine trees in the blue light of dusk, when Matt called, sobbing.

He was incomprehensible. "Stop crying," I said, not unkindly, but in the tone one might use with an overexcited child. He took several deep breaths. Finally stable, he told me that after ingesting a tincture of cannabis he had recalled a traumatic childhood memory. I listened, skeptical. Recovering traumatic childhood memories in your midthirties while high seemed like a disproven therapeutic cliché. I kept these thoughts to myself as he continued his series of revelations: everything had changed now, he wanted love, he wanted a family, I would never want to live with him, it was over. I listened to this without feeling, unable to suppress the exhilaration brought on by the mountain air and my day of hiking, drawn to the fireplace, the glass of red wine, and the pot-au-feu waiting in the hostel's dining room. My lack of sympathy was without cure; I couldn't take him seriously,

his pain meant nothing to me, so the relationship ended, humanely, over the phone. We never saw each other or spoke again. It was my life's most perfect breakup.

The next day, I crested an Alpine ridge overlooking a grassy bowl in the landscape. A small herd of chamois grazed below me; the wind blew ripples in the surface of a small lake. I was utterly alone. Snow-covered peaks towered around me. I wanted to scream with happiness. I wondered what might happen next and I thought of the long-haired man I had met after my drug lecture in Gowanus two months before: Andrew.

I waited a few weeks to let things settle. Matt had been staying at my apartment in Bushwick while I was away, but when I got home all traces of him had vanished. I had a single moment of intense emotion, when I went to make coffee and the basket of the moka pot was gone. Matt didn't drink coffee—who had he made coffee for? A storm of fury passed through me. I reminded myself that it was over, that nothing Matt did or thought mattered anymore because I would never see him again. I ordered a replacement part online. At the end of June, I went to Fire Island with my book club. We were reading Robert Caro's biographies of Lyndon B. Johnson. We drank rosé and ate potato chips on the back deck at sunset and listened to Neil Young and the Grateful Dead. We took acid and walked down the beach to get Rocket Fuel cocktails at the Shack. Later, those last weeks of June would glow in the past, as the last time when I had self-possession, as the last time when any number of possibilities for life were still arrayed before me, instead of just one. After getting home on the first of July and dropping my bags, I wrote Andrew a text message, asking if he wanted to get a drink. I put my phone on the table and waited. A jet descended overhead toward LaGuardia Airport, and then another. Maybe he was out of town. Then the phone vibrated, and we arranged to meet.

4

MY COMPUTER HAD DIED ON FIRE ISLAND, ELECTROCUTED BY THE saline air or possessed by a ghost. Before my date, I rode the train into Manhattan to drop it off for repair. The city was deserted for the Fourth of July weekend. On Ninth Avenue the taxicabs rolled over manhole covers with an empty clank. Air-conditioning, perfume, and compressed pop music poured out of Sephora onto the sidewalk. The Apple Store was a stainless-steel locker. The technician, clad in his dehumanizing polyester uniform, channeled into a vector of the gadgets he sold, looked disappointed that the system failure did not appear to be my fault. "We're going to have to send it in," he told me, and the computer was taken away. Outside, the hot air from the city rose up into the sky where it cooled and grew heavy. I took the L train back to Brooklyn. When I got out at Morgan Avenue, a small crowd stood outside the turnstiles watching a violent rainstorm. I waited next to French tourists and Bushwick goths staring wordlessly at a billowing curtain of rain, then lost patience and walked home in it. I took a shower and dressed. I put on black shorts, a white T-shirt, no makeup, sandals.

I walked down Broadway under the corroded girders of the elevated train. The downpour had not so much stopped as suspended itself; I couldn't tell if the temperature was hot or cold, if it was rain-

ing or not. A clammy mist hung in the air. We had planned to meet at Flowers for All Occasions, a bar in a former flower shop that sold Fritos and cocktails made with soju because they didn't have a liquor license. I walked in and saw a man with long hair sitting by himself at a table. A pang of fear struck me that I had misremembered this man as attractive, but he turned out not to be Andrew. Andrew wasn't there. Then he came out of the bathroom. He had cut his hair, which now stopped just before his chin. He wore all black, with a black baseball cap. He didn't have cash, so I bought his beer. This was our second conversation. To prepare for the date he had read a little bit of my writing but otherwise knew nothing about me. He had thought our texting was strictly about music, he told me, but then I had asked him out. I quickly learned, with a sinking feeling, that I was five years older than him. "All my girlfriends are older than me," he said. Then he added, grinning, "Not that you want to be my girlfriend." I smiled and looked at the floor. After the beers, we walked to OMG Pizza and got slices, which we ate as we walked the half block to Bossa Nova Civic Club. There, at a corner of the bar, in the air-conditioning and fog, his blue eyes radiating sweetness and interest, he kissed me for the first time. I invited him back to mine. We walked together to my apartment and had sex, then he went back to Bossa to watch a friend's DJ set. I didn't think I would hear from him again. He wrote me the next day.

He was a stoner, which gave him a laid-back California affect. He would lose his wallet, phone, and keys on a regular basis. He lived in Ridgewood, Queens, in a railroad apartment he had to himself, down the street from a deli that had a freezer piled with Mexican paletas and a bar with pinball machines. Visiting Ridgewood was like going back in time, to an orderly and prim fantasy of a city, with low-rise brick buildings, storefront real estate offices with neon signs, a doctor's office that had a gold-stenciled caduceus in the window, and a small

library with an American flag blowing taut in the summer breeze. The second time we met, he waited for me under the Seneca stop of the M train, smoking a cigarette and drinking an iced coffee. When we walked in the door of his dingy first-floor apartment he drew me toward him without speaking and we fucked on the gray cushions of his cigarette-burned IKEA couch. It was a couple of hours later, after the second time we had sex that day, this time on his mattress, the window air conditioner blowing cold air over us, and after the orgasm I had, and as I watched him retreating to the bathroom, that I started to cry, because I knew that I could not live without him.

I liked his little black tuxedo cat draped on her cardboard scratcher. I liked his Selsun blue shampoo and his Irish Spring soap. His primary possessions were the shirts hanging in the closet and vintage synthesizers. His apartment had roaches. His books were all works of nonfiction political economy: Hardt and Negri, Naomi Klein, Thomas Piketty, but it turned out these were the remnants of someone he used to be, a person who wore tortoiseshell glasses and a Burberry trench coat, a person who served a cheese plate when he had a dinner party. Now he was into techno, and wore black T-shirts, black Levi's, black New Balances, wire-framed glasses, and a baseball cap, day in, day out. His life had a material simplicity. When he logged onto Amazon, the site would offer recommendations for audio-video cords and black baseball caps.

In the morning we got up and washed our bodies with Irish Spring. We walked to the coffee shop and drank iced coffees. He got a lemon-poppyseed scone and I got a sesame bagel toasted with butter. It was the kind of hot New York day that made you count the hours until night, when the sun would relent, the lethargy would lift, and it would be time to find friends in a dark room. He rode the M train with me back from Ridgewood to Myrtle-Broadway. He sat down on one side of the train and I sat on the bench across from him

and he gave me a reproachful look of mock hurt and patted the open seat next to him. After that day, I was in love.

Which was not to say that I had any certainty. Shortly after our first dates, Andrew went to Berlin for a month. I monitored him online, where he appeared in photographs picnicking and drinking dry sparkling wine on the banks of the Landwehr Canal. He celebrated his thirtieth birthday at Berghain with coke, ketamine, GHB, ecstasy, and speed. He texted me from the club, where he honored the requests of the urine fetishist who crouched near the urinals, murmuring, *"Bitte, bitte?"* He rode out a k-hole in the bathroom, just going back and forth from the faucets to the hand dryers, alternating cold water and hot air on his hands until he came through to the other side. As the weeks passed, he wrote me with decreasing frequency. He hinted that he was having sex with women and flirting with men. He went to Dekmantel, the music festival in Amsterdam, and his only text message had been a photograph of a cat sitting on a car. Of course, I thought, as I stopped hearing from him.

The night he came back I went over to his apartment. He had gone from Berghain to the airport and was now only half-aware of his surroundings. He passed out after we had sex and I tried not to be disappointed. In the days that followed he canceled plans a couple of times or would sometimes disappear. He gave me chlamydia. I was worried. I had a phobia of dishonest people. He was not the only man who was interested in me, yet it was as if there was nobody else.

We decided to meet for a conversation in Maria Hernandez Park. We walked the park's little jogging loop. Three loops made a mile: three times past the dog run, the basketball courts, the corner where the drunks gathered under the trees unless the cops had decided to harass them that day. Our walk had an official air. It was convened as a relationship congress and an apology. We circled the loop and Andrew told me that his tendency to disappear had become the break-

ing point for every one of his relationships but that it wouldn't ruin this one. He was ready to have a partner, he said. Our friends were modern like that, and everyone liked to say the word "partner," with all of the respect and equality and maturity that it represented. "My *partner*," we would say smugly when we told colleagues at work about our weekends. We decided we would be partners, we would be modern, we would be nonmonogamous, we would not let history impose its gendered traditions upon us, we would discover new forms of commitment, but we would be together, we were together now, and that had been what I needed to know.

We sat on a bench. Andrew hung his head. He had read an advance copy of my book and said that a line had stuck out at him. It was the one that said that at the beginning of every relationship you already know how it will end. The dynamic was now established: my watchfulness, his reclusion. We would figure that out later. I had spent the whole of my adult life worrying about love. Now I had it, so it was time to worry about other things.

5

BEING IN LOVE MADE ME HAPPY, AND I LOST INTEREST IN CHANNELING all of my knowledge about nutrition, disease, and medicine into a life of perpetual risk management. The things I gave up during this time included jogging, daily flossing, omega-3 supplements, and the dire sense of professional competition that had given purpose to my solitude and driven my ambition. I abandoned the impulses toward self-help I had picked up while dating Matt. I stopped going to yoga and I stopped going to the Buddhist discussion group I had been attending in a Bushwick loft, which was led by a retired Haitian American monk named Phuntsok who had studied in a monastery under exiled Tibetans. How do I explain it? I used to be so careful. I never used to stay up all night. I used to be severe, recriminating myself when three days had passed without jogging. I used to spend energy trying to maintain physical and mental homeostasis through healthy living and disciplinary practices of learning to be less reactive to the ups and downs of life. When I was unhappy and without love, the regimes of personal risk management had given my solitary days an illusion of purpose. To write I had to be lucid, and I had to write because I didn't have my own family and if I didn't write I would have nothing to show for my life. Now that I had love I no longer needed to fill my days with

goals or discipline. I lost drive, I got lazy. I began to see antidepressants as a capitalist plot. My friends changed. I never woke up early.

I was happy, but I was also afraid. I had accumulated too much advice about how to avoid cancer and build cardiovascular endurance. Matt had taught me about the phytoestrogens in soy products and the Roundup sprayed on genetically modified corn. I retained this information even when I didn't want to. I had probably thought more about the endocrine-disrupting chemicals in plastic than I did about my favorite books. I couldn't go out in the sun without thinking about ultraviolet radiation; I couldn't paint my nails without thinking of formaldehyde. I resented years of reading the news, which had exposed me to so many strategies for prolonging my life. Each day was a long series of decisions about things to buy and what to do to protect your body from the systems of destruction that took place beyond your control. Exercise, wellness, and the mimicry of ancient rites had been coping mechanisms, but now that I wasn't alone, I found I no longer needed them. So Andrew and I snorted cocaine together and had sex in the bathroom at Bossa. The sun still set over the rooftops and the jets still flew in one after another, but now I had someone holding me, his erection pressing against me in the mornings.

The months that followed were the happiest of my life. My book *Future Sex* was going to be published in October, I was in love, and a new phase of my life had begun that marked a break with my life in New York up until that point. I had moved earlier that year to the apartment at Myrtle Avenue and Broadway, where Myrtle slashes diagonally through a grid of streets and the elevated J and M trains meet overhead in a squealing roar. The landmarks of the intersection were Mr. Kiwi, the twenty-four-hour greengrocer; the Start Treatment and Recovery Center, where people lined up before dawn for

their methadone doses; a Popeyes–Dunkin' Donuts–Checkers fast food franchise; and several deli–slash–smoke shops where you could buy chicken over rice, or pamplemousse-flavored LaCroix, or a *Rick and Morty*–themed bong. One of these delis, Day & Night, blasted a never-changing playlist of music over the intersection, and commuters waiting for the trains above would sway absent-mindedly to "Sexual Healing" and "Everybody Everybody." Andrew bought his cigarettes tax-free under the counter for seven dollars at Big Boy, which was also the only deli in the neighborhood with both a Bitcoin ATM and print copies of *The New York Times*.

Big Boy was also said to be the heart of the mysterious trade in a psychoactive substance called K2, empty foil bags of which littered the streets. K2 was a catchall term for a general category of synthetic cannabinoids sprayed on plant matter and smoked. Although the substances were sometimes called "synthetic marijuana," they really had nothing to do with weed; their classification as a cannabinoid meant only that the chemical interacted with the same receptors in the body as did cannabis. By all appearances the effects of K2, at least as far as they could be observed on the streets of Myrtle-Broadway, were distinct from that of ordinary weed. K2's primary advantages seemed to be that it was really cheap, readily available, and, as far as I could tell from reading accounts online, produced a high that was not especially exciting but less boring than being sober. The summer after I moved to the neighborhood, Myrtle-Broadway briefly made headlines when a bad batch that contained a chemical called AMB-FUBINACA caused more than thirty people to pass out on Broadway in a single day. I later read an article in *The New England Journal of Medicine* about "the hospitalization of multiple persons on the morning of July 12, 2016," that "turned a block in the Bedford-Stuyvesant area of Brooklyn into what was described by the lay press as a 'zombieland.' " A precursor for AMB-FUBINACA, the article

continued, was synthesized by a researcher studying the body's endo-cannabinoid system and was patented by Pfizer in 2009. It would likely have remained in the archives if it were not for entrepreneurial chemists looking to skirt United States drug laws. The bad batch that summer had been sold in the bodegas around Myrtle-Broadway as "herbal incense" under the brand "AK-47 24 Karat Gold." Drugs in New York were class-specific consumer goods; AK-47 24 Karat Gold was not a drug the young professionals would be microdosing.

The gentrifiers had their own delivery services for pot, mush-rooms, pills, ketamine, and cocaine: the cars with tinted windows that would pull up outside bars; the punk stoners who delivered mush-rooms and weed to our apartments by bicycle. The street users had anxious conferences in doorways or hunched over duffel bags. People nodding off on the sidewalk, getting in arguments, tying off next to the MetroCard machine, or striding purposefully across Broadway regardless of traffic were part of the landscape, along with an NYPD presence whose sole mandate seemed to be harassment of the drug users. Stretchers loaded onto ambulances were a not-uncommon sight at Myrtle-Broadway, and the commuters who flooded out of subways in the evening would sometimes step around solitary figures standing at the top of the stairs, statuesque and staring, physically upright but mentally gone.

The neighborhood had layers, like the file of an image in Pho-toshop. Each layer was distinct, or maybe I'm avoiding the word "segregated." The street scene of the K2 and heroin users at Myrtle-Broadway was one such layer. Another was the older shops and busi-nesses: Las Mexicanitas grocery and Guadalupana Bakery and Mi Bella Cholulita Deli; Enrique's Unisex Salon, where I would get my hair blown out before weddings, and which had elaborate holiday window displays; the laundromats; the barbershops; the botanica that held ceremonies in its basement on the weekends. The layer in which

I belonged was the one that threatened to put the other ones out of business. It was the most recently added one, of childless adults who had artistic pursuits, worked on their laptops at the Little Skips coffee shop, and defaulted to they/them pronouns as a position of respect. They referred to New York City as "occupied Lenapehoking" or "the place now known as New York City" as a reminder that everyday language could be a proxy for harmful concepts they did not want to endorse. They dressed in used clothes, commuted by bicycle, cut their own hair, volunteered at the Bushwick Food Co-op or one of several community gardens, attended noise shows at Silent Barn or Market Hotel, and lived according to a constantly shifting political consensus articulated mostly via scolding on social media. This group, some of whom came to New York to get away from intolerance in the places they came from, now suffered the guilt of gentrifiers even as they faced their own displacement by the deadening waves of wealthier young professionals who would soon have their Amazon orders and takeout salads delivered to the sterile, newly built condominiums that were rising all around the neighborhood. Part of the concern with signaling care came from evidence that they were remaking the neighborhood in their own image, which no acknowledgment of privilege or gesture of historical correction would remedy. Rents were going up.

My own introduction to Bushwick had happened years before I moved there, on a series of dates with a man I met at a party during an off moment with Matt. This man, who lived on Knickerbocker Avenue, or maybe it was Saint Nicholas, and whom I never even ended up having sex with, had introduced me to the neighborhood as if I were a French tourist coming to photograph the street art with a to-do list from Yelp. He met me in Maria Hernandez, had tacos with me at Dos Hermanos, drank coffee with me at Cafeteria La Mejor, and bought me a burger one night at Mominette. He took me out for Vietnamese

food at Bun-Ker, at the first small location on Metropolitan, and we watched an exhibition of performance art called "Anxious Spaces" at the Knockdown Center. We went to Human Relations, the best used bookstore, where they had a first edition of Louis Zukofsky's *"A"* on display on a high shelf. We had martinis and patty melts at the Narrows and looked at the Missed Connections section of *Showpaper,* the newsletter that carried the listings for all the neighborhood venues: Market Hotel, Palisades, Shea Stadium, Silent Barn, Bossa. When we went to a noise rock show at Secret Project Robot he brought me a pair of earplugs. After this short courtship ended, I kept going out in Bushwick. I liked that at Happyfun Hideaway a woman would walk around with a basket selling marijuana Rice Krispies treats. I liked that at Bossa they served watermelon juice and imported Club-Mate from Germany. Some of the ayahuasca ceremonies I had gone to were held in a dance studio off Flushing Avenue, where black curtains were hung in the windows to block out the glare from the twenty-four-hour gas station below.

Well before I met Andrew I was drawn to the neighborhood's techno scene, and in a way I found him while looking for it. At some point in that same year I got into drugs, I had started following someone on Twitter who went by the handle @DanceBitchBK. She would post every weekend about local DJs who played in warehouses and bars. ("I tell you where to dance," read her bio. "Usually in Brooklyn. Usually not a club.") My interest in the music was related to my interest in drugs. The scene @DanceBitchBK posted about seemed like it might bring together the kind of people I wanted to find. I was looking for a psychedelic setting that did not have the Wikipedia pantheism of the ayahuasca circles or the tech-industry libertarianism of late Burning Man or the cheesy commercialism of an EDM festival or that tried, like the MAPS practitioners I'd seen lecture at the Horizons conference, to turn every experience of altered con-

sciousness into therapy. But the drugs were only one part of it; it was also my wanting to be around people who were world-building, who went out at night prepared to present themselves, with their bodies, their sexuality, their fashion, and their music, in confrontation to the forces of contemporary triteness. Even if I lacked the ingenuity or imagination to be such a person myself, every encounter with this form of aesthetic resistance, even just a person artfully dressed on the subway, gave life meaning.

I made Matt take mushrooms and go with me to see Silent Servant at a Bunker party at Trans-Pecos in 2014, but that was another experience that had been intellectually disappointing to share with him. We tried to go to a Resolute party at 88 Palace, the restaurant-venue in Chinatown, but even knowing nothing we knew that we didn't like the music or the crowd. Until it closed at the end of 2014 we fit in better at a small venue called the Body Actualized Center, which was emblematic of that particular moment in time in Bushwick, when a witch store opened on Flushing Avenue and it became cool to wear Grateful Dead T-shirts again. Body Actualized was decorated with sacred geometry, and the scent of palo santo hung over the dance floors. It had yoga classes, tarot-reading nights, electronic music shows, an unlicensed bar that served drinks infused with psychoactive herbs, and a peace-and-love vibe that was more California than New York. It had a metal geodesic dome on a platform in the backyard. You could climb up and the mosquitoes would bite you and you could chat and make new friends. At tarot-reading nights the young fortune tellers in the neighborhood would gather and offer cheap minireadings. A young gay man told my fortune for fifteen dollars. "You will be unlucky in love," he prophesied.

All of this was a break from the gloominess of my existing social circle, which was mostly limited to other writers and journalists, people who wrote or edited novels, magazine articles, and criticism.

These writers lived in south Brooklyn in a state of lamentation. Everyone wanted to be one of the names that glowed from the past, the cultural icons who had led interesting New York lives, but we no longer lived in a world where books or magazines held widespread attention. New York had become expensive and therefore boring. The medium we loved could no longer bring us the cultural prominence we desired. Writers no longer lived in Malibu, wore white suits, had expense accounts, drove convertibles, or wrote personal essays about going to Hawaii when their marriages foundered. Writers had no money, and therefore no style.

The writers asked themselves: What was of the now? Their output illustrated the uncertainty. Was Beyoncé the thing? Or was it "the golden age of television"? Was it the decision to have children in the age of climate change? Was it a true-crime podcast? Was it the alienation of contemporary exercise regimes? Was it articulating generally observable social media trends? A person could try to fit into an established mold, and be, say, a hard-boiled war correspondent, but even our country's unlawful massacres abroad no longer had the power to compel the public. The writing was laden with hyperbole and false epiphany. It anxiously attempted to convince the reader of the importance of unimportant things—of the genius of our mediocre pop stars, of the revolutionary nature of token political symbols. Very little that was written pierced the ersatz nature of the world around us.

The writers contemplated if there was any way out of their cultural obsolescence. As ambitious people, they wished they had made choices that would have taken them to Hollywood or Silicon Valley, where the attention of the public and its riches were concentrated. Did tech have any need for a person who could write well? No? Then perhaps Hollywood would option their novels or articles or, even better, invite them into the writers' room. We all hoped that the world we described with our words was authentic, and that it mattered, but

if the magazines and websites we wrote for were people they would have seemed deranged, hyperventilating between insistent optimism and dire pronouncement, shouting out lists of face serums and television shows at random intervals. The writers who succeeded in finding a mass audience did so through physical charisma, positivity, and subtle hints that they knew of the right things to eat and to buy. They shared careful self-portraits on social media using the insecurity-generating strategies of advertising. Desperate to stay contemporary, even writers mistook vanity for style, for culture, for intellect. Only later, well after Donald Trump had glided down the golden escalator to his place in history, did I make the connection between the process by which life had become propaganda and the political phenomenon we were on the verge of witnessing. Why were we surprised that such a society would come to be led by someone whose entire identity was advertising and branding and the endless repetition of his own name? And isn't a leader only a manifestation of a collective logic? Everyone played this game of self-magnification, even cultural critics and intellectuals. Entire cultural industries remade themselves around this new advertorial moment, where there was no longer a reality, there was only the avatar.

Before moving to Bushwick in 2016 I had lived for two years in Park Slope in a very cheap eight-by-ten room in an apartment I shared with two men in their late thirties. My roommates and I got along well. We would sit in the evenings and drink together in the living room. We had big parties on New Year's Eve and for our birthdays, grown-up parties with whiskey on ice and the occasional line of cocaine in a bathroom, where our guests judged the books on the shelves between conversations. Park Slope had the park, where I went jogging, and the food co-op, where I stocked pluots and coconut milk yogurt and moved boxes of amaranth cereal off conveyor belts onto shelves. It was fine. I was trying to live cheaply and write.

But no, I hated the neighborhood. Smugness oozed from its leaves and blossoms. I would watch the privileged children of Park Slope walk to their segregated public school each morning with their BPA-free bento boxes packed with seaweed snacks and feel unreasonable disdain. Not that I was not part of this problem, whatever it was, the class politics of an unequal society. I could not claim to live an original life, none of us could, but the homogeneity of the neighborhood was alienating. It was one of the highest-income zip codes in the city. I saw suburban upbringings all around me, and the fantasy of city life made tolerable to the small-minded because all the difference had been priced out of it. The neighborhood had a way of making us, older single people still living with roommates, feel out of sync, or like we had failed. There was nowhere to go out at night.

In 2016, when I came back to New York after a year in Berlin, I moved to Bushwick, where I could afford to live on my own and hope to find others who shared my own nebulous desire for refusal, whatever that was. The old brick building where I found a place had been converted into apartments around the turn of the millennium in an early wave of gentrification and given the aspirational name of the Opera House Lofts. I had moved in just after a snowstorm, taking over the lease from a drummer named Santos who had decided to move back in with his wife after a trial separation. I paid the security deposit with the advance for a book about Nigerian cinema that I hadn't started to write.

According to its promotional website, the Opera House Lofts had been the home of a German music society in the early twentieth century. Later, the Hasidic owners had for a time used it as a kind of halfway house for Hasidic heroin addicts, or at least someone had told me that once at a party. The building's management, in their pursuit of tenants who would pay higher rents, had tried to make it into an adult dorm. It had a grimy practice space and a television lounge in

the basement, a mirrored dance studio, a small gym with one working treadmill and three broken ones, a broken vending machine, and a laundry room where only one or two washing machines ever worked at a time. The building's superintendent was a large British man named Tony who had bags under his eyes and a slow, gentle demeanor. He would sit in the side yard flanked by two large dogs on summer evenings. He responded promptly to plumbing matters, which at Opera House were not infrequent.

Sound carried very well there. I could hear the Slovenian artist couple yelling at each other upstairs, and I could hear the music of the techno DJs downstairs when they practiced their sets. Sometimes the Slovenians' bathwater would leak into my bathroom and sometimes mine would leak into the bathroom of the techno DJs and Tony would send us text messages emphasizing the importance of not getting water on the floor, but otherwise our interactions were limited to overhearing one another through our poorly insulated floors and ceilings. I was not interested at all in my rancorous upstairs neighbors but very curious about my downstairs ones.

The music scene that had seemed elusive and underground from south Brooklyn was, in my new neighborhood, coming through the floorboards. One Saturday morning, a few weeks after I'd moved to the Opera House, I went to get groceries at Mr. Kiwi and the entire store was throbbing with bass coming through the ceiling from Market Hotel, the venue upstairs. Clusters of people dressed in black stood outside smoking. I wanted to know who they were, and what they were doing. (Andrew would later tell me, because he had been there: the party was a thirty-six-hour Bunker-UNTER collaboration that had started Friday and ended Sunday; "This one weekend will mark new beginnings in New York nightlife," read the flyer.) On another day an editor came by to drop off a book he wanted me to review and told me he knew the neighbors below me, the DJs. Their

names were Aurora and Daniel, he said. This couple lived with their friend Olga, who was also a DJ. The editor had gone to Daniel and Aurora's wedding on the roof of the Opera House. After he left, I looked Aurora up on Facebook. She had dark hair and pale skin and wore winged eyeliner. I gave her page a blue thumbs-up.

The Opera House was funny in that people were always coming over and realizing they had been there before. Tao Lin came over once to borrow some modafinil and realized an ex-girlfriend had lived downstairs, in the room now occupied by Olga. When Andrew came over for the first time he told me that he also used to date someone who lived below me. This turned out to be Olga. "Is that weird?" he asked me. I said I didn't think so. It contributed to my sense of destiny. He had been looking for me, it was just that he had forgotten to go up one more flight of stairs. Andrew and Olga were still friends. She was a haughty Russian American computer programmer, tall and leggy, incapable of anything but the most brutal honesty, who dressed like a character from *Hackers:* round tinted glasses, miniskirts, platform sneakers, oversize graphic T-shirts referencing bands like the Prodigy and Dead Kennedys, chain-link jewelry. She performed simply as "Olga."

Bossa Nova Civic Club, a short walk down Myrtle from my apartment and where Andrew and I had first kissed, was the center of their music scene. I went to Bossa for the first time in 2014, having read about it on @DanceBitchBK's Twitter feed. I went sober and by myself, but something had clicked for me in this black box that seemed to have no pretenses—or rather, in a place where multiple DJs had names that referenced Deleuze, the pretenses were ones I shared. It was a small venue, with a capacity of about one hundred and fifty people, decorated with artificial palms and purple-and-pink LED lights. The dance floor had checkerboard linoleum like a soda fountain, and was usually wreathed in fog from a machine. Its bifur-

cated layout had a room for conversation and a room to get lost in sound. Inspired by the membership systems of 1970s New York dance parties, Bossa issued membership cards to its regulars, who didn't have to pay a cover on the weekend. It wasn't just the music that was interesting but also the fashion, the graphic design of its party flyers, the actually good cocktails, the bartenders, the humor. There were other places to hear electronic music at the time but none with such a low barrier to entry and with music every night. A can of Modelo cost four dollars.

In the first weeks of our relationship, Andrew and I started going to Bossa two or three times a week, sometimes just for a cocktail after work, other times to do drugs in the bathroom and dance until it closed at four. During that first late summer the air-conditioning, the darkness, and the scent of the fog gave us the sense that we were entering a portal out of the sweltering city, and the bar served the sparkling wine dry and cold, just like at Berghain. Andrew's friends, whose jobs in computer programming or media or bartending were secondary to their ambitions as DJs or producers, started to become my friends; in my friends and the worlds of journalism and book publishing, Andrew showed very little interest, which was fine, since I was losing interest too. In the beginning I had asked some of my writer friends to come on the nights when Andrew was playing, but they found the music cold and repetitive; they preferred conversations in bars or living rooms. They didn't stay out all night. They did not see the freedom I saw in music with few lyrics. I sensed their skepticism and their judgment of my increased drug use and that I appeared to them to be experiencing a kind of regression. I stopped hanging out with them as much. My life had reached a point of divergence, where the social world I had frequented in my previous five years in New York was now going to recede.

6

ONE OF THE DJS DOWNSTAIRS, AURORA HALAL, WAS A COFOUNDER AND director of Sustain-Release, the three-day rave in the forest that I had discussed with Andrew the night I got his number. Sustain had started two years before at a children's summer camp called Camp Lakota in the Catskills. In promoting the party, my neighbors, all of whom contributed in one way or another, avoided the word "festival," which had connotations of corporate sponsorship. They framed Sustain as something between a family reunion and a summit for the heads: "strictly for the freaks," as the flyer put it. Sustain sold fewer than a thousand tickets each year, and a newcomer needed an invitation from someone who had gone before. Andrew had gone for the first time in 2015 and made a bunch of friends there, including Olga. After our first date he had given me his invitation and we had bought our tickets together. The staff of Bossa ran the bar and security, and many of the artists came from the same neighborhoods on the borders of Bushwick, Bed-Stuy, and Ridgewood. In a way it was as if they transported one Photoshop layer of Myrtle-Broadway to the woods and set everyone free from chrononormativity and the challenges of having to commute home after a party.

I packed a sleeping bag, a borrowed tent, a gallon Ziploc bag of mushrooms that had recently been given to me as a gift from a

person who grew them in Oregon, a few tabs of acid, some clothes, and a water bottle. The buses chartered to shuttle the ravers from Brooklyn to the Catskills left from a desolate area of warehouses between Williamsburg and Bushwick. Andrew came to my place first. He scanned my bookshelves for something to read, and took my copy of *Moby-Dick* for the ride. We shared a car to the bus stop, where a line of people dressed in black stood with their stuff sacks, tents, and coolers inside a garage, waiting to be checked in by officious volunteers holding clipboards. I stood next to Andrew, leaning against him, which produced a small flood of oxytocin. We were checked in by my downstairs neighbor Daniel, who was wearing a Grateful Dead T-shirt and carrying a clipboard. Andrew and I put on each other's wristbands with an air of ceremony and then dragged our bags into the luggage hold. I sat next to the window and Andrew took the aisle seat, greeting his friends. Olga was there, tall and beautiful, with her boyfriend Michael, both of them programmers and DJs. The mood in the bus was giddy; a movie was put on. "You're reading *Moby-Dick*?" Olga asked Andrew, and he put the book away. I was shy meeting so many of his friends at once so I looked out the window at low rooftops and billboards for personal injury attorneys as the bus inched through traffic over Newtown Creek on the Kosciuszko, over the Robert F. Kennedy Bridge, over the Hudson River, and out of the city.

That year Sustain was at a new location called Camp Kennybrook, so the setting was unfamiliar not only to me but to Andrew and his friends. The bus pulled under the camp's arched front gate as the late-afternoon sun cast golden light over a grassy meadow, where the candy-colored domes of tents already rose up. I set up my tent near the tree line, then walked with Andrew to his bunk bed in a cabin, where he realized he had forgotten his sleeping bag in Brooklyn and would have to share mine.

As a kid I had gone to a YMCA summer camp in the roadless wilderness where Minnesota borders Canada, a land of cold, clear lakes; of moose, bears, loons, and beavers; of vast starry skies. Not for the first time I pitied the children of the tristate area, who could access nature only through expensive private day camps in the dark, Lyme-infested deciduous forests of the Catskills, with their low peaks and muddy, stagnant ponds. Sorrow welled up in me as we entered the cabin, which had a plywood interior and the extra-long, vinyl-encased mattresses of college dorms. The ghosts of ten-year-old boys lingered in the obscene graffiti penciled in the rafters. Next summer they would return, unaware that the space had absorbed another energy altogether, as the leaves on the trees began the death rattle of fall, and the techno enthusiasts of Brooklyn, wearing leather harnesses and black athleticwear, snorted their first drugs of the weekend. Olga, who had built the ticketing website for Sustain, also got to host a cabin populated with her friends, half of whom seemed to be Swedish, the other half Australian, all of them fancy. In the bunk next to Andrew I watched, fascinated, as a European creative director named Markus unpacked his Rimowa suitcase, moisturized his face, brushed his long blond hair, then carefully cut his first lines of cocaine for the evening.

I hovered uncomfortably next to Andrew. It wasn't only that I was shy around new people, but getting high with boyfriends had always brought out a dark and grasping side of me, where if we did not ingest the same drugs in the same moment at the same dose, I would be in terror of catching a different wavelength and getting left behind. I watched, beady-eyed and anxious, as Andrew crossed the room to do lines with his friends. I was still at that time a little bit of a control freak about mixing drugs, especially if I was going to take a psychedelic. My thinking still bore the influence of Matt, who had been committed to a more ceremonial approach to drug-taking and

was pious about limiting his use mostly to plants and the secretions of frogs and toads. Matt and I had taken GHB together, and I knew he had done MDMA before, but I don't think I ever saw him snort a powder, so I was nervous and worried that I was an impediment to Andrew's enjoyment with his friends. I watched him lie back, his long limbs draped over the bunk bed, laughing with his friends. They called him fluffy, because he had the happy enthusiasm of a golden retriever. I simmered with darkness.

But he returned to where I was sitting, on the bottom bunk of a bed, and together we each took a translucent gelcap into which the carefully weighed white powder of a synthetic hallucinogen called 4-AcO-MET had been scooped with a metal lab spoon. Vendors on Lysergic, the dark web marketplace from which it had been sourced, called the drug "digital mushrooms" because it was an analog of psilocybin. It was technically not a banned drug in the United States, but it wasn't quite legal either, because of federal laws that prohibit the distribution of chemicals with molecular structures similar to banned substances. We wandered outside. It had gotten dark, and the first strains of music could be heard echoing over the pond.

There was an understanding at Sustain that it was only by agreeing to follow certain rules that we would all be free. These rules were simple: Only smoke in designated smoking zones. Pick up your cigarette butts. Don't bring your own alcohol because it was only by selling alcohol that the event would break even. Don't touch anyone on the dance floor without their consent. Plus the list that hung on the wall of every reputable bar in Bushwick: no racism, sexism, ageism, homophobia, transphobia, et cetera. The festival's organizers claimed the pond was filled with snapping turtles so that nobody would try to go swimming in it. Instead, the ravers took outings in pedal boats and canoes that they tried to paddle while facing each other. A floating bridge connected one side of the pond to the other,

an unstable surface that had to be supervised by a gatekeeper with a flashlight at night to prevent wasted pedestrians from tumbling into the water. At night, as the air cooled, the warm air off the pond would rise and condense into mist that mingled with the synthetic fog of the machines pouring out of the dance music stages.

We walked along the asphalt path to the stage, Andrew greeting friends every few feet with the enthusiasm of someone having just arrived at a convention. The drug started to hit just as Andrew began introducing me to many of them. I started having difficulty speaking, so I wandered into the main stage to move my body through the come-up. The space was a metal-sided gym with the boundaries of a basketball court marked out on its concrete floor. Fog filled the room, forming a weather system crisscrossed with red lasers. The gentle rhythms of an opening set were playing. Inside, the people who still mostly appeared to me as a crowd of strangers swayed in the not yet populated space. For their country sojourn the techno heads had put on their resort wear: hunting camouflage with the sleeves ripped off, mosquito-net hats, zip-off hiking pants, Lycra shorts. They dressed to sweat. The reflective patches on their running shoes flashed in the light. They moved their arms in slow circles. They stretched their hamstrings and bounced up and down.

I swung my arms from side to side, closing my eyes and twisting at the waist until the uncomfortable moments of the come-up passed. The nausea caused by whatever storm of neurotransmission and serotonin taking place subsided; the dilation of my senses completed itself. The exact nuances of 4-AcO-DMT are lost to me. I had once been very methodical in my trip reports, but I had let that go, too, and therefore only remember colors, the distortion of time, euphoria, a high that was lighter than acid and didn't last as long. An hour or more passed, and the room began to fill up with people. As we danced, the gymnasium cast itself into the music and haunted it

with an echo of bouncing basketballs and squeaking sneakers, such that every track had the potential to be a jock jam. The net over the DJ setup was lit with a ghostly strobe, and when I looked around the room at the crowd, it was as if everyone who'd had a kickball thrown at their head in gym class was having a do-over. They were dressed in 1990s fashion like children going to day camp, but they were adult-size, and as they compressed time using psychoactive chemicals, the pep rallies or the golden plastic trophies or the joint snuck under a bleacher or the drills they'd been made to run around orange traffic cones surfaced in their minds and blended into the music as the music blended into itself. We were all on the same team now; we'd finally made varsity. Honey Dijon, the house music DJ from Chicago, played Nirvana's "Smells Like Teen Spirit" that night, and it wasn't corny because we were basically reenacting the video that had played over and over on MTV when we were kids.

When I got tired I found Andrew outside and we walked over to the Bossa stage, the second venue, which was inside a small lodge with a wood-paneled interior. Naming the stage for Bossa was more of an honorary gesture than an official partnership. It reflected that mostly local artists were booked to play there that year, but also that so many of the bartenders and staff who helped put on Sustain worked at Bossa too. This stage was the more intimate environment, with its much smaller dance floor and a lower ceiling, and the wood floors didn't tire your legs out like the concrete of the gym. It was now after two in the morning. The confusion of the early hours of the drug had passed and my mind settled into an enhanced clarity. I quickly lost Andrew again, who when high could not go twenty minutes without a cigarette and therefore spent most of his time outside smoking and chatting rather than dancing, but he was always easy to find again, since he was usually the tallest person in a room. A fractured, silver light moved over the darkened dance floor, and

I wove my way through the moving bodies toward the front, where a DJ played with the same concentration of speed and deftness that mesmerized me when I watched videos on YouTube of a Chinese factory worker assembling a makeup brush or an Italian grandmother twisting tortellini.

The DJ's name was Stingray; he performed in a balaclava and a black satin baseball jacket with the Detroit Tigers logo; he played vinyl. He stood in front of his open record cases, some of the records placed at an angle in preparation; sorting and switching, lifting the needle and placing it again, one hand holding his headphones against one ear, the other mixing. In the depth and clarity of the tangle of sounds emerging from the speakers that night, I began to understand I was experiencing something of a higher order. It wasn't that I hadn't been paying attention to the music before, when I'd gone to Berghain or danced at Bossa, but maybe I was initially drawn to the scene for other reasons. Now the speakers held every detail, the dancers were locked in to a communal current, and my brain chemistry was primed for a flood of pure sound. It could have happened somewhere else, or with another DJ, and probably most people who have felt it could say where it happened to them, but this was the first time that I understood.

The music did not say what to feel or when to feel it. Instead it followed a process of defamiliarization and destabilization. To make a literary comparison, it had the discontinuity of poetry instead of the continuity of a story or a novel; it pursued a different order of sense-making. Just as a difficult poem could generate narrative through meter and rhyme even if its words avoided anything as obvious as a grammatical sentence, so it was too with the nanotechnological electronic sounds that Stingray mixed, switching records in and out in a rapid blur of movement. "Songs"—the compressed pop ballads that played at Mr. Kiwi as I put a bag of rice or an onion into a shopping

basket; the acid-infused seventies guitar bands my friends and I would listen to as we grilled hot dogs on Fire Island; the mediocre electro-pop and neo-folk artists who earned the hyperbole of music critics; the nineties hip-hop that had given my politics its foundation and that told the true story of American violence—all of that *said something.* What techno offered was not meaning but space, and the possibility of evoking the complexity of the world through discontinuities and breaks, interruption and hybridization.

Stingray had started playing techno and electro at Detroit motor-cycle clubs in the 1980s and 1990s. Like the most interesting poets I knew, he read about microbiology, genetics, and physics, and wove these fields into his work. His tracks had titles like "Acetylcholine" (a neurotransmitter), "Dendrite," and "erbB-4" (according to Wikipedia, "a receptor tyrosine kinase that is a member of the epidermal growth factor receptor family"). He channeled his curiosity about the order of the world into the sonic. I danced, my body becoming a kind of static, until a sudden longing for Andrew overwhelmed me.

I found him outside the gym, smoking another cigarette. He turned his kind gaze over me, happy to be found, and we wandered together through the grounds of the summer camp, jumping over a small rivulet of water that had formed in a recent rainstorm, resting on rocks that vibrated with the intelligence of the geologic eras they had seen. We wandered together back to my tent and had sex, our minds dissolving into our bodies. Holding each other under the unzipped single sleeping bag, our hearts beating with contrails and crowned with diadems, Andrew told me for the first time that he loved me, and I told him I loved him too. I had the distinct sense that it didn't matter what happened with the rest of my life. We held each other and fell asleep for a few hours. Outside the tent the partygoers blundered back to their campsites, peeing in the bushes along the way.

. . .

THE NEXT AFTERNOON, BEFORE THE POOL PARTY AND THE BASKETBALL tournament, we attended a lecture in a grove of pine trees beneath the summer camp's ropes course. The speaker was a producer and critic who DJed in nightclubs as DJ Sprinkles and made electroacoustic, ambient, and video work as Terre Thaemlitz (he had other monikers, but those were probably the best known). Sprinkles varied her pronouns and dressed in boy drag or girl drag depending on context or mood. She described herself as transgendered (a term some trans people rejected), explaining that she saw gender as emerging from social relations rather than as the emanation of an internal essence. She was in her late forties and represented a different generation of New York club culture: the pre-Giuliani, pre-gentrification past that the scene I was getting to know consciously honored and nostalgized, but from which it was divided by a generational break, such that someone my age was almost always among the oldest people on the dance floor even when many of the DJs my new friends revered were pushing fifty. We were earnest about learning about earlier eras of New York nightlife in the way that my generation was earnest about everything: posting reading lists online; categorizing works of history under subheads like race, gender, and sexuality; circulating essays like "A Music-Lover's Guide to Tinnitus." Sprinkles made house music that had a political subtext, which reminded listeners that the music had its origins in the longings of people fighting for their physical survival. "So what was the New York house sound?" he asks in the spoken introduction to the album *Midtown 120 Blues*. "House wasn't so much a sound as a situation," she continues. "The contexts from which the Deep House sound emerged are forgotten: sexual and gender crises, transgender sex work, black-market hormones, drug

and alcohol addiction, loneliness, racism, HIV, ACT UP, Tompkins Square Park, police brutality, queer-bashing, underpayment, unemployment, and censorship—all at 120 beats per minute."

Sprinkles had lived and worked most of his adult life in Japan but performed mostly in Europe, giving lectures and exhibiting at museums and galleries and playing house music at clubs. He was known for playing sets uncompromising enough to bore a dance floor, and for refusing to kiss a ring. To her, difficulty was part of a broader "defense of pessimism," as Thaemlitz wrote in an essay I read later, when I went home and ordered *Nuisance,* her collective writings: "to critically reject the incessant optimism lurking at the core of virtually all media, conferences, concerts, events, and symposia."

Difficulty came to be a defining characteristic in her work. "Occasionally, my transgenderism excuses some of my cynicism through common associations of the 'bitchy queen,' " she wrote. "As my bitterness accumulates with time, and my sociability withers both professionally and privately, combined with my general lack of queenish behavior to buffer my cynicism with a façade of personality, it gradually becomes clear to all that I am in fact little more than a nuisance. Bookings are down." To me, Thaemlitz was, like most hard-core cynics, an idealist. The world was as disappointing as people like DJ Sprinkles understood it to be, and to insist on hopefulness could only obscure our understanding of the conditions in which we lived.

We gathered in a collective hangover on the ground before her, sitting on stumps and in the pine needles, consciousness descending back to baseline with the slowness of dust motes. She wore a white V-neck T-shirt, gray jeans, and slides, long hair parted down the middle, wire-rimmed glasses. Sprinkles did not pander to our naive good intentions; she did not spare us her pessimism or her cynicism. Instead of extemporizing freely she read from an essay that had been

published in Japan as "Naisho Wave Manifesto," or "Secrecy Wave Manifesto." The essay was about the politics of refusal: When one is confronted with a totalitarian system of thought, sometimes the only effective form of protest is silence. She led with the example of women in Japan, who when faced with intransigent gender inequality have responded by choosing not to reproduce human life, passively sabotaging the Japanese economy with a declining birth rate. She drew from her own experience of responding to homophobic bullying with a practice of invisibility, of closeting. She quoted Che Guevara: "Silence is argument carried out by other means."

Then she turned to music. Many if not most of the people sitting on the ground before Sprinkles were musicians and DJs, some full-time, others practicing on a smaller scale. All of them relied on social media and digital streaming platforms to share their music. The wisdom that exposure, page views, and plays were necessarily good had gone mostly unquestioned. Sprinkles, in contrast, made a practice of requesting the removal of her work when it was uploaded by fans on YouTube and SoundCloud. When he asked that the work be removed, a standard error message informed users that the uploads violated copyright: the corporations did not even allow an artist to state their own reasons for noncooperation. Sprinkles objected to having her work on corporate streaming platforms not for reasons of authorship but for protection—protecting copyrighted samples from audio-scanning software, protecting collaborators who might be persecuted under the homophobic or transphobic laws of their countries, maintaining a relationship of understanding with a knowing audience. Putting music on a corporate website, said Sprinkles, was the equivalent of dumping a box of CDs in a shopping mall and walking away: "Not a queer move."

Sprinkles left us to ponder this alien praise of obscurity, which went counter to the reigning quantitative metrics of an entire gen-

eration's self-worth. Then she opened the floor to questions. I don't remember the question that led to the answer, but I remember she dismissed our little happening. She called it "Techno Sha Na Na." I didn't get the reference, but I think I got the idea. Sprinkles was saying that what we had convened was another bogus spiritualism, a fake revival of a bygone era. When I got home I looked it up. Sha Na Na was a doo-wop cover band that played at Woodstock and in the 1970s had a television show set in a 1950s diner where the characters wore poodle skirts. Nobody argued it out. Even I, who was new to the scene, could fill in the blanks. Genres of music that had been shaped by the adversarial experience of being excluded in America were now co-opted by well-meaning young professionals who had gone to college. The trans sex workers and johns of Sally's II, the Times Square club where Sprinkles had been a resident DJ in the early 1990s, had survived without our careful politics of sensitivity. I understood this point of view as an accusation that we had gentrified a subculture just as we had gentrified the neighborhoods we lived in. In the failure of our generation to mount any kind of effective resistance to the vampiric new technology that fed off us, or to the increasing concentration of wealth and power among a few individuals, or to our lifelong debt peonage, we could instead only mimic what had come before. We were searching for an experience of gathering and sound that did not remind us of someone trying to sell us something, that did not echo the existing forms that we could no longer trust, but the suggestion was that we could only co-opt, we could not invent. The group sat chastened. We had thought we had found something of our own but there, on the green moss, our serotonin levels plummeting, we were told we were mistaken.

Later that night I had my own thoughts. I had a batch of acid that consistently made me depressed. I eventually threw it away but that night I took some. I thought Andrew would want space to be with

his friends so I avoided him, tripping by myself. The music was too much for me, I was having one of those heady trips where I got analytical and ruminated instead of getting lost in euphoria. I wandered over to a campfire to think better. This scene, guided by the ethos of the handful of people who organized its parties, had an ethics that was anticommercial, that understood that something was lost in any creative endeavor that oriented itself primarily around popularity and profit. Perhaps it was overdetermined, but at least it was trying.

The founders of Sustain had studied New York's past and found an archetype in the Loft, the party that a metaphysically inclined Italian American promoter named David Mancuso had started in his apartment in SoHo in 1970. The Loft held weekly parties and was organized around a membership system. It was underground in that it had used its invitation-only system and BYOB policies to skirt New York's strict cabaret laws, which banned dancing in bars without a special license. Mancuso played the records and orchestrated the party's vibe, whose progression he modeled after the three Bardos described in *The Psychedelic Experience: A Manual Based on the Tibetan Book of the Dead* by Ralph Metzner, Richard Alpert, and Timothy Leary: a calm that led to a frenzy and then a catharsis. The music was predominantly by Black artists—not techno, which had not yet been invented, but soul, R&B, and disco. As the seventies progressed, and money flowed into discotheques like Studio 54, the Loft kept serving a crowd seeking a purer, more spiritual experience of dance, who shared an understanding that exclusivity and celebrity came with economic discrimination (there was a difference between the Loft's membership system, which was free, and helped keep a dance floor of queer, Black, and Latino people who might be using illegal drugs safe from cops and bigots, and a door oriented toward bringing in money and famous people). The Loft still existed in 2016, and continued after Mancuso died late that year; there were parties at

the Ukrainian Cultural Center in the East Village every few months. They had taken on the feel-good character of a community center potluck. Old neighborhood heads would come out and dance, but in the present day the Loft was more of an homage to the past than a vanguard of new music, and the parties ended at one in the morning where once they would have continued into the next day.*

When I first moved to New York in the early 2000s, the big clubs of the nineties were dead, and I rarely heard techno or house at the Manhattan bars with dance floors I went to, like Lit, Orchard Bar, or APT. I moved away for several years and wasn't there for it, but the small and somewhat nerdy electronic music scene that reemerged in New York in the mid-to-late 2000s, and was the precursor to Bossa and Sustain, seemed to have taken its cues and its ethics from Berlin as much as from the Black American origins of techno in Detroit, or in the country's 1990s underground rave scene, or in New York's own long-suppressed nightclub tradition. The aesthetics of the revival were austere and knowing, almost to the point of churchiness, and to differentiate itself from the major-label EDM of Electric Daisy Carnival or the fur coats and leggings of Burning Man there was an outright aversion to Merry Prankster–ish interpretations of psyche-delia. At Sustain I was self-conscious of the Burning Man stickers on my water bottle—this was not a place to express one's inner hippie. The aftermath of the recession still lingered; there was a simplicity in people's clothes and a rejection of excess materialism. Sustain had a "no costumes" rule at one point, and in 2016, when I went for the first time, nearly everyone still dressed in black. The lighting was minimalist and stark: simple lines of blue light overhead like Space Mountain, or the exposure of the leaves in the clerestory windows of

* *Love Saves the Day: A History of American Dance Music Culture, 1970–1979*, by Tim Lawrence, is the most comprehensive history of the Loft.

the Bossa stage. On Friday night the leaves as seen through the window were lit in such a way that they appeared to be black and white, and on Saturday they were in full color, a subtle little mindfuck. This was all in the tradition of Berghain and Panorama Bar in Berlin. The most crowd-pleasing party trick in Panorama Bar was opening and closing the shutters of the windows once the sun came up.

The weekend had a surprise guest, a 1990s-era English drum-and-bass DJ who performed as Source Direct. Andrew, who had slept about four hours the entire weekend, was among the last people on the dance floor. He had changed into an all-white outfit, now muddied from his wanderings through the night. In the throes of my miserable acid trip I became convinced that because he had told me he loved me the night before he was now making a point of ignoring me. In reality he was just drunk and having fun. We were still learning how to manage closeness and distance. I asked if he wanted to go to sleep; the party was on its last legs. "I just want to put off the real world for a few more hours," he told me, making invisible cube shapes with his hands as he lurched to the drums and bass. I went to bed. When the music finally ended at midmorning on Sunday we went together to the makeshift coffee shop. As we waited in line we watched Source Direct. He sat alone at a booth, talking to himself and frantically searching for an invisible missing object under the table.

We took the bus back to Brooklyn, an air of estrangement between us. I went home and showered, then went to my book club, where I discussed another volume of Robert Caro's biography of Lyndon B. Johnson with my friends. Then I took the L train to Ridgewood and got into bed with Andrew. We ordered Mexican food and watched television in bed. The bad acid was out of my system. I was happy and calm again. We had declared our love for each other. What was happening was real.

7

IN THE 1980S, WHEN I WAS A KID IN MINNEAPOLIS, MY MOM HAD SUB-scribed to *Spy* magazine so she could keep up with New York City derision even though we lived in the placid upper Midwest. *Spy* had a lot of graphic design elements that a child could understand, and from its cartoons and jokes I learned the names of the New York City villains in the tabloids at the time for tax evasion or securities fraud, people like Leona Helmsley, Michael Milken, and Ivan Boesky. I liked "Separated at Birth," which compared thumbnail portraits of the tabloid figures as a joke, or "Celebrity Math," which added or subtracted two famous people to come up with a third. A six-year-old could get the joke of Tammy Faye Bakker having been separated at birth from an Ewok.

Donald Trump was always in *Spy*. He was the kind of joke whose humor comes from telling it over and over again. He had golden bath-room fixtures and marital drama. Whenever he or his wife, Ivana, would appear on television, dripping in diamonds and blown-out hair, Ivana's nylons and red lipstick catching the light of flashbulbs, my mom would mutter under her breath, since she disdained mate-rialism and was of the opinion that plainness was a sign of integrity.

Another memory, from sometime in the mid-1990s, was a fashion spread of their daughter Ivanka in the pages of *Seventeen* magazine.

Ivanka was around my age and had a round and dopey-looking face. Her modeling career was an early example for me of a corrupted fiction that required multiple levels of consensus to maintain. Much later, when I worked as a reporter for *The New York Observer*, her husband, Jared Kushner, was the publisher. He was a real estate scion whose dimples looked like they had been carved into his cheeks with a silver spoon. He fell in the category of a universally disparaged person whose bad ideas had to be placated because he paid us. He had bought a newspaper because Rupert Murdoch was his "mentor." One by one, the funny writers on staff quit their jobs after he took over. Punch lines eluded him. Now, in 2016, the members of the Trump family were national protagonists, and the jokes had to be told with a straight face. Just as counterfeit, however, were the belabored efforts to generate enthusiasm about Hillary Clinton's "poise" and "intellect" and the refrain that she was "the most qualified presidential candidate ever" and that it was now "her time." I voted for Bernie Sanders in the New York primary. After he lost the nomination, I watched Chelsea Clinton's speech at the Democratic National Convention, where she described her daughter's fondness for blueberries and how her own mother, Hillary Rodham Clinton, used to read her *Goodnight Moon*.

Clinton lacked the political conviction to even say the words "Black Lives Matter" in a presidential debate. Neither candidate would take any action that threatened the bottom line of even one major American bank or corporation, which would therefore mean no meaningful attention to climate change, health care, the student loan crisis, affordable housing, consumer protections, antitrust regulation, campaign finance reform, income inequality, or any of the issues that kept the country impoverished, indebted, unhealthy, undereducated, housing insecure, stressed-out, and drug addicted. The difference was only that one candidate was also a racist, kleptocratic liar. It was

not news that Americans could be violent and selfish. Now we would learn if the country was still interested in clinging to certain myths of benevolence, or if it would abandon the charade altogether.

The new right-wing politics of transgression were unfamiliar and initially difficult to comprehend. Before, conservatives had adhered to a Nixonian vision, religious and clean-cut. Now, suddenly, conservatives were adopting an attitude of punk-rock iconoclasm. They grew beards and dressed like Earth First! activists but with guns and body armor. The left was taken aback to see itself mocked with an unfamiliar *knowingness,* with the irony and nihilism we saw as our strategy of critique.

At the same time, it was now the left that had adopted a secular religion, complete with religious censure. My friends and the young people of Bushwick believed ourselves to be articulating a new moral order. We expressed this morality through the use of careful linguistic signifiers and acronyms that broadcast to a mutually understanding audience a politics of care and a heightened sense of taboo. Loss of status and authority for gestures of insensitivity, cultural appropriation, sexual harassment, or discrimination allowed our morality to take shape, to assert itself, to clarify its codes and upend hierarchies. Unlike moral codes that had upheld the patriarchy and limited the sexual freedom of women and queer people, we saw our morality as being predicated on an extremity of concern, where the well-off owed reparations to those who bore the burden of structural oppression. Acknowledging one's complicity with power, or joining in periodic waves of mass sloganeering online, helped us convince one another of our shared goodness. We believed changing language could remedy inequality. As a writer, I was haunted by old usages and ignorance in my past that could, in the future, be used as evidence of my inhumanity.

In mid-October, with the election nearing, my book *Future Sex*

was published. New books are published, by industry standard, on Tuesdays. That Tuesday I sat in my apartment by myself, looking out at the apartments and the birds, and wished somebody would call and say something to mark the occasion. Nobody did; the day passed unremarkably. In general I tended to stop caring about any one piece of writing once it was published. I would soon forget the terms of my own arguments, which came to me with such urgency as I wrote. If it was a work of journalism, I would often forget the names of people I interviewed or quoted; if it was criticism, time would pass and I would forget the plot of the book I reviewed, the names of its main characters, and sometimes even its title and author. I would write something in a frenzy of thought and then it would be dead to me. I was happy when a piece of writing seemed to be a success, which I gauged by whether my friends read it or not, but if nobody read an article or a book review and it disappeared without a trace I did not mind. With the book I was horrified to discover how much I cared, how sensitive I was to every criticism.

I had a reading at McNally Jackson, the highlight of which was Andrew's eyes watching with pride from the audience and his excited and loving embrace afterward. I organized a book party at Elvis Guesthouse, a bar in Manhattan, a party that turned out to be a casualty of the shift in my life. I asked a musician named Juiceboxxx to DJ. Juiceboxxx was an erudite selector—he had a radio show on NTS, and an eye for the nuanced Americana of energy drinks—but he was not interested in the world of Bossa and the Brooklyn techno scene, which he saw as a little too pious and insular (we had discussed all this at a diner before the party). My relationship with Andrew still seemed too new to just ask him and his friends to DJ, which is what I would have done a few months later. The party was therefore not a success. It was neither here nor there: literary people who would never be compelled to dance tried and failed to discuss articles from *The New*

Yorker over the music; a few of Andrew's friends who had nothing in common with the book people weren't interested in any soundtrack that contained something so banal as lyrics. We did cocaine.

I was losing myself. My world oriented itself toward Andrew like a compass toward a magnet, toward his tastes, his friends, the social scene I wanted to inhabit. I was in a moment that should have been celebratory but instead seemed false. A book fixed one's thoughts and opinions to a particular moment in time. As time passes, the thoughts and opinions might change, but the book stays the same, and one is expected to repeat its ideas with certainty and confidence. With *Future Sex* I had circled the cul-de-sac of my gender and sexuality, looking for a way out of what I saw as the tragedy of the female condition. Polyamory, sex work, orgasmic meditation, mimicking the sexual freedom of people with cis male bodies—none of it seemed to offer a way toward what I was looking for, which was agency and equality.

The weeks after the book's publication were filled with interviews where I discussed the pursuit of sexual freedom at the very moment when I was being relieved of its burdens. In my public appearances I spoke as a fraud, because for all of my optimism in the book, which was about my willful search to find meaning and sexual connection while being alone in the world, the opposite was being proven to me: nothing was better in life than having a boyfriend and being in love. After all the work I had done to try to see myself as a new kind of person in a new kind of world, now I was settling into convention and finding that it fit like a glove.

For years, I had bitterly dismissed the idea of "choosing to have a family." As long as love and partnership eluded me it had never felt like I was making a choice. I could have had a child with Matt, but the thought of having a family with someone I didn't love was too unhappy to seriously consider. I would have had to shoulder all of

the financial and logistical infrastructure; I would have had to think constantly about money and where to get it. Now, with Andrew, I saw that there would be a choice. He had a good job, he had health insurance. I was thirty-five, it was not too late, but for the previous five years I had tried to figure out how to live life outside of the kind of family I had grown up with. I had withstood the discomfort of changing my expectations. It was only in my thirties that I had finally studied my sexuality, had learned to read the cues of my body, had acquired something like confidence and learned how abundant sex could be if I was not shy about expressing an interest in having it, sex with strangers and sex with friends. A wedding now seemed like a dumb pageant. I watched my friends believe they could find protection and care in an institution that had given women the legal status of broodmares, their belief that marriage had been modernized and reformed and that one could enter into it without becoming another person's servant. "She chooses to desire her enslavement so ardently that it will seem to her the expression of her liberty," Simone de Beauvoir had written in *The Second Sex*. "When woman gives herself completely to her idol, she hopes that he will give her at once possession of herself and of the universe he represents." De Beauvoir was one of few women who had articulated her resistance to this false promise, and who had done so with the determination to be happy. Even if it meant I would end up alone, even if it made my life more difficult, something in me resisted too. I knew there would be a cost, but I could not believe the lie that if I mimicked the patriarchal model of family I would receive comfort and safety in exchange. That was the lie of fascism. I knew I would never be able to cosplay as a wife, not after all of that learning. So Andrew and I entered into our relationship with the unspoken understanding that we were not on a trajectory to build a nuclear family, that we would not make such demands, and from the outset Andrew thought it was

his responsibility to tell me: He didn't want kids. I hated him for that, for daring me to leave. He knew I would not leave.

We had agreed at the outset to be in an open relationship, but it was never clearly defined. Both of us were mostly too lazy, or too in love, to have sex with other people, and the agreement, at least in my mind, was that if one of us had sex with someone else it wouldn't be a relationship-ending event, especially if it were a casual, one-off thing. That and honesty, always honesty. Experience had taught me not to daydream about the future of relationships, so I didn't. For now we would get to know each other. The future would develop like a photo, until one day when the image would be fixed.

The publisher postponed my book tour until after the election. I voted that morning at the affordable-housing complex near my apartment, assisted by an elderly poll worker who presented me with a spiral-bound register to sign. I fed my paper ballot into a scanner. That night, I took a friend out to dinner for her birthday at an Italian restaurant in Manhattan. The battery on my phone died. It was almost nine when I got on the M train back to Myrtle-Broadway. The DJs downstairs were hosting an election party and Andrew was already there. Their apartment was bigger than mine. The second floor of the Opera House had lofted ceilings. The apartment's main room, with its high windows, was dominated by an enormous fiddle-leaf fig. A lighting designer who did installations for parties had made pink tube lights that rested in the windows and cast a soft glow. Around a table littered with open bags of chips and candy, the partygoers stood despondent. As I arrived Andrew broke the news to me that Trump was winning, that he was in fact almost certain to have won. The room was full of DJs, but nobody wanted to play music, and the CDJs sat unused on the far side of the room. There was nothing to do except go upstairs to my studio. We had sex; then we held each other in my bed.

"It might not be that different," said Andrew.

"Maybe not," I said.

"They might be incompetent."

"Maybe."

"At least we have each other."

The next morning I took the subway into Manhattan, on an errand I don't remember. The train car was silent, the faces of the riders clouded and serious. I checked this observation as melodramatic—this was New York, a city that had its own momentum and imperatives—but the dull November morning remains in my mind as the rare instance when one could discern a collective mood, a dark sense of foreboding.

I went on my book tour a week after the election. Every morning I woke up and got on an airplane. After the readings, if nothing was planned, I would go eat oysters and drink sparkling wine that I could expense to the publisher, texting with Andrew while I ate alone. In San Francisco, I met with the polyamorists I had written about. They had gotten married at Burning Man the previous summer, and bought an apartment. They had managed to pull off a life that was conventional and unconventional at the same time. We had an afternoon of doing ketamine in their warehouse loft apartment in the Mission, their giant Norwegian forest cats rubbing back and forth against our legs and purring, the images of a surrealist animation projected on the opposite wall. The last stop on the tour was Portland. The plane back to New York was overbooked, but nobody wanted to give up their seat. The offer the flight attendants were making over the speaker went higher and higher, until it was $1,200. I was no longer a person who did whatever she wanted, who had no reason to be in any particular place at any particular time. I just wanted to get back to New York, and to crawl back into bed with Andrew.

There was so much horror in falling in love, and knowing the

depth of pain it could bring. My primary preoccupation became how it was possible that people fell out of love. I couldn't enjoy the intoxication of it. I couldn't bear the thought that I would one day take Andrew for granted and hassle him about quitting smoking. I listened carefully to stories of breakups and divorce, looking for clues about how we manage to ruin even the greatest things that ever happen to us. "I have fallen terribly in love, which can only lead to great hurt," Sylvia Plath had written to her mother after meeting Ted Hughes.

Andrew and I had our first argument in mid-November, after he flew with me to Miami for a book fair. It was our first time on a plane together, but we were seated separately. "Breaking all the rules to tell you I love you," he texted me from the front, as the flight attendants instructed us to put our phones in airplane mode.

We stayed at a mildewed hotel that overlooked Biscayne Bay. The weather was not as warm as one might have wanted from Miami. We spent an afternoon in Miami Beach, where I showed him the little apartment on Second Street where I used to live, and we went for a drink at Mac's Club Deuce, where Andrew could smoke inside. On a Saturday night we discussed going to a club in Miami called the Electric Pickle that was said to be the city's equivalent of Bossa. I had to appear on a panel at the book fair the next morning, and was worried about staying up all night. Andrew became sullen. "If we go out, I'll want to stay until the end of the party, because that's what I do," he said. "I'll want to stay, and make friends, and not leave early." Something twisted inside me. "But what about me?" I asked. "It's just what I do," he repeated. "I go out, I do drugs, I want to stay until the end of the party." I started to cry, unsure how to interpret this sudden coldness. Were we not in this together? In the end we did not go out at all. A subtle dynamic that had always been there came into clearer relief: Andrew was more free than me. He had more fun. It was easier for him to make friends, and easier for him to find people who would

have sex with him. I was older, my body could not handle as many drugs, I needed more sleep, I could not do my job if I was hungover, I was shy around strangers. I could neither keep up nor sufficiently let go to let him do whatever he wanted.

Love, which I thought might bring with it belonging and security, instead activated an emotional dependency that destabilized me, and a longing for constant reassurance that made me panic, because it came with a fear of loss. I would stare at my phone if Andrew didn't write me back immediately, then fantasize about never speaking to him again. My sense of myself was getting more and more distorted. I was losing myself to a man. I needed to remind myself who I was, and my book about the Nigerian movie industry was overdue. There was a place that I usually went when I needed to run away from something, and when I needed to get a lot of writing done. When I got back to New York from Miami I booked myself a flight to Berlin without discussing it with Andrew. I needed to reclaim my solitude.

8

I ARRIVED IN BERLIN JUST BEFORE THANKSGIVING. WET LEAVES PLAS-
tered the cobblestones. It was dark all the time. In the bars and cafés,
women in vintage sweaters and red lipstick lit tall, tapered candles at
dusk. The darkness enveloped the city but the cafés served fresh mint
tea and plum cake and occasionally even had cats. The Christmas
markets were open; it was a nice time of year.

I took a taxi from Tegel Airport to my friend Anna's apartment
in Schöneberg. The reason I went to Berlin in times when my life
was uncertain was my friend Anna. Anna was from Sardinia and had
a mythological Mediterranean childhood playing on rocky beaches
in azure waters, breaking the salt crust off a grilled fish, learning
from the nuns who took care of her after school to darn socks, and
reading Russian fairy tales as a child and Homer as an adolescent in
the *liceo classico*. At sixteen she won a scholarship to go to board-
ing school in Swaziland (now Eswatini), where she learned English,
broadened her horizons, and partied with the children of the southern
African elite. Among the experiences we shared were memories of
the isolated beaches of Mozambique, where you could see the spouts
of humpback whales migrating offshore from the sand dunes, and
certain improbable connections to the aged socialist ideologues of
Frelimo. She had moved to Berlin in the mid-2000s because, in the

new century in the still new European Union, that was what ambitious young people from Mediterranean countries would do to escape the high unemployment rates and the social conservatism of home.

Anna spoke Italian, English, French, Spanish, Portuguese, and German and could switch between all these languages without confusion. We had met in New York, at journalism school. We had both disliked it but when I reflected on the $20,000 loan I had taken out for my master's degree, my friendship with Anna had justified the cost. She taught me about Europe, which is to say that she taught me a different set of responses to contemporary problems. She taught me that during a heartbreak the appropriate response is not to read a self-help book but to read *Anna Karenina*. She gave me a window out of the intellectual limitations of New York, with its performed obsessions, and she and her friends had a different approach to sexuality and relationships that made the drama and romance of my American friends look childish and uncontrolled. The European acceptance of snobbery was invigorating and a good corrective. With her, I was reminded that mistaking complexity for elitism was a right-wing way of seeing the world.

New York had upset her. Plastic takeout containers and the ravages of convenience culture and the lack of tenants' rights and the exploitative system of tipping. The city was pressured by scarcity and greed and, for her, one of the worst consequences was the fake friendliness generated by servility. This was just run-of-the-mill American capitalism, but it's understandable how it can come as a shock to someone raised in the Old World, from places where daily life included pecorino and malvasia and ironed, hand-embroidered linens, and where these things aren't fancy but just life at grandma's house, along with candied oranges, spit-roasted pigs dripping over flatbread, trade unions.

Anna, who had lived in so many places, had tried to make New

York her own. She had immediately bought a Vespa and bravely gunned it across the Williamsburg Bridge. She made us seafood pastas at dinner parties in her Columbia student housing. But it wasn't a good fit. The day after graduation she was back in Berlin, and I followed her a few days later to visit her for the first time. That was in 2009. Bar 25 was still open, the ramshackle indoor-outdoor club on the Spree where the party would last all weekend. We went there one Sunday afternoon and I didn't understand it at all. This was before I had any interest in drugs and I remember getting kissed on both cheeks by a Frenchman in a sailor suit who had been awake for days. The club had a series of little trailers with people passed out inside them, and lockers where you could keep a change of clothes and a toothbrush if you were planning to stay all weekend, and a disco ball glittering in the afternoon sun. I mostly remember high people, who scared me back then. I was still at that time taking my 150 milligrams of Wellbutrin. In the years since, I had visited Anna in Berlin many times, and had spent almost a year in the city when I was trying to finish *Future Sex*, because there I could afford to live without roommates, which was too expensive in New York. Now I had another book I was having trouble finishing, and another thing to run away from.

WHEN I ARRIVED AT ANNA'S APARTMENT FROM THE AIRPORT THAT fall, she had just gotten back from a visit to Sardinia and was unpacking suitcases full of vacuum-packed meats and cheeses and olive oil from her family. Her apartment had high ceilings, a jungle of plants, a white IKEA couch, light bulbs that hung down from the ceiling on cords, an open-shelved bar filled with glassware and bottles of alcohol. She made me breakfast. In the years since graduate school she had quit journalism, imported a meat smoker from Tennessee to

Germany, and started a barbecue stand at a market hall to great success. Ordinary things always tasted better when she served them, and so it was with the little stainless steel pot of Neapolitan espresso and the small dish of yogurt with almonds and honey that she gave me for breakfast when I arrived from the airport. She had a beef tongue in the fridge from God knows where and told me how excited she was to prepare it for me for dinner. She would boil it, she said with excitement, then slice it with homemade mayonnaise. I was so lucky to have such a friend.

Anna would have let me stay on her couch, but to have space to write I'd sublet an apartment I still dream about, a thirty-six-square-meter studio in Alt-Treptow, on Krüllstrasse. I had stayed there before, in 2015. The lease was held by a gay Portuguese choreographer who had to go back to Porto for a commission. He had very few possessions and the apartment was almost empty: blond wood floors, an IKEA bed on the floor, a table at which I wrote, a window that looked out into a courtyard with an enormous tree, a small kitchen. He had an antique Miele vacuum cleaner that worked like a new one. The studio was warm and bright during the day and dark and silent at night, and when I sat in the kitchen in the mornings and looked out the window at the tree while drinking my coffee I would experience an indescribable happiness.

In this solitude I wrote, or at least I tried to. I was trying to be disciplined but it was hard. I had taken the assignment to write a book about the Nigerian movie industry for money, knowing full well I was not qualified to understand Nigeria, one of the most complicated countries in the world. I thought that when I arrived in Lagos some idea of what to say about it might emerge, but there is no city like Lagos, which demands of its 21 million residents an unusual amount of resourcefulness and was enough to convince me, as if I didn't already know, that I would not survive in conditions of extreme adversity.

Berlin, in contrast, was a city I had been visiting for years, a place I could land in and immediately resume established routines: coffee in the morning, solitude, writing, my horrible experiments in cooking or the sad single-person meals I would eat at takeout restaurants chosen for their anonymity. I had planned this trip to include two weekends, since going out was perhaps the real point of leaving New York: to prove to myself my own capacity for freedom, to remind myself that I was not a needy, clingy girlfriend. And I wanted to go to Berghain.

Does Berghain need an explanation? Berghain had its roots in a gay club called Ostgut that opened in the late 1990s in a former railcar repair station in Friedrichshain. After Ostgut closed in 2003, its promoters found a new venue in an enormous former power station, installed a Funktion-One sound system, and made a giant techno club. When Berghain opened in 2004 it was after a property bubble in Berlin had burst, and the nightlife culture that had started after the fall of the wall in 1989, and peaked with clubs like Tresor and E-Werk, had collapsed in on itself. Berghain was symbolic of a second wave of post-reunification Berlin club life, one populated by a pan-European jet set who took advantage of open borders and cheap easyJet and Ryanair flights. But to call Berghain a tourist destination would diminish something of what it stood for and what it offered, which was also a refuge for people from cities where public sex, all-night parties, and spacious real estate in which to dance had been outlawed or priced out of accessibility, including other cities in Europe. When it opened, Berghain was more of a gay club; as time went on it gained broader appeal for a wide range of people who needed a place to alter their brain chemistry, freely express their gender or sexuality, and listen to music that is best played extremely loud without the cops rolling in, laws regarding opening and closing times, and handsy or homophobic heterosexual men.

Berghain ascended during a time when in the United States, underground rave and club scenes had become marginal to nonexistent in places where they had been popular in the 1990s, including New York. This would change within a few years, but in 2010, when I went to Berghain for the first time on a New Year's visit to Berlin without having any idea of what it was or what it stood for, the great midwestern techno DJs were better experienced there than they could be almost anywhere at home.

I was old enough to have caught glimpses of an earlier iteration. When I was in my teens in Minneapolis in the mid-1990s, a rave was something that took place in a cornfield, as it often did in those years, when Aphex Twin and Daft Punk played in farmyards in rural Wisconsin. I did not think of a rave as something that happened inside a club, and had been confused at first when Andrew, texting me from Germany, had referred to the people at Berghain as "ravers." Only later would I understand the contortions and erasure by which music that had an epicenter in the upper Midwest filtered its way into my own white, middle-American consciousness in such a distorted form that I thought it came from Europe. As a young person I'd owned CDs of Massive Attack and the Orb and LTJ Bukem and Roni Size and had even seen Aphex Twin perform. I always thought of "electronica" as a British sound, and hadn't any clue of the subculture attached to it, let alone its connections to the Midwest. When I went into Bossa for the first time, I could not have articulated the thread between what I had heard then and what I was hearing now.

It was unfortunate but undeniable that for a lot of Americans around my age (millennials, if we must)—for me, for Andrew, and Olga, and most of the DJs and promoters they knew who were young in the 2000s—most of what we understood about the American roots of techno had been mediated through Europe, where the culture had continued to develop while in America it had passed through a mori-

bund decade. Berghain was the shared referent, a place where we had all gone and experienced a maximal version of the hedonism that interested us, a standard to which we collectively referred. Berghain was one reason Bossa had a postcard from Berlin on the liquor shelves behind the bar, and why it served Club-Mate. It had taught people like us the possibility of a certain twenty-four-hour style of partying, an approach to drug-taking, and an unwritten code of queer social and sexual ethics that had since become the basis of a shared understanding for a global scene.

By the time of what I considered my first real experiences in Berghain, when I was staying in Berlin in 2015, the club had become both a symbol of the post-reunification Berlin of artistic and sexual freedom and a barometer of the rising rents and gentrification that threatened to homogenize the city into one like any other in Europe, and Berghain into a place for exchange students to put on S&M costumes and take ecstasy. Berghain, like Berlin itself, had to struggle with its success and popularity, and what protected it was no longer the shared alienation of a self-selecting clientele but the restrictive door policy that kept out drunk Brits in stag parties. The door people, who were functionally anthropologists, had the task of maintaining the vibe while also keeping the club porous enough for the unexpected to happen.

Like any institution with status and longevity, people would often pronounce that Berghain's best days were over. What had started as a gay club had gotten too hetero (the arguments began), there were too many tourists, the sex and intensity of the experience were diminished by throngs of visitors more interested in observing than acting, and it was continually threatened by the forces of gentrification. From the perspective of a New Yorker, where everything you care about will eventually get shut down by either cops or landlords and carving out spaces of freedom demanded energy, ingenuity, and financial risk, the

place's ability to build institutional longevity was impressive—also the fact that it was permitted and legal even though people occasionally died there. In New York, it was not only a question of there never being such a giant patch of available real estate, but also that so much freedom simply would not have been allowed.

For a DJ, Berghain was a credential that held the promise of attracting the attention of festival and club bookers and could launch an international career. The club's power and its reticence—its owners did not speak to the press—generated fear and paranoia. Artists who spoke out about the identity politics of its bookings or door policy risked sabotaging their careers. But there were all the complaints and then there was the thing itself. Here was the problem: there was nothing else like it in the world.

I texted Otto, a German Nigerian journalist friend who was then in his Berghain phase. This was how it would go for people, Germans and foreigners, that some would arrive in the city and have a Berghain phase where they would go almost every weekend for six months or a year, then eventually get . . . not bored, exactly, but reminded of other responsibilities. One risked the possibility of falling in, of losing the thread, of waking up ten years later with your brain chemistry scrambled and your hearing shot. We met outside the club at midafternoon on a Sunday. I locked the bike I had rented to a fence by a cluster of dead vegetation under gray and darkening skies. Through the fence I saw my friend dressed in regular street clothes: a wool coat over a gray T-shirt, jeans, leather shoes. He said he had recently thrown a pair of shoes away because they had taken on the permanent odor of stale beer, fog, and cigarette smoke of the club. The former power plant loomed over us, almost neoclassical in appearance. There was a short line. My friend was a regular and we had no problem at the door. At the security checkpoint I emptied the contents of my pockets into a plastic tray. The bouncer asked me to

open the case containing my earplugs and shake them out. She sifted through my cash and scrutinized my New York driver's license. She put green stickers over the front and back cameras on my phone. I paid my fifteen euros and got a stamp on my wrist. Then we were in. We left our things at the coat check, and put our tags around our necks.

The Klubnacht begins on Saturday night at 11:59 and ends sometime on Monday morning, thirtysomething hours of party. The longest I've ever stayed there was fifteen hours. The club has multiple dance floors: In Berghain, the main hall, the music is usually harder techno. Upstairs is Panorama Bar, where the DJs often play happier music—house, disco, electro—although these are not fixed rules. In the summer a garden is also open, with Astroturf lawns and a shipping container that serves as a small dance floor. The building is a maze of metal staircases and scaffold passageways and stairwells with windows of colored glass where, during Berlin's golden hours, the light shines down on the cigarette butts and the wet floors and the empty bottles through the miasmic air. There are spaces in which to rest one's feet and sit on a hammock suspended from chains. There is a dark room that is the de facto domain of the gays, but not the only place to have sex. Multiple bars sold different things and I had become accustomed to the particular drinking culture of Berlin nightlife: sparkling wine served over ice, shots of peppermint schnapps, beers. For water most people would refill an empty beer bottle in the bathroom to save money. Everything about Berghain has been pored over: the phallic light fixtures in Panorama Bar, the louvered blinds that snapped open spontaneously during the day to let in sudden bursts of light, the row of sex cubicles on the edge of P-Bar, the Eisbar that served ice cream during the day, the dark room.

Then the bathrooms. The bathrooms at Berghain were designed for maximum utility. The toilets were stainless steel and had no seats.

The doors of the stalls were saloon style, two panels that met in the middle with a latch and a rubber flap that had holes ripped into it by people trying to peek inside. The faucets were the kind that you pushed until the water timed out and emptied into a stainless steel trough. The urinals were another stainless steel trough bathed in a kind of shallow waterfall. The trough maximized the number of men who could pee at one time; they could just line up next to one another like at a baseball stadium. There were no paper towels, for the mess they would have made and the toilets they would have clogged, just hand dryers. It was code of conduct in Berghain that you did not snort your drugs in the open, which meant that the toilet stalls were like clown cars, friends all going in at the same time to take drugs, take turns peeing, complete sex acts. As the hours passed, the toilets would get more and more intense. At peak times the lines were long, the floors littered with bottles, cigarette butts, mini Ziploc bags. You dropped an earplug or a twenty-euro note at your peril—once anything touched the floor it was dead and gone. The bathrooms were places to buy, sell, trade, and share drugs, but also where you tended to make friends. One thing that was nice about Berghain, when it was at its best, was that it is a generous place. People were friendly to one another.

Otto and I did our first circuit, climbing up to the main hall, then up to Panorama Bar. The club was not crowded. It was the hours between shifts, when the people who had started partying Saturday night were going home and the people who had planned to start partying on Sunday were just arriving. Otto went to the bathroom to try to source us a pill. I waited for him and watched people walking in and out. On Sundays, Berghain was a funnel that brought together familiar faces. I saw one of my yoga teachers from Jivamukti Berlin, the one who would always play the best music and had pieces of candy tattooed on one arm. I saw a woman whose apartment I had

visited the year before when I was looking for a sublet; she'd been looking for someone to cover the rent while she went and got bottom surgery in Thailand. Otto came back with the pill; we each took a quarter of it. Time passed: upstairs, downstairs, upstairs. In the stairwell, where windows revealed that night had fallen, we split the second half of the pill. In a corner, I saw a man straddling another man. I averted my eyes out of politeness but it turned out the one man was trying to keep the other awake. Others gathered around. His eyes kept rolling back into his head. His friends tried to keep him conscious. "We don't like to see that," said Otto, so we turned and walked away. The bouncers at Berghain will kick you out if you fall asleep. We sat in a concrete cubicle and I drank my gin and tonic and Otto drank his orange soda. "You seem tired," he said. "But," he added politely, "I don't know you that well."

My mind was doing its darkness routine and I was having a withdrawn day. I didn't really feel the pill. I danced in Panorama Bar mechanically, sweating, caught up in heady thoughts. I wore black shorts, a black T-shirt, nylon polka-dotted socks with black cuffs, black Adidas high-tops. It wasn't that I was tired, I was just depressed. I was having a spell of inertia. It pooled inside me like an oil spill, suffocating the dolphins and waterfowl. I pictured an antique Miele vacuum sucking it out with the sound of the suction device at the dentist's office. But no, it was too deep, it was a bog, it was the stored carbon of millions of years. As in—the pill we took didn't seem to be working.

I went to the bathroom. In line I stood next to an Italian from Milan who introduced himself as Mario. He offered me some powdered MDMA in a baggie and I went into the stall with him. I licked my pinkie, dipped it in, licked it again. "I can't stand the taste of it," said the guy from Milan, so I held his black leather wallet while he rolled a twenty-euro note, dumped out some of the powder in the

baggie onto the wallet, and snorted. Snorting MDMA was not common, but of course it also worked. I found it repellent. I was grateful to Mario but I didn't really like him, and when we walked back to Panorama Bar and he put his hand on the small of my back I moved away. "What?" he asked. I smiled and on the dance floor the crowd slowly parted us. We didn't see each other again.

The floor was crowded now. A wild-eyed woman flirted with everyone; a veiny man with a fan tucked into his waistband would periodically wield it with grandiosity, bestowing a great draft on the ecstatic and sweaty floor. He was shirtless and delighted in dancing with people, fanning them and forming bonds. Other people stood out: a beautiful German blond with red lipstick wearing a white ruched shirt, her hair messy and tied up. She looked both fancy and suitably decayed for the circumstances. The DJ was very short. I hadn't bothered to see who was playing.

In what I would realize, over time, was characteristic for me—a very delayed response when I orally ingest any drug, from caffeine or a weed edible on up—I guess I got very high. The club by then was far busier than when I had arrived, but there seemed to be more space between people. They acquired a kind of softness. The grime and sweat disappeared and the place with this filter overlaying it suddenly became courtly or at least gentle. The incandescent bulbs over the dance floors, the constant up-and-down of the stairs, and the havoc of the bathrooms acquired a calm and a warmth. The dark bog inside me retreated and became a still pond glimmering with golden light. It was late at night now. The blinds in Panorama Bar were shuttered for good.

It was around then that I met a young Austrian named Felix. I have no idea when or how. He was very young and simply attached himself to me. His hair was short and blond. He was tall. He looked like he had just descended from an Alp, like he knew his way around

goats. He had the politesse and calm and manners of continental Europe. I knew what he seemed not to, which was that I was at least ten years older than him (twelve, it turned out). He kept following me until I asked him not to. I hurt his feelings, I could tell. What was wrong with me? But then, hours later, I met him again on the dance floor of the turbine hall. The party had advanced and our feelings had too. "You made me sad!" he said. I apologized and said I hadn't found my friend in any case (that had been my excuse to run away from him, looking for Otto). "I'll be your friend," he said, and finally I accepted. He lived in Alt-Treptow. He worked in a restaurant that had a Michelin star. The night was maturing. Felix introduced me to another new friend. His name was Miguel, and he was around my age. They had met in the bathroom. Miguel was from Spain. Miguel and I had a hurried, private conversation. Felix had rejected his advances, said Miguel, unhappily. I told him that Felix had been hitting on me but that I found him too young. "No," cried Miguel, appalled. "He's wonderful!" He wondered if the three of us could get together . . . ? I think he even suggested it to Felix because later Felix asked me what Miguel had told me and I pretended not to be able to hear him over the music. I felt a lot of things but sexual longing was not one of them. My body was hopelessly aligned toward Andrew, wherever he was, taking bong hits on the far side of an ocean. He had colonized my very cells.

We passed a long time dancing together, our love triangle, which as the night continued became more like a platonic family. Norman Nodge was playing, or Boris, or at one point AnD, a duo from Manchester who played the hardest set I've ever heard, music that sounded like cannons firing, like deep-sea submarines sounding, like helicopters crashing, like nuclear war. I found Otto dancing in a corner of Panorama Bar then lost him then found him again in the bar next to the main dance floor, sitting on a padded platform suspended

from chains. I was staring at him without seeing him until he stood up and waved. It was now, I remember, two in the morning, because his friend Julia said she needed to go home, she had to work the next day. We went to the bar for a drink and I suddenly felt faint, cold sweat pouring out of me. I hadn't eaten for more than twelve hours. I sat down and drank an orange juice and felt better. More hours passed.

Berghain had certain built-in strategies for eventually making people leave. One was that nobody was allowed to fall asleep. Another obstacle was cash. It was a cash-only establishment but had no ATMs, and even the cigarette vending machines didn't take cards. There was some food, but it was food designed for people who aren't hungry, who are eating only not to fall over, like bananas and ice cream. You could get an espresso or an acai smoothie or breakfast muesli or an electrolyte drink. The snacks were sold at the Eisbar, which closed at a certain point in the night, and which was upstairs overlooking the main dance floor. I loved the Eisbar, which was flatly lit overhead and where you could nourish yourself with sweet and caffeinated things before returning to the inferno.

At one point I had sat there with Felix, who drank a cherry-banana juice. I sipped an espresso and let my eyes go slowly out of focus while I rested my feet. The windows of the café rattled with the throb of the bass. Refreshed, we returned again to the main floor. Sometimes you fall in love with someone at the club. They become your modal tree, your search image. You look at them. Mine was not Felix but a man in a plaid shirt and jeans I kept seeing on the floor of the main room, ordinary, bearded, very handsome. He moved with a slowness that hinted he was on acid. He looked like he had stepped through a portal from the forests of the Pacific Northwest of the United States onto the dance floor. I kept seeing him. I loved him.

At some point transference happens. You become one with the place. The world outside stops existing. The effects of the individual

drugs you put in your body are no longer subtly discernible. You drop in; the hemispheres of your brain meld and start levitating. Time passes. The music is so loud it vibrates your organs. The times I have gone to Berghain compress into a single experience, I can't sort out the different images. When you first arrive it fits in the order of the outside world but then the changes subtly begin, and the bartender is naked; the tall woman stumbling is wearing a T-shirt that reads "Late Checkout" on it; I look for a place to sit down and avoid a mysterious pile of banana peels on a couch. The faces at the club become familiar, then they become your friends. By the time I finally left I had been at Berghain for fourteen hours. I biked home across the Spree. The sun was pink on the TV tower. I went home to my window and the tree outside, pulled the heavy velvet curtains closed across it, and went to sleep.

9

AS WAS CUSTOMARY AFTER GOING TO A PARTY, I SLEPT THROUGH THE daylight hours of Monday, forced myself to get up and eat food, then slept again until Tuesday morning. I woke up renewed. It was a strange effect of intense partying that sometimes I emerged from it with a mind as clean as a sidewalk that has been hosed down in the morning. My diminished cognitive state made it difficult to perform tasks that involved short-term memory or paying attention to other people, but the hangover acted as a reducing valve that made it easier to focus and write. Occasionally blowing my mind with drugs had the consequence of focusing my thinking to a single channel instead of multiple ones, such that I could concentrate with rare intensity. I made coffee, laid out my notebooks, and watched as sleet rained down on the blackened skeleton of the tree outside the window.

I was having a problem with my writing, and the Nigeria book was symptomatic of the problem. I would be tasked with completing a particular assignment as a journalist, which demanded in the writing the adoption of a tone of authority and a focus on information. But in every journalistic assignment there would be a parallel experience, the real one, which would have been far easier to write about but useless for the task of conveying information about the subject.

This conflict, between information and experience, had stagnated my writing. The personal writing I had done in my twenties had been taken over by journalism, which paid me, and in journalism it was difficult to reach the reader in any kind of emotional sense, which was the only way a reader would care at all, and the only kind of writing that lasted in time. The book about Nigerian cinema was for a series of short books published by Columbia University about globalization. When the publisher proposed it, I had counterproposed a book about what I actually wanted to write about, which was the destruction of the Amazon rainforest. Unlike Nigeria, where I had never been, I had lived in Brazil and spoke Portuguese, but the publisher had wanted the book about Nigeria so I finally said yes. I decided that anything could be pulled off with enough research and reportage. I really needed the money.

I had spent five weeks in Nigeria the year before, most of it in Lagos, not long enough to understand a place. Lagos seemed to me the future of life on Earth, a future of intense competition in which all the wealth and resources were concentrated at the very top and no one could rely on collective infrastructure for basic necessities. In my time in Lagos, I stayed in Ikoyi with a well-connected Nigerian American friend. Sitting in traffic with him and his friends on our way to dinner, I half listened to chatter about polo ponies and vacations in the Seychelles while outside the windows an utterly different reality played out. Lagos traffic and driving habits were notoriously chaotic, so the budget I had submitted to the publisher included a line item for a driver to take me to movie sets. His name was Solomon and he was a very Christian and caring man who knew his way around the vast city without ever needing a map. As I sat in the back seat, I would listen to him on speakerphone diplomatically settling disputes between his three young children, who would call him when one had stolen the toy of another or some similar injustice. We became

friends on Facebook, where he would post videos of TB Joshua, the celebrity pastor of a Pentecostal megachurch, who called forward prostitutes from the crowds who attended his services, and saved their souls. Every day Solomon drove me across the Third Mainland Bridge to Ikeja or Surulere or Maryland, where I interviewed directors and visited their movie sets. I learned that Lagos was not a city where smiling earned respect. I watched the movie producers I interviewed perform imperiousness with their inferiors, and learned to mimic it. The books sold on the streets extolled entrepreneurial strategies and evangelical Christianity. I kept seeing the memoirs of Ben Carson, the Black American neurosurgeon who was running in the Republican presidential primary, for sale in hotel lobbies. The myths of self-reliance and upward mobility were very popular. As I sat in Berlin and listened to my audio recordings, I could hear how my voice hardened as the weeks went on.

I saw a lot of similarities to the United States, where it was increasingly the case that getting and staying rich was worth any transgression, because the reminders of what life would be like if you were not rich were all very near at hand. When the possibility of a normal middle-class life recedes, exuberant scheming sets in. I realized upon leaving Lagos that it was probably better not to have children. I would not be able to bestow upon them the tools of survival. I had been raised soft, with expectations of public resources—libraries, schools, parks, clean water, boneless and skinless chicken breasts wrapped in packages on refrigerated shelves. I was hopeless at negotiation and pushing my way to the front.

The writing seemed impossible. Working from the discredited subject position of a white person writing about a West African country, these culturally deterministic observations I kept having, or even negative judgment, had to be avoided in the work. "I am subject to a double infirmity," Claude Lévi-Strauss once wrote. "All that I

perceive offends me, and I constantly reproach myself for not seeing as much as I should."

Lévi-Strauss, whose subject position was also now discredited, had written that travel was not merely displacement in space but also movement through time and the social hierarchy, which for a woman, as the cliché went, would often mean lectures from taxi drivers about marriage and family, which in America were no longer considered polite. I hated the pitying glances I received when people learned I was in my thirties, unmarried, and had no children. I befriended a film producer who had an incurable fondness for aphorisms and, like many Nigerians I met while writing in my notebook, almost immediately observed out loud that I was left-handed. I marveled at the expanse of readymade phrases that came to his mind, phrases that sometimes took me a minute to parse. "In the content business if there's no content in the content you can only buy the pig in the poke for a while," he might say to me, or, with regard to a movie he'd started making before lining up the finances, "A soldier does not think about death before he goes to war." Upon learning I was unmarried he quickly promised to find me a husband. I told him I had a boyfriend. "I said husband, not a boyfriend!" he said, scandalized, although then he admitted to being relieved I was not a lesbian. "The Bible says Adam and Eve, not Adam and Steve," he said gravely. "Yes, I've heard that one before," I replied. It was an unfamiliar experience, the emotional exile one felt in a society that still had consensus about how everyone should live their adult life. At home, in New York, we all pretended any chosen familial arrangement or lack thereof was equally valid and reflective of one's careful personal choices about identity even though most of the hetero people ended up married anyway, the rightness and ordinariness of their way of life affirmed to them by Superbowl ads and their joint tax filing status.

I had one perfect day in Nigeria. I was in the north-central city of

Jos, where this aphoristic producer was making an epic movie about a legendary Hausa warrior named Queen Amina. (He was, in his way, a feminist, in that despite his belief in the supremacy of marriage and his Christian homophobia, he extolled powerful women politicians and film directors.) Through a friend of a friend, I found a place to stay in the dormitory of a Christian mission, and through the same contact the Nigerian couple who ran the mission offered to show me around. Their names were James and Mary. They left their three children at home, picked me up in the morning in a white pickup truck, and led us in prayer before we began our daylong excursion. It was a typical Sunday for them: We paid a visit to the village where they had grown up, and where they now had a small photocopy shop; then we went for a walk in hills tawny with dust and golden in the afternoon sun. We visited a house they owned on the edge of the village and ate lunch outside: mango juice from a carton, rice with some meat. A hedge of cactuses around the edge of the yard kept out the goats. The house was a work in progress and did not yet have running water. I carefully flushed the toilet with water from a bucket. We discussed the violence of American movies, and what made life in America so complicated and expensive, and why everyone was so stressed out and unhappy even though we had so much more material wealth than everyone else in the world. I said I wasn't exactly sure of the reasons, but I ventured that we were almost all of us in some kind of debt, and that health care was expensive, and education, and housing, and that there did appear to be some kind of spiritual paucity that was making everyone hateful, insane, and dependent on psychiatric medications. We spoke about household appliances that Americans had as a matter of course. "When everything around you is a machine then you become a machine," James said, a sentence that I knew, as soon as I heard it, would continue to echo around my mind for years. As we drove around their village James and Mary stopped for every pass-

erby walking down the road to greet them. When we got back to Jos we stopped again, to pay respects at a wedding. The bride and groom swayed together on a dance floor while well-wishers came up and rained cash over them, money that was picked up and put into bags by helpers wearing matching wedding-themed T-shirts. I pictured a life lived according to the values set out by the designated doctrine of the god I was born to believe in. But one was placed outside of religion not by choice but by history; no amount of prayer or mimicry of tradition would resurrect any certainty in me about a standard of authority ordained by God that I needed to follow. Consensus wasn't willed, it was the expression of the people around you and how they felt. It was the collective mind, which couldn't be overridden by any one individual. I was lucky that my identity allowed me to pass without being on the receiving end of hatred, that who I was made me subject only to pity and not to violence.

What I liked about reporting was that, like drugs, it caused a temporary defamiliarization that could reveal my own insularity and myopia, if I were sensitive enough to recognize them. Unlike with hallucinatory drugs, however, this view from a new angle had to be distilled and conveyed back to an audience, and with a tone of expertise. I pictured a possible reader, a low-level Netflix executive tasked with researching investment opportunities in an emerging market. I focused on summarizing the movies themselves. The smaller the movie's budget the more likely it would be a morality tale: a woman who had struggled to conceive children would sleep with a man who was not her husband, the husband would learn the resulting children were not his and curse them, the family would lose its fortune, a priest would perform an exorcism, the curse would lift but only after the mother died a horrible, punishing death. The higher-budget movies, made by Nigerians who had studied abroad or watched a lot of Shonda Rhimes shows, were more likely to be gangster narratives or,

as in America, romantic comedies where everyone was rich. These would usually have a scene where the male protagonist delivers an abstract PowerPoint presentation in a boardroom. The good women were virgins, even in the twenty-first century.

I gazed out the window at the sleeting Berlin winter, trying to remember Nigeria. I could still lie to myself in Berlin that everything would turn out okay, which given the history of the city was idealistic, but I could do it. In Berlin, if you didn't think too hard, it was possible to have some optimism about the future; there would be a slow progression toward energy efficiency, LED lighting, and the phasing out of single-use plastics; the needy would be cared for and housed; the social pressure to marry and reproduce was an artifact of history from which humanity had liberated itself, and the nuclear family would be exchanged for the collective promise of social democracy. By the end of a week of frustrated writing, I was ready to go out again. I got a dealer's name from a friend and bought cocaine on a darkened street corner from a scary-looking tattooed Italian with a sullen girlfriend hanging on his arm.

I woke up that Saturday, opened my phone, and read a horrific headline. I put the phone down, then lay in bed looking out at the tree. My phone lit up with a text message from Andrew, who was at a party at a warehouse in Greenpoint that overlooked the East River. I pictured him there in the depth of the night. He told me how special the venue was, that there was an ambient room with daybeds and houseplants and glow-in-the-dark stars. He was lonely without me, he wrote.

I asked if he had read the news. He hadn't, so I told him: there had just been a fire at a warehouse techno show in Oakland and thirty-six people had died. The people who had gathered at the Ghost Ship the night it burned were members of the Bay Area's counterpart to our scene. Our friends had lost friends. It was horrifying because it could

have happened in any city, especially New York, where low-budget event spaces were as difficult to come by as in Oakland. I spent most of the day reading about the fire and the devastated posts online from people I knew who had lost their friends. That night I dressed to go out with an awareness that I was lucky to have this life, which could end at any moment.

Nights in Berlin developed at their own pace. One might begin with dinner, or drinks at a friend's house. We would hang out at one setting until it exhausted itself and only then did we contemplate what the next setting might be, never trying to keep an appointment or arrive at a particular place by a particular time. If we weren't careful this meandering could start on Friday night and continue until Monday afternoon. That Saturday I met Anna for dinner at the pasta restaurant her boyfriend ran in Neukölln, then we went to Motif, a wine bar run by other friends around the corner. The bar had unfinished walls, vintage furniture, and a turntable set up on which someone played italo disco at a volume that allowed for conversation. Anna took such delight and interest in food and drink that when she went out bartenders and chefs always wanted to give her things to try, so we sampled bottles of wine between trips together to the bathroom to do lines. When the bar closed, we moved on to a friend's house, a massive, high-ceilinged Altbau apartment that was tidy and bare. A fluorescent tube light in one corner lit up a solitary fern. The dominant piece of furniture in the dining room was a table around which a group of adults sat as if at a formal dinner, except the only thing on offer was a single plate onto which lines of cocaine had been cut and a rolled-up euro note had been placed. We sat there for hours, talking, joking, evaluating internet dating profiles. The plate went around the table, and then a little amber medicine bottle, with an eyedropper, of GHB. "I erased my dealer's number," one guest lamented when the call went out for more cocaine, which eventually arrived after a pool-

ing of money. Newcomers passed through all night long, drunk from office Christmas parties. One of the new visitors, a clean-cut blond man who carefully hung his long wool coat over a chair but kept on his red cashmere scarf, turned out to be a doctor, and began a long lecture in precise, German-accented English about the perils of GHB. He saw people in the emergency room all the time for it, he said, mostly thin young women whose bodies couldn't handle their doses. In excess, a person just stops breathing, he continued, as the small bottle was passed around again, and he declined it without pausing his lecture. As a precautionary measure, users of GHB deployed certain strategies, like taking a screenshot of the time on their phones to make sure they properly spaced their doses. With GHB I had broken my rule about not doing drugs that could easily kill you, but I had always been so cautious when I tried it that I failed to experience its effects beyond a vague sense of softness and warmth. Its promise was of a kind of warm drunkenness, joy, and euphoria, and for some people heightened sexual desire. In New York it was one of the few drugs underground promoters banned like they meant it, and even though it was still widely used, getting caught with it could get you permanently blacklisted from a party or venue. Not only was taking GHB dangerous but it was also seen to be a question of bad citizenship: a death at a party would not just be a personal tragedy; it would kill the scene.

The sun came up. The cocaine ran out. Anna and her boyfriend had gone home hours ago. The seats around the dining table began to empty. A few of us walked out under a cold, gray morning sky and hailed a cab to the next setting.

We went to a party called Cocktail D'Amore, held at a club called Griessmuehle, in Neukölln. The founders of Cocktail were Italians (they fit in somewhere in Anna's network of compatriots) and Cocktail was a gay party, not only "queer" in its vague utopian sense but

also mostly a room full of men. The party was held once a month; it had started late Saturday and would go until Monday morning.

There are few circumstances that fill me with more elation than going from the deserted streets of a city on a weekend morning into a portal where the fun had never stopped and the desolation of a Sunday can be put off for another few hours, or twenty. We arrived at a slow moment at the door and got through quickly, despite one of our party having recently gotten banned for falling asleep in the club. My eyes were vibrating in their sockets—no more cocaine. We checked our coats and did a circuit. In the windowless main room, a DJ played to a crowded floor under blue lights. Beyond this room was a kind of large sunroom with panes of colored glass in the windows. A bar was at one end. In addition to serving drinks, a large pot of soup was being warmed on a burner for anyone who was on the verge of falling over and needed something to eat. On the other end of the sunroom was a DJ setup that was for now unused. We bought beers. The drink calmed me. We went out the back door. The backyard resembled a junkyard—there was a kind of treehouse hung with used tires; an abandoned car; shipping pallets repurposed as benches. Griessmuehle was in its full glory in the summer, when the partygoers could arrive along the canal by boat and the party was half-outdoors. In the winter it was austere and bleak. We crawled inside a concrete tube that lay on its side, the kind I remembered from playgrounds in the 1980s, and dosed a little more GHB. This time, as we returned to the dance floor, I felt warmth and a kind of physical happiness, although I still can't say exactly what it was like.

I had gone to the party with a couple, Andreas and Carlos, who were my age and newly in love. They were radiant with adoration and a visible desire for each other in which everyone around them wanted to bask. Carlos was tall and dark-haired and Andreas muscular, blond, and bearded. They complemented each other, dark and

light. The third member of our party, Paul, was a German American who could switch seamlessly between languages and had a little bit of a mean streak that terrified me. He also knew Andrew, and had accompanied Andrew on his month of hedonism the previous summer. When I introduced myself to him as Andrew's girlfriend, he had raised his eyebrows and smirked: "Must be a pretty recent relationship." I texted Andrew and told him. "I'm sorry," he wrote back from New York, with a frowny face emoji. I made a vow to sleep with someone before I went home.

I had some concerns about invading a space where I did not belong, but I was here now. My friends went their own way and I danced in the blue-lit room. I soon realized that the gender imbalance put me in a favorable position. The small number of hetero males at the party had very little to work with; they began introducing themselves and inviting me to the bathroom. I went first with a young Spaniard with pale skin and sad, dark eyes, who told me he was a poet. We danced, we went into the bathroom and did lines of ketamine, we came back and danced some more. Andreas appeared with a crumbled bit of a pill for me, then continued on to find Paul and Carlos. My Spaniard, with the nice manners of most of the men I would encounter at parties in Berlin, asked if he could kiss me, almost apologetically, making it clear that it was not meant as any kind of exchange for the drugs he had given to me. I thanked him and said not today; we slowly let the men dancing around us move us apart.

As the day progressed and the crowd grew smaller as people from the night before dropped out, the main room closed and the party was channeled into the bright wooden room with the colored panes of glass. The DJ now was a Japanese woman who went by Powder. Her real name was Moko Shibata and she had a day job as a clerical worker in Tokyo and a night job as a globally touring DJ in the electronic music underground. This was the first time I saw her play, but

I would go on to see her in New York several times, and she became one of my favorites. Her mixes blended electro and house music and were light and airy, tracks floating into each other like dandelion seeds carried by the wind. In her mixes swallows swooped around, and hot air balloons floated up into the sky.

The sun streamed through the windows, restoring color and joy to the day. The aggression of last night's cocaine sweated out of me. The happy glow of ketamine and the pill I had taken began to warm me and lift me up inside, and feelings of love flowed out of me again. I watched Carlos and Andreas. They were tall and handsome, and made a point of always being near each other, their bodies always in contact. They were good-looking, but it was the warmth of two people who were no longer exiled to solitude that drew others to them. I saw men come up and proposition them, and occasionally they would retreat to the dark room as a group of three, but the men who wanted their attention were like supplicants begging from royalty. Both Andreas and Carlos, I noticed, had to accept the advance. I envied their freedom, and tried to imagine a world where Andrew and I could go to a party, his arm slung around my shoulder, having to hug me closer to sip from the beer in his hand, as men and women tried to cruise us the way that men were cruising Carlos and Andreas.

I was now offered more ketamine by a young Australian, evidently straight, a lawyer who had quit his career and ended up in Berlin, probably on some misguided quest to be a musician (Anna was always warning me that Berlin was a city where people shipwrecked). The Australian and I took a trip to the bathroom with some other friends he had collected and within an hour we were in a party relationship and had exchanged numbers. I wanted to stay at the party forever but I ran out of cash and hadn't eaten for more than twenty-four hours. The soup at the bar, which in any case had looked revolting, was now all gone. Well after it had gotten dark again I

went back to Anna's. She fortified me with pasta, and then, because I was still too high to go to bed, I went to Berghain. All the fun was at Cocktail, I should have just gone back. Panorama Bar was populated by European tourists in goth costumes, and I missed the colored window squares and the glitter disco ball and the warmth and the boys.

A group of people dancing together in a room with no schedule should be a simple thing to accomplish yet it never was. The ingredients in theory were very straightforward: the right space; the right people; a good sound system; a good selector; a coherent dance floor; security that was there to make the party better, not worse; a libertine bathroom policy and toilets that worked; nobody interfacing too heavily with their phones; enough time for psychoactive journeys of different duration and scope; a cover charge low enough to accommodate people from different social classes. In New York, a person had to break so many laws to throw this kind of party, a party that was so good that you did not want to leave and that nobody would force you to leave before it ran its natural course. In New York one had always to contend with the brainwashing that had made every individual an advertising agency for a single client, that was more about creating the appearance of fun rather than the fun itself. But while I danced at Berghain, I thought about how when a party in New York was good I liked it better than any European counterpart, because it was my home and my friends, because techno was Black American music that emerged from a specifically American set of challenges, because New York was a place into which an entire country's sexual deviants and disaffected geniuses were funneled, or at least that was its legacy, one that perhaps was no longer true and maybe they all went to Berlin now. I finally got tired. I went home and went to bed.

Later that week, I went out with the Australian. We went dancing at a bar called Sameheads in Neukölln, then he came back to my place. We had sex, but I found him arrogant and performative. He wanted

to stay the night but I sent him home. He called to hang out again the next day but it was no use. I could perform sexual freedom, but I was emotionally tied to one person. I missed Andrew so much, and when I went back to New York it was with a sense of surrender. I could no longer perform independence. I had no choice but to lose myself to the person I loved. Back in New York, I told Andrew about hooking up with the Australian and we had a little fight. Then we decided to move in together.

We stayed in New York that year for Christmas, celebrating with my family. My brother and his girlfriend had just had a baby, and I was grateful to have a boyfriend along as the family rearranged itself around its newest member. My parents were always pleased if I was attached to a man, and were relieved when they could project to their friends the appearance of their children having conventional lives. That year Andrew and I could triumph in our heteronormative coupledom. We got a gift certificate to a restaurant where we could go eat heirloom tomatoes together, and Andrew pretended he wasn't a cigarette smoker, and we smiled for photos of us holding the tiny baby, my hands with their black-painted fingernails clutching her.

10

NEW YEAR'S EVE IS THE WORST NIGHT OF THE YEAR TO GO OUT IN NEW York City. For the passage into 2017 we stayed in, took acid, and walked downstairs, where my DJ neighbors had a small party. We danced and drank and talked and kissed at midnight. We took breaks with our friends to go upstairs to my place, where a magazine had lent me a virtual reality headset for an article I was supposed to write for *VICE* about virtual reality pornography. I'd downloaded a bunch of videos of giant animated women with plasticene genitals in a fictional sex dungeon and POV fantasies with toned California bodies but had also been playing around with the non-adult content, since they gave me a password to the game store. Our friends went back and forth from the party to my studio to draw pictures and play racing games in the alternative simulated universe.

Andrew had come over and set up the system for me a few weeks before, knowing how much it turned me on to watch him plug in cords and display technical competence. The plugs of the virtual reality machine took up an entire power strip. His initial immersion into the metaverse involved shooting lasers at menu screens and calibrating sensors. "I'm in an IKEA kitchen and it's falling apart," he narrated as he worked his way through a demo where a "typical British-accented C-3PO" taught him how to operate the hand con-

trollers. Once the sensors he placed in the opposite corners of my apartment were calibrated, he handed over the headset to me. The welcome screen showed the night sky, the firmament of stars, and a glimpse of planet Earth from outer space. The words "THIS IS REAL" hung over a horizon of clouds.

The virtual reality software designers specialized in the digital re-creation of threatened ecosystems. My first evening in possession of the machine I came home from a night out, put on my headset, and watched a jellyfish float around to a soundtrack of New Age arpeggios. I was a bodiless fragment of plankton in a vast ocean. A sea turtle swam gently beneath me. The anemones swayed with the currents. It was a glimpse of the future, when Earth would be over-heated and diseased, and mountains of trash would cover what used to be nature. The virtual worlds would become more intricate as the one we lived in was becoming an exploding IKEA kitchen. As 2017 began, Andrew played tennis on a court that floated in a blue sky, the balls zooming into the ether when they went out of bounds.

The party downstairs ended and the sun came up, but we couldn't go to sleep. We'd taken the acid too late at night, and when morning came we were still tripping too hard. We ordered pizza, ate it in bed, and spent the day watching *Planet Earth II*. I finally drifted off in the afternoon, closing my eyes against visions of snow leopards scaling desolate peaks and monkeys leaping from rooftop to rooftop. The soundtrack accompanying the monkeys was vibrant and uplift-ing, then grave and somber as other kinds of leopards were caught on motion-activated night-vision cameras snatching away people's pets. I buried my face against Andrew's shoulder, inhaling the scent of cigarettes and Old Spice. His body was warmer than other bodies.

I found the listing for our apartment one night on StreetEasy a few weeks later, within minutes of it being posted. I clicked through the photos, having difficulty believing it was real. I called, texted, and

emailed the broker, frantic with worry that it had already been rented. It turned out that he was out to dinner nearby and could show it to us on his way home. Andrew came over from Ridgewood.

The apartment occupied the entire fourth floor of an old brick building that had likely been a former factory. The building was next door to the Opera House, which meant that if we moved there I wouldn't have to change any of my habits or alter my psychogeography: I could calculate the same times into Manhattan, and still buy my fruits and vegetables from Mr. Kiwi. We climbed the four flights of a wrought-iron staircase. The stairwell looked like a good place to murder someone, filthy and with graffiti all over the walls. We arrived out of breath at a steel door covered in stickers that had aged into a museum of early 2000s underground hip-hop. It opened into the main room, a giant loft space that would have been big enough to hold a dance studio, with a column in the middle and an open kitchen. The floors were made of plywood rectangles that had been stained a dark color and nailed down, which gave the space a raw, unfinished appearance. The apartment's front windows looked down on the elevated train tracks of the JMZ and Broadway beneath them. The kitchen was newly renovated in the style of shitty New York rental apartments, with white ceramic tiles and a dishwasher. Two large bedrooms in the back had high ceilings and a view dominated by the wall of the Opera House. There was a third, alcove room off the front where Andrew could have his music studio, and a fire escape on which he could smoke. Every room had large closets. The train roared by every few minutes, but the apartment's double-paned windows reduced the noise, at least while they were closed in the winter. We looked at the apartment and then at each other. It was an auspicious sign to have an apartment this good.

We had applied but still not gotten word if it was ours when we went to UNTER for the first time together. It was a time of anxiety,

late January, the words "President Trump" still new enough to pro-
duce estrangement; a head-down-and-cursing kind of cold outside.
I had a headache that night and wasn't sure if I wanted to put my
body through the effort of staying up until dawn and snorting drugs.
Andrew assured me it would be worth it. There was no getting com-
fortable, no venue would ever last, and it might be the last time. "I'd
just like you to see the place, it's kind of magical," he said. "We can
just go in the ambient room and snuggle."

UNTER was a queer party that had started in 2015 in the base-
ment of a coffee shop down the street from Bossa. At first it had been
an after-hours thing; after Bossa closed at four, the promoters would
herd everyone who wanted to keep going down the street to the next
venue. Then it kept getting bigger.* UNTER was thrown by a col-
lective of people whose primary operator (every illegal party had
to have a person who was a little bit of an operator) was an Uzbeki
American promoter named Seva. I think his day job was producing
fashion parties and art events, that kind of thing. Techno raves were
maybe a side gig. Seva's girlfriend, who was also part of the collec-
tive, was a DJ named Ariana who went by Volvox, a blond Brazilian
American who wore her hair in a topknot with the sides shaved and
played punishing techno with perfect posture.

UNTER was high-concept. The collective had an architect who
would lay out the party's design in AutoCAD and a graphic designer
who made flyers that riffed on pharmaceutical packaging, or classical
sheet music, or a can of Raid, or an X-ray of a pelvis with a giant dildo
lodged in it. Most of the parties had a concept, sometimes one that
recalled twentieth-century geopolitics (in 2015, a DJ had dropped out
over the theme being UNTER Bomb Threat). Seva wrote the copy

* For more about the party, see the *UNTER Rave Posters Volumes I and II.*
In volume II, especially, the founders recount this history.

of the flyers with Nick, who was a graduate student in performance studies at NYU and DJed with a Bossa bartender named Kiddo under the Deleuzian moniker Pure Immanence. UNTER framed its work as political in nature. "Tired of being subsumed by the totalizing ideological stranglehold of capitalism?" asked the flyer for UNTER City. "Sick of being churned through the meat grinder of corporate real estate?"

"UNTER City is a place where we focus on providing real, felt alternatives to the dominant mode of production through what we call 'group communo-shamanistic ki-tharsis.' On the margins of urban life, we've established a safe haven 2 performatively transform your monotonous life of debt servitude into the sweaty good life of your queer communist utopian dreams." This elevated language was both serious and not. It was a shared aspiration that drew people together in one room and an acknowledgment of our alienation; it was also poking fun at its own wishful ideation. What we did in these spaces was closer to a kind of scavenging, landing on a carcass to pick at the bones until the apex predators swatted us away. We accompanied the property developers, flapping around them. We hung out in the same places, and they might have done the killing but we could not claim to be their prey. Yet the hedonism was a resistance to something. It took extreme cognitive measures to get out of the "totalizing ideological stranglehold"—the ads and the social media posturing, the insistence on the fact of your race or gender and where it was meant to place you in the social order. You could meditate for a lifetime or you could reset the computer in a single night with some drugs. We might not have believed in the higher authority of religion but neither were we frolicking around in a decadent cult of the self—if in the world we were atomized, at the rave, for a few hours, we could model a collective ideal with its own manners and ethics. Except to put it that way is too earnest, and UNTER was more punk than that.

After we decided we would go to the party I called my drug dealer. I had met her through Matt, who I think for a time supplied her with mushrooms although I never really asked. I had never asked Matt much of anything about his mysterious sources of cash income, and he had never volunteered any information, but for a time in 2014 he'd had gallon-size bags of psilocybin mushrooms lying around an apartment he was subletting.

These mushrooms had been important to me. They had given me one of two psychedelic experiences that, in all the times of taking drugs, had been singularly transformative (the other was the first ayahuasca trip). One night that year during a snowfall I had taken five grams on an empty stomach from one of these bags—Terence McKenna's heroic dose—for a solitary introspective journey. It was the first week of 2014. The apartment Matt was subletting was in one of those giant, old, rent-stabilized buildings in south Brooklyn, with grand stone facades and hexagonal-tile floors. It was dingy, fluorescent-lit, and the hallways smelled of cooking. We were trapped among the belongings of the apartment's usual occupant, who was evidently some kind of spiritualist and had decorated the place with pink Himalayan salt lamps, crystals, and dank tapestries. The place smelled of sage. The apartment was dark, or maybe it was just the dark of an early January night.

Snow was expected but had not yet begun when I ate the mushrooms, lay down, and waited for them to take effect. I had no fear. Matt was there, trip-sitting. I knew the psilocybin was taking effect when a face began manifesting in a scarf that was hanging from the dresser in my line of sight. I closed my eyes and the trip unfurled. Almost immediately the hallucinations took the form of entities. Plural in number, unlike ayahuasca, where the voice had been solitary and female.

Matt was hovering around me, burning things, wafting sage smoke, turning rainsticks, conducting symbolic ministrations. The entities, which were playful, indicated that the honors of pseudoreligious ceremony were irrelevant to them. I then told him, "You can leave the room now, they're taking care of me," which I only know because he liked to make fun of me about it later. He went into the other room.

The entities made it clear, as other psychedelic experiences had, that Matt, who at the time was my boyfriend but with whom I knew I was not in love, "didn't matter." "He doesn't matter," they said to me, and he was thus dispatched from my psyche and not addressed again. The mushroom entities were playful. They were addressing me from somewhere else, possibly outer space. The manner by which they reached me was high tech. They had planted themselves into the mushrooms, which they used as a conduit. They had no visual appearance; they were just voices. We were all of us, humanity and Earth, under their watch, and the sense I had was that when a person took mushrooms it was like a phone rang wherever they were, and they picked up, to communicate and offer guidance. The trip resembled an intake session. They were examining and scanning and they had access to every thought and memory I had—"Mandalic Universal Newspaper Busybody Gossip God," as Allen Ginsberg had put it. They saw me whole, the way I could not see myself, or anyone could see me. They saw that I was a skeptic who would not "believe" in them, who would find any possible way to convince myself that they were not all-knowing space beings or spiritual presences but just some byproduct of the interaction of psilocybin with my 5-HT$_{2A}$ receptors, that they knew me so well because I knew myself so well, even though it was only on mushrooms that I could see everything from a perspective that seemed not my own.

"Yes, she's difficult," they murmured among themselves, giggling, and then, to me, "You don't have to believe in us." They indicated that it didn't matter what I believed or didn't believe. Religious ritual was only one of the ways they had been received on Earth but was not the only way to treat them with respect, or so I gathered. To have taken the mushrooms was to have already made the necessary gesture. My consciousness was in conversation with itself, and there was unsurprisingly very little disagreement that belief in God was not a prerequisite for access to the mystical.

My attempts to commit their lessons to memory were impeding my immersion. I mean the part of me that was always writing. They caressed me with loving mental tendrils. They told me I was good. They told me my mission in life was to "observe and report." They contemplated the book I was writing, and told me it would be good. They reassured me that I had a purpose on Earth to fulfill that would bring humanity closer to its next phase of evolution. They were not messianic, but they hinted that there were broad forces at work, propelling all of us toward a collective destiny. They told me to trust myself. "Observe and report," they kept repeating, and all would be good; it was my mission in life.

The question of love emerged, of the love that I wanted and that seemed to elude me. "We're sorry, we're so sorry," they kept saying, in deep sympathy. They told me that love would not arrive for me, but that it would be all right. This had a far more calming effect on me than my attempts to reassure myself that "everything would be all right" in a state of ordinary consciousness. If only the uninfluenced mind had such an ability to soothe. I believed the reassurances. I believed them later, even once I had found Andrew.

They scanned my body for health problems, and lingered with concern on my uterus. They helped me recover someone's name I had been trying to remember. They manifested a few dark and mon-

strous images, to tell me how they could scare me if they wanted to, while reassuring me that they weren't going to scare me, it was only to remind me of what they were capable.

I registered very few sounds from the outside world as all of this took place. One of them was the recurring scrape of a snowplow on the surface of the street. I only opened my eyes once or twice during the experience. The show was in my mind. The room was lit only by a candle, the amber glow of the streetlights outside, and New York's purple nighttime ambience. When I came back to myself it happened suddenly, like dropping off a cliff. The mushrooms were simply gone. I was ravenous. I was physically exhausted. Five hours had passed in a moment, and I was stunned to discover that the outside world was now blanketed in several inches of snow.

I didn't have to be under the influence of mushrooms to know that our individual futures and those of all humanity were inextricably linked, and that the pace of change seemed to be accelerating. I hoped, as we burned all of our bridges to culture, religion, and the natural world, and made it impossible to turn back, that there would hopefully be more than a dead end on the other side. As for my uterus, it was an obvious source of worry, the origin of so many mysterious sensations and humors. But even now I am trying to convince myself that the experience, with all of its comforts and prognostications, was somehow false. For obvious reasons I told very few people about it.

There was no "they," but even in my skepticism I had a tendency to anthropomorphize the mushrooms into perpetrators of charlatanism, as if trying to undercut the prophecies of some especially canny fortune tellers. One of the panels on psychedelics I had attended that year emphasized the importance of waiting to act on "advice" or revelations that the plants often supplied. It was better to wait a few weeks to paint your house with polka dots, quit your job, tell a stranger you love them. Just because the messages feel true and

urgent does not mean that they are. The possibility of living my life in a delusional state of false revelation brought on by drugs troubled me. If I accepted the messages generated in a mind rechanneled by psychoactive chemicals, would I start believing in things that aren't real?

The mushrooms had said a lot about writing. I had chosen the work I wanted to do but I often regretted it. It kept me apart from the world, and its demands for isolation made maintaining relationships difficult. I knew my writing would be piled up with all the other writing that would be read or not read and mostly forgotten by the next generation. After the mushroom experience, I didn't question the rightness of the work any longer. A certainty was there. I didn't have the genius I envied in others, but this was how I was going to spend my time. The work would be read with the same disdain or gratitude with which I read the work of others. I might not have anything important to say but the process of inquiry and observation was what gave my life meaning, even more than the attempts to put anything into words.

I had not done mushrooms since that trip. Three years later, as Andrew and I planned for our weekend out, I thought of the life-changing, epiphanic phase of doing drugs as behind me. The effects of psychedelics had become, if not normalized, then somewhat predictable. I didn't expect to have any more transformative experiences on them. I had stopped taking them for introspection and was now, with Andrew, more interested in using them to enhance the experience of a party, a practice Terence McKenna might have seen as frivolous, but McKenna had also thought that December 21, 2012, would mark the end of time. Matt and the drug dealer had ended up having some kind of falling out related to the mysterious sources of cash I never asked about, but since my relationship with him had ended, she and I could still talk, which was good, since at that time

she was being supplied with a wide array of high-grade psychedelics. She had pressed ecstasy pills, which in Europe were common but in America could be harder to find, 2C-B, ketamine, mushrooms, LSD, and occasionally coke. I always thought I deserved some kind of finder's fee for connecting her with Andrew's friends, who then connected her with the whole broader Bushwick rave scene, which she serviced for a year or two until she started to get high on her own supply. The quality and variety of drugs she sold took a sharp decline, and she began displaying symptoms of paranoia that made her customers nervous.

That Friday, Andrew and I each took a tab of acid around ten, then went downstairs from my place to hang out with Olga. UNTER at that time was more of an after party, and didn't even start until two in the morning, so there were a lot of hours to fill before the main event of the night began. When we left I was tripping very hard, and I have little memory of the freezing car ride to Greenpoint.

The building on Huron Street in Greenpoint where UNTER took place every month or so for most of 2017 was slated either for demolition or renovation, but in the meantime it was empty and available. Or maybe it wasn't. The rumor was Seva had produced a party there, but the venue had never asked for the key back, and apparently nobody ever checked on the state of things inside. So UNTER had kept throwing parties without authorization there for nine months running, although the place got progressively more disgusting. Once the owner finally caught on later that year and changed the locks, a Facebook post cropped up asking if anyone wanted to volunteer to go back in and retrieve the party's infrastructure.

But while UNTER was still being held at that venue, we would walk in and feel like we had won something. Like we had won New York City. Greenpoint was, after all, the plain center of everything that was wrong: moms in shapeless dresses pushing around strollers,

the toddlers all with names like Harper and Bjorn, nannies walking the family Australian shepherd, subway-tiled bars where nothing fun has ever happened no matter how many glasses of pét-nat were consumed there. The building was on the waterfront, across from a construction site where yet another glassy high-rise was going up. The road was torn up outside. One night later that spring the party happened after a few days of rain, and UNTER provided everyone with surgical booties so they wouldn't muddy their shoes on the way in. They took pride in attention to detail.

I never went there without a distorted consciousness, so none of my memories are exactly sound, but we climbed a dark stairwell to an upper floor, the sound of the muffled bass shaking the walls. I don't think we had bought tickets in advance, but that night they hadn't sold out. The venue consisted of a warren of rooms in what used to be an office. Some rooms still had gray office carpet, and others had off-white linoleum floors. We walked down a corridor and stepped into a flat-lit central room with windows that looked out over the city. If it were a video game this would be "home," a place to go when you needed a neutral reset. In one corner, Kiddo stood selling juices, fruit cups, and mineral waters. Down a corridor, in almost total darkness, was the main dance floor, which at that hour was already at peak intensity—a little too intense, Andrew and I both agreed, after putting in our earplugs and walking in, swaying for a few moments in the darkness amid heaving bodies, then walking out again. We bought a green juice from Kiddo and took it to a disused conference room where the lighting designers had put strobe lights behind the falling cork ceiling tiles. We sat down on the floor and each took a swig of juice and a pressed pill. The video game would have been of the zombie-themed postapocalyptic genre: the wires hanging down from the falling ceiling tiles, the soap dispensers in the bathrooms empty. It had a still-intact kitchenette, and the counter where we crushed up

our ketamine had burn rings from a coffee urn. Because the venue was illegal, sex acts, drug insufflation, and cigarettes did not need to be confined to bathroom stalls or outdoor areas, which was liberating, and I gave Andrew a blowjob in a room that had been left dark for sex. There were bare breasts and bare asses, leather harnesses, drag queens and dolls, ravers in sportswear or dressed all in black. The fashion was good; nobody here used partying or psychedelia as an excuse to look "zany," to wear novelty sunglasses or put glitter on their faces. At UNTER you would never, just as you would never at Berghain. One of the offices, a corner room with windows that looked out on the East River, was the de facto smoking room, crowded with people sharing papers and pipes, laughing in a haze so thick it was like being inside the tailpipe of a car. Smoking analog cigarettes wasn't allowed in the ambient room, where we spent the first couple of hours of our night lying on pillows and chatting with friends, waiting to pass through the mind-dissolving phase of our acid trip and for the ecstasy to come up. This was the room Andrew had described to me in December when I was in Berlin, with the glow-in-the-dark stars and the daybeds and plants. Huge red paper lanterns hung from the ceiling, their light programmed to rise and fade, bathing the small knots of people cuddling and talking in gradations of crimson. The setup in the ambient room was on a low table in one corner, where DJs played the sounds of waves and birdsong over soft synths and sat guru-like amid pillows, presiding, flanked by potted plants.

I can describe this room as I remember it, but I cannot bring it back. The building is gone now. I know I had conversations, but I don't remember the conversations. I made friends and learned people's names, and sometimes where they were from, but rarely what they did for a living or anything else about their lives and ambitions outside the rooms we occupied. We were there to dissolve our identities. I don't want to give the impression that we had to be high

to enjoy the party, but the happiness and euphoria we calibrated in ourselves through the careful and considered manipulation of drugs was in pursuit of a glimpse of our best selves, which we achieved through means that some might consider an ordeal, a pushing against the limitations of wakefulness and consciousness.

I'm sure that if you asked any experienced raver what their preferred party formula was, even a sober raver, they would be able to tell you. Different personality types were drawn to different drugs. Some people just took Adderall to stay awake and smoked weed to add a layer of interest to their surroundings. There were cokeheads and ketamine queens and people who microdosed mushrooms. Others took a carefully weighed-out dose of MDMA or dipped into their little Ziploc bags of it all night. The sober crowd drank Club-Mate for the caffeine and smoked cigarettes. Most of us specialized in polyintoxication. We learned how each drug interacted with another drug, and when was the best time along the journey of one chemical to add another. I can only speak personally but it was a carefully calibrated affair. I checked the composition of my powders with chemical reagents and weighed doses into gel capsules on a scale before going out. Getting it wrong would ruin the night with a stomachache or vomiting or a k-hole or a panic attack or an overwhelming desire to go to sleep. It could mean the nightmare of the lights coming up and the music stopping while you're still tripping balls, or the opposite, feeling listless and bored and wanting to go home at the height of the party. Calibrate it right and the experience would be a sublime dissolution of the self and the concerns of ordinary life.

It was in 2017 that I figured out that my party drug of choice, if it was a party where I could stay up all night, was LSD. My friends made fun of me for it, and some of them found it to be a volatile option, but for me the advantage was longevity. When everything else wore out its half-life the acid would still be there, roiling, and I

could turn it up or down with whatever else I laid on top of it. There was a reason that it was, as the website Erowid put it, "the standard to which all other psychedelics are compared." Acid was physically nontoxic and psychoactive at such tiny doses that it was unlikely to be adulterated or swapped with a garbage research chemical. (There was a fake acid going around in the Silk Road years called 25I-NBOME that had been linked to several deaths, but before that appeared in the supply, around 2013, if a drug was psychoactive in blotter form it was almost certain to be LSD and nothing more dangerous.) Acid by itself didn't make me feel sick or give me a hangover, although it would psychologically amplify any ill effects from other substances. That night at UNTER we had taken a full hit, probably two hundred micrograms, which was a little much for a party. I remember trying to buy a bottle of water from Kiddo, and his kind smile when he saw me struggling to figure out my wallet and waved off payment. (Andrew would always say that he knew he had hit a sweet spot at a party when money no longer made sense to him.) I later figured out that my preferred dose was between seventy-five and a hundred micrograms two or three hours before going out, so that by the time I arrived at the party I was tripping but still able to hold conversations and tell left from right. I didn't like getting to the point where I would mistake strangers for people I knew, or marvel too exuberantly at the sunrise. The idea was to enhance my surroundings but not get stupid.

Despite its history and reputation for ego dissolution and messianic ideation, acid was never an introspective drug for me. It never offered any of the major epiphanies that psychedelic plants had given me. A day on the beach or in a park on acid was nice enough, but I liked it best when immersed in a setting that offered auditory and visual stimulation, especially of the kind that was engineered expressly for people on acid. The founders of Detroit techno had not been drug users, and the founders of Chicago acid house may not

have named the squelching sound produced by a synthesizer called the Roland TB-303 after the drug, but acid and other psychedelics were being taken on the dance floor, and the music and the drugs became conceptually intertwined. To take LSD was to be a part of a lineage that had begun in 1943, around the same time as we entered the nuclear age. There was a continuity to it—the music that had sounded good on acid fifty years ago sounded good on acid in the present, and raving was an outgrowth of a culture of acid psychedelia in America that had been honing best practices for several generations, that had crossed lines of social class, race, sexuality, and geography. As a straight white girl from the Midwest, the archetype of the nerdy midwestern acid freak from the land of crust punks and wooks was an established role I could comfortably inhabit. As for Andrew, who with his hair and glasses looked like John Lennon hybridized with white Jesus, people would often come up to him at parties and ask if he was selling LSD. But LSD was, at least for me, a drug of discernment. It demanded authenticity and complexity and revealed the ersatz. Things I found to be intolerable on acid included blinky LED lights, most commercial music, the taste of water in plastic— anything artificial. If a person's outfit passed the acid test it meant it was subtle, that they weren't trying too hard; I would often need to change clothes once I started tripping and realized I was wearing a dumb costume and needed to tone it down. Acid had a very decisive way of winnowing out the people I didn't like from the ones I did. Friendships bonded by an LSD trip, people who were cool to be with and with whom I had hit the same wavelength, had a deep unspoken love and understanding. In this it was different from MDMA, the drug that built so much of rave culture. "Molly lies," a friend had once said to me, meaning that it made you dumb, that everything was fun on it, all music was danceable, every person was wonderful, and the blinky lights looked pretty. There were times when taking a

happy pill was necessary, but after looking at brain scans in a book about drug addiction that showed cortical changes that lingered for months after a person took MDMA, and stories of people who took so much it stopped working for them, I tried only to take it two or three times a year, when I was really going all out and knew a party would last for twelve or fourteen hours, and always as a candyflip on the downswing of an acid trip, which was a recipe for the sublime.

I thought of acid as an almost-regal drug, and could not understand how some of my friends would get through the night on short-term highs like ketamine or cocaine alone. My tolerance for cocaine in particular was limited, and at a certain point I would get queasy and disgusted and want to stop (for Andrew it was the opposite—once he started, he would do it all). At parties that went all night and into the next day we would watch people pass through an entire MDMA journey, get tired, and go home when we were only just starting to pass into the golden hour. I say "we" because when Andrew and I partied we timed our acid trips together. Tripping on acid was part of our party identity, a formula we agreed on together and which became our routine.

That night at UNTER was like so many other nights: a line of cocaine when the acid became too rangy, which cut through the fog like ice and drew dissolute thoughts back into line; weed to turn the acid back up again; beers to take the edge off. The downside of acid was that when the party was at its peak, say from three to five in the morning, the dance floor was often too intense for an acid trip—dark and chaotic, the music like a jackhammer. If we were candyflipping we would time our MDMA to be able to keep going until ten or eleven in the morning, and after the queasy come-up my tiredness would go away and I would lose the last vestiges of self-consciousness. We would often not commit ourselves fully to the dance floor until the sun came up and the crowd thinned and then it would just be us and

our friends in a final stretch until the end. And only then would we start seriously with ketamine, which for unspoken reasons we saved until the end, when all the lingering layers of the real world had been scraped away. Ketamine was for me a cure, a restorative powder that dissolved any lingering anxiety from speed or coke, that returned the physical body to homeostasis. When taken with acid, the mild derangement of ketamine, which deconstructed the unity of my surroundings into fragments, was a kind of recession into the mind that allowed me to become fully lost in sound. It had a multicolored visual quality as well, and the gentle uplift gave us a final burst of energy as we submitted our bodies and disassociated our minds to computerized sounds played at excessive volume.

These nights with Andrew were a different kind of consummation. Sex could restore our connection when we became estranged from each other but these psychoactive and physical ordeals were a deeper proving ground. It seemed to me a proof that, as each chemical altered another layer of consciousness, when everything else had been taken away, my love for him was still there, and when daily life once again took over there would be this core inside me that knew that when everything had disintegrated there was just him, there would just be him.

UNTER was not a peace and love party; its whole thing was hard music and catty humor and being a little bit mean (I once saw a young person who showed up draped in a pride flag get turned away at a pride party). That winter night in January I remember a looped sound like a metal drill ripping through a ship's hull, or like a cyborg coughing up a hairball made of wires. The stranger dancing next to me turned and said, "What is that? It sounds like a pterodactyl!" To see the sun come up over the city while we danced on acid to heavy techno with the people we loved was an indescribable feeling. In the winter sunlight the smokestacks of the Con Ed steam plant across

the river puffed fluffy clouds, the windows of Stuy Town winked back at us in gold, the East River ran gray and cold; the people contained within the buildings invisible. Views of Manhattan did not come cheap. Getting to possess this view in a way that was fully our own seemed like a coup.

At UNTER, as at many parties, the thing I went for, the true and ephemeral weird, the deep psychedelia, the Dionysian moment, often did not reveal itself until the morning. I wondered how the people I would see there traversed the real world in disguise, because I only saw people who looked like them in certain parties at certain hours. They had PhDs in drugs. They knew how to show up in a way that turned the world slightly upside down. If UNTER was a fetish party (as the ones on Halloween usually were), Seva, the promoter, was known to emerge after sunrise in full drag. I remember a long-haired person who had a thick black band tattooed all the way around their torso who would always be there shirtless at the party's end. Another friend would appear at the end of parties holding a giant coffee cup that read "Just Wait Until This Kicks In." One might find oneself dancing next to someone fully nude, or someone in a baseball cap who looked like he'd just stepped out to walk the dog. The bodies were chubby and they were thin; bodies no longer really mattered. A little bit of sex might be happening in the corners or sometimes next to you. We passed around vape pens or poppers or keys or beers; we hugged each other and gossiped, but mainly we just danced.

Most of the windows on the main dance floor were blacked out. Directly behind the DJ, however, one was hung with a red piece of fabric to let in the daylight. This window would end up opened for ventilation even in winter. People who don't do psychedelics think that the mesmerizing thing should be fractals and dancing bears, but like I said, artifice doesn't always pass the acid test; acid wants authenticity. There was nothing more beautiful than the DJ standing backlit

in the window, and the red piece of fabric behind her that would sometimes flap in the breeze, revealing behind it the monoliths of Manhattan bathed in the light of the early-morning sun, as the long and difficult night receded and we danced in communion with our friends.

When the party finally ended and we walked outside into the freezing midday glare, the construction workers took out their phones and took pictures of the bedraggled and limping ravers beginning their long treks back to Bushwick and Ridgewood and Bed-Stuy. From the scaffolding the workers asked us what was going on in there. "Nothing!" someone shouted back.

Hanging off each other, our legs so tired we were practically unable to walk, avoiding patches of ice, Andrew and I made our way to the sunlit Greenpoint corner where the car he had ordered on his phone would pick us up for the bizarre liminal space that was a Lyft ride home from a party. The tinny pop music playing through the radio of a Toyota Camry sounded more alienating than ever, and the fifteen minutes of trying to act normal while getting driven home were sometimes the most anxiety-producing minutes of the whole thing. That year the song in the car in the mornings when we were going home was invariably Ed Sheeran's "Shape of You," until it became a joke that it was "our song."

After a full bodily immersion into techno for hours the sound of it continues to ambiently throb for a few more. I heard the beat in the sound of water coming out of a faucet, in construction noise, in the rush of the train past the window, in the compressor of the refrigerator. A DJ named Eris Drew has called this continuing resonance the "motherbeat." Recalling an epiphany she'd had listening to the air conditioner in her van on the way home from a party in Chicago in the 1990s, she has described it as "an example of the durational Deep Listening I did at the party focusing my mind enough to use the air conditioner to connect the Rave experience to 'all that there is.'"

I liked the day after a party as much as the party itself. Once we moved in together, we would stagger up the four flights of stairs to our apartment, open the door, and confront the angry cat, who would be upset about having been left alone all night. We would feed her and coo over her, take off our disgusting clothes in the living room, shower, and fall into bed. We would spend the day sleeping, fucking, watching television, drinking Gatorade, competing for the cat's attention, and placing large orders of Chinese food. All three of us—me, Andrew, and the cat—shared a love for a day of being extremely lazy in bed. It was one of the valued principles of our little family.

Partying like this did not constitute a politics of resistance, but it moved our entire frame of reference in its direction. I could hold those rooms in my mind and measure them against the counterfeit promises of meaning and belonging offered everywhere for sale; inside of them I saw a future of bodies and ways of being that made the petty bigotry outside look like the convulsions of a dying age. We all knew we were lucky to have caught the moment at all, and even years later those of us who were there don't even really need to talk about it that much. In any case, the only words I can think of that name what it was like to be there have been corrupted.

I I

EARLY IN 2017, I HAD GONE TO PEARL ART SUPPLIES AND BOUGHT paint pens and posterboard with the idea that, with Trump taking office, we would be out on the streets every week. That time was an interlude, when it seemed that earnest appeals to "democracy" and "women's rights" might prevail over bigotry and conspiracy theories. In retrospect, this incredulity in the face of a new political reality was a kind of hangover. The country was still rubbing its eyes, dumbfounded.

On Inauguration Day, Trump gave his "American carnage" speech, evoking a country in ruin: "Mothers and children trapped in poverty in our inner cities; rusted-out factories scattered like tombstones across the landscape of our nation; an education system flush with cash, but which leaves our young and beautiful students deprived of all knowledge; and the crime, and the gangs, and the drugs that have stolen too many lives and robbed our country of so much unrealized potential." The nation watched as the Obamas boarded a helicopter and flew away from the White House toward a future of NATO summits, paid appearances at Cantor Fitzgerald conferences, and kitesurfing with Richard Branson. That night, we met Andrew's mother in Washington for the Women's March planned for the following morning. She had made a poster in PowerPoint,

her preferred design software, that showed a looming Vladimir Putin pissing out of an outsize penis over an illustration of a small, whining Donald Trump. Andrew, who was good at puns, came up with the slogan "Fight the Shower," and as we marched people kept stopping her to pose for photos with the sign. For my sign he suggested "Uterus vs. Them." I had gone to protest George W. Bush's inauguration in 2001, the year the Supreme Court had decided the election in his favor. Like most protests of that era, it had been small and pointless. More than four hundred thousand people had shown up for the Women's March in Washington and several million had attended marches across the country. It eclipsed the inaugural audience by many thousands of people and was soon being called one of the largest single-day protests in U.S. history. Neglecting to remember that groups of earnest women were the butt of every joke, its participants knit pink hats in reference to Trump's vulgar comments about sexual harassment and made signs about birth control and the boardroom. They moved along like a giant river and then went home. Aside from Occupy Wall Street six years before, and the Black Lives Matter protests that had started in Ferguson in 2014, street demonstrations in our era had almost always been marked by obedience. While anti-fascist demonstrators had broken the windows of a Bank of America and a McDonald's the previous day, and two hundred people had been arrested, the attendees of the Women's March the following morning had discouraged property destruction.

The mood of purpose lingered for a few weeks, however. Someone who lived in a high-rise off the Williamsburg Bridge had put letters spelling out "RESIST" in their top-floor windows to motivate the commuters on the J train. In February, when Trump banned travelers from countries with Muslim majorities, we painted more signs and got on the J train to JFK. At Terminal 4 we got out of the AirTrain and immediately ran into friends, which worried me: Was it going

to be that small of a group? But the indignities and outrages started coming too rapidly. The protests made no difference at all, and within a few months they had diminished. A "March for Science" in April was poorly attended. I put the paint markers I had bought to make signs in a drawer and I didn't take them out again for a long time. The country assimilated to the new reality. As each scandal landed, the one before it was forgotten. If Trump did something unpopular, he would quickly drown out the memory of it with something even more unpopular. It became clear that each affront, no matter its limited sphere of outcomes, was a symptom of a larger shift. The shift was bigger than one awful person, or one political party, or even one country. Its symptoms started repeating themselves all around the world, each country with its own selfish, nationalist leader: Modi, Bolsonaro, Johnson, Putin, Netanyahu.

Like most people I knew, I wanted to participate in some form of opposition but found it hard to find. I think all the moral posturing online in those years had something to do with this sense of utter helplessness. In the absence of tangible change, we settled for soothing bromides about sustainability and ethical consumer packaging and advertising. It was another symptom of our troubled consciences. It did not feel good to live this way, and the routines of our ordinary politics would not address it. Many people I knew on the left foundered in relativism. The Democratic Party had sold out decades ago to billionaires, bankers, and warmongers. America and its myths of freedom were canards betrayed by the country's origins in slavery and genocide, and liberalism was just a comforting lie we told ourselves as we massacred abroad. In short, we had no leg to stand on. Reading books about the rise of fascism in Europe in the 1930s, which I started doing almost compulsively, was somewhat instructive, because it revealed that opposition to certain forms of evil was more important than ideological purity. But the failure of the left to

offer meaningful electoral alternatives lent a sputtering quality to our indignation, and a kind of pointlessness to it. Nothing stuck to Trump, who offered living proof of the power of amorality. I knew of this power already from reading biographies about the CEOs of the big technology companies, about how Steve Jobs would park in the handicap spot. There is very little that can be done when a society decides that the only rule of life is to get yours, and that empathy, concern, and worry are for losers and chumps. Trump proved the power of the lie, that lying prevails over honesty by making the honest person look cuckholded and weak. Pleas for goodness had no power against this consensus unless they came in the form of sufficient numbers of people refusing to go along, and in 2017, despite the women who brought the largest show of protest in Washington in decades, those in power sided with Trump, and the left later derided the Women's March as a useless show of white privilege anyway.

The energy died, and instead what settled in was the awareness that a lot of bad things were going to happen, and that very little would be done about it. People on Facebook began posting about canvassing in Pennsylvania in 2018, when the Democrats could at least hope to regain power in Congress. This seemed like a very long time away. A quorum of people had accepted the Trumpian philosophy, and it would take another four years before we knew if it actually represented the center. We stopped doing much of anything except reading the news.

Andrew and I had our own expression of nihilism, which was partying, and our own form of retreat, which was setting up our little life together. We moved into our new apartment seven months after our first date. Andrew pulled up to the curb in the movers' truck from his apartment, wedged between the two large men in the front seat, the cat in a carrier on his lap. We climbed the stairs together and let her out into her new home. The trains put her in a heightened state

of anxiety and she hid behind the toilet, where she stayed for the next two days.

I missed the sunsets over the housing complex from my old apartment but nothing else. Here the view from the front room was more circumscribed—a row of low buildings across Broadway, a multistory apartment, an empty lot—although the tinted windows of Woodhull Hospital, a dark modernist building on stilts that looked like it could house the headquarters of a totalitarian space council in a science fiction book, would sometimes gleam pink in the evening with the radiance of neon. At night I would sit on the couch and look down on the commuters in the white glow of the train as it pulled into Myrtle-Broadway. They never looked up at the windows of the buildings as they passed. They stared out into nothing, headphones on, or they looked at their phones. Sometimes when I was waiting for the train on the Manhattan-bound platform, I would walk to its western edge and send a text to Andrew, who would open the window in his studio and lean out on the fire escape. We would grin at each other and wave. Coming home from the city, I would make a point of looking up and seeing if I caught a glimpse of him or the cat, and would notice if he had forgotten to shut the window after smoking.

The roar of the JMZ haunted our dreams but I liked having such a close affiliation with it, since it was my favorite train in New York City: twenty minutes to Manhattan, all aboveground, part of which one spent crossing the Williamsburg Bridge, looking out at the vertical immensity of the city, the ferries propelling along on their busy missions in the water below, the sun always rising and setting and coloring the glassy buildings orange, lavender, and pink. I took pleasure in watching the tourists see the view for the first time, taking out their phones and murmuring to one another in French. As the train reached Manhattan it screeched and slowed alongside a forest of apartment blocks on the Lower East Side before descending

underground at Delancey Street. Each window of these buildings had people behind it, and each one of those people was a world, but all of this humanity, zoomed out, appeared simply as vertical rectangles layered upon one another and reflecting the sun. When crossing the bridge on the train I tried to imagine the hive within the buildings, the people lined up like dots in a row, looking down at the rectangle in which I sat, which was in motion. Had everyone suddenly disappeared, the thicket lined up along the river would gleam and shimmer in the same way, and the train that we rode in would appear the same from the outside as well.

Moving in together made life much easier. It no longer mattered if Andrew lost his phone and couldn't text, because now we lived in the same apartment. He found a free piano on Craigslist, just because we now had room for one, and we filled the front area by the windows with plants. When the cat emerged from behind the toilet she took to intensive monitoring of the pigeon activity on the parapets of the building across the street. I went to Chinatown and bought large paper lanterns from Pearl River and fixtures from a lighting shop on Canal Street and we stood on chairs and hung them from the ceiling. Andrew used a "creativity stipend" he got at his tech job to buy light bulbs that connected to our Wi-Fi and whose color and hue we could adjust with our phones. He bought a pair of used CDJs and set them up next to his turntables. On weekdays we would wake up each morning and eat breakfast together. The cat would walk back and forth between us rubbing up against our legs, then Andrew would bike to his office and I would write. On weekends our house was the gathering place for our friends to listen to music and have drinks before going out.

My income from book payments and the occasional review were sufficient to live off of, and I had invitations to conferences and festivals lined up until fall. It was a good year for Andrew too. He had

started a new job that he liked. He put out his first record with a house music label in London; he played a set for Boiler Room that offered more exposure to his music. He had a radio show with his friends every other week, and the party they threw at Bossa once a month.

Our life became one of contentment and easy routine. I had an ally alongside me to process the world, but living together also made our conflicts more clear. We had two. The first was the one that had led to our first argument, that Andrew liked to close down the party, and when I would wake up at three or four in the morning on a weeknight and he hadn't returned I would panic and get angry. The second conflict was about Andrew's daily habit of deep, stupor-inducing bong hits. This conflict was similar to the first in that it resulted in arguments that took place almost exclusively between the hours of three and six o'clock in the morning. For all my love of drugs, I was not a stoner. Cannabis made me tired and depressed, I rarely smoked it. I was also just not a daily drug user. I didn't even drink coffee every day, or use amphetamines to write. I could not treat writing as an emergency because a piece of writing could not be completed in one go but took daily practice over a series of days or months. If I was hungover, or if my brain was adjusting to the sudden withdrawal of chemicals, I would get depressed, have trouble concentrating, and not work; it was that simple.

Andrew was the opposite. He primed his mind to make music or write code by generating a chemical frenzy whereby he dissolved all external concerns in order to descend into a dark plain of nothingness and mono-focus. The ingredients of this state of mind, consumed by him on a daily basis, were cannabis, nicotine, and caffeine, with whatever alcohol happened to be in the house added to the mix late at night. (At his tech job, at least as far as I knew, he was sober all day.) But cannabis was the primary element: he associated creativity

with getting deeply stoned. The black hole into which he descended to make music could only be generated in solitude, at night, because it also demanded the disappearance of all people and their needs from his consideration. Andrew self-identified as an addict, but only in the sense that he saw this aspect of his personality as hardwired and unchangeable, not because he saw it as a problem he had any desire to address or fix. He tended to bring up addiction not as an affliction but as an excuse.

The confusing thing was that I liked that he was a stoner. I had an extant teenage fetish for skateboarders; I would be flooded with affection watching him sit in the windowsill, his deep inhales and slow exhales, the soft bubbling of the bong. Sometimes he would inhale, grab me close, kiss me, and shotgun the smoke while I inhaled. It was a party trick. But I hated that he stayed up all night. The two conflicts, the closing down the party when he went out and the generation of the black hole on nights when he stayed home, were in fact the same, and rooted in my hatred of being forgotten altogether, and of the way Andrew could simply turn me off in his mind when he needed to. I had no such ability. I was always aware of where he was in our apartment even when I was working on my own projects. My inability to turn off this awareness seemed biologically rooted and specifically female, which irritated me because I hated any symptom of biological determinism and got upset when I could not rid myself of traits coded as "female." I could picture the ultra-laid-back stoner chick, his ideal partner, who wouldn't care at all about the weed or the staying up all night. I tried to inhabit her state of mind.

When I traveled for work, which I did all the time, I would be liberated of this need, and would not care at all whether Andrew went to bed early or late, whether he was high or not high, whether he was out having fun or staying home, even whether he might be sleeping with someone else. He, on the other hand, would then feel abandoned—

this was his conflict with me, that I was constantly leaving—and he would get depressed and not be able to work at all, and the freedom to stay up all night created by my absence had no use for him. His tendency to stay up late would spiral into an uncontrolled state where he burrowed into the black hole of weed smoking without coming up for air at all. We were stuck in this tension.

One cold winter night when I woke up after three and he did not respond to my text messages I went so far as to get dressed, put on my coat, walk to Bossa, and confront him in tears on the dance floor, where he was too stoned and drunk to respond with anything more than sullen anger. On another day, after the sun came up and he had still not gotten home, I had called and begged him to come back. He promised to leave soon, but instead stayed with his friends listening to records and snorting drugs for another two hours. By the time he came home at nine in the morning I was irrational with fury. I wouldn't let him back in and made him go stay at a hotel. That I had once kicked him out of the house became something he would bring up when we fought from then on.

Andrew's view was that he simply loved me and also loved to stay up all night, which centered all of the dysfunction in my response. My friends offered the perspective that he could have, you know, cared, and come home when he said he would, but that would not have made me feel better. I wanted him to do as he wished. Many of his friends stayed out all night without their partners, who never seemed to get upset about it. But conflict seemed all right; I had grown up with conflict at home and so had he. He got wasted and I got upset sometimes—I didn't mind a little squalor in my life.

In any case, we had a purification ritual in the form of staying up all night, dancing, and losing ourselves in each other, which we did that year on an almost-monthly basis. The words hovering over the virtual reality horizon had said "THIS IS REAL" but the par-

ties we went to that year were the only thing for me that were real, and the only time in the years that I had spent in New York that I had moments, in the hours before another dawn, when I had absolute certainty that there was nowhere I would rather be in the city. I was, for once, in the middle of a spontaneous and special thing without needing to look a certain way or dress a certain way or be anything but what I was; the look and feel of the parties had not been engineered or contrived, but were the manifestation of a collective feeling.

If I didn't count my book about the Nigerian movie industry, which I finally finished and was published that fall, I wrote very little in 2017: a few book reviews; a Talk of the Town for *The New Yorker* about the effort to repeal New York's Cabaret Law, which banned dancing in unlicensed venues; my article about virtual reality pornography. I was living off the money from the sales of foreign rights of *Future Sex* and the delivery and acceptance fee of the Nollywood book. What punctuates that year instead are parties and trips to other countries where I flew for hours and contributed metric tons of carbon dioxide to the warming atmosphere to sit on panels for thirty minutes and talk about theories of sexuality I wasn't sure I cared about anymore.

I could have learned the names of birds and trees that year I was not writing, or taught myself how to code, or figured out a new subject for another book, or trained for a marathon. Or the more obvious things: marriage, figuring out how to earn more money, preparing to have children. Instead, I learned the geography of nightlife. I hadn't been paying attention during the beginning of this iteration of electronic music in New York, a scene that had started to grow eight or nine years before from the seeds of older parties like the Bunker, which had started in 2003. I had missed out on Steel Drums and Club Shade and the Spectrum and however many other parties

132 · EMILY WITT

referred to with nostalgia by the people who had been around for longer. I only heard secondhand about characters like Georgio Carpet, the infamous party regular who would show up, roll himself in a carpet at the foot of a bar, and ask people to stand on him as they ordered drinks.

The New York labels that started in the early 2010s had put out music by artists who were grungy and masculine; the productions were lo-fi, and some of the artists had crossed over to electronic music from the punk and noise scene. When Discwoman started in 2014 as an all-women-and-nonbinary collective, it was as a little bit of a backlash. Over the course of the 2010s, the scene had moved from punk clubs and indie rock venues to more genre-specific spaces; the promoters had learned more about setting up good sound systems, and certain visiting artists started attracting more than a mostly male audience of internet-bound music nerds.

There was a difference between Europe, where there had been continuity in the scene and where a club like Tresor in Berlin had carried on for decades, and New York and other American cities, where it had all but vanished for a while, which meant that as a small scene starting to resurrect itself from the ashes there was perhaps more of an emphasis on knowing the history and honoring underground artists whose music might otherwise have been forgotten, to try to connect the present with a past that had been lost. DJs and promoters had gone back and forth from Berlin and learned its particular party style; they had gone to Movement in Detroit and studied the genre's history; they had gone to the Loft and studied the legacy of Paradise Garage and New York's disco past. They tried to look for imbalances of power and instances of cultural appropriation to the benefit of trying to build a scene that broke with the inequities of the past and centered the music's Black American history, turning

away from Europe at the same time as they mimicked it. The year I devoted myself to partying was therefore a time when all of this was reaching a saturation point, as a bunch of parties that had started in the early 2010s were getting better and more popular. New York was making itself known as a place to go out again, and New York artists of the new generation, like Aurora and Volvox, were starting to get big bookings in Europe.

That still-nascent stage of our era of New York dance music made a lot of us feel as if we had double lives. Most of us were well-behaved people. We had professional jobs in the city and then we would come home to Bushwick and do drugs and have experiences that people in our larger demographic had no idea were happening, at least not to the depth to which we took them, even people who were supposedly near to us in politics and aesthetics. In that year, it was like we were a part of a big, safe bubble. Some of us were in our thirties and having friendships in a way we were told that you were not supposed to have as an adult. Subcultures were for the very young, and scenes and drugs and staying out all night were something you grew out of. And yet there we all were. Most of us, once we were inside the scene, felt as if it became our real life. But there was also a satisfaction in being good at our day jobs at the same time, or going regularly to the gym, or whatever other signal of reliability we could convey. We were playing both sides. The understanding of the world we shared didn't easily translate, and you couldn't explain it to people who weren't also looking for it. The single people in the scene struggled to date anyone outside of it; people would try, but it invariably wouldn't work because it was at the parties where they felt most themselves, and it was too hard to explain to someone who did not already understand.

We shared an ironic sense of humor and a dissatisfaction with a

New York of expensive restaurants and Ticketmaster venues. There was always a dissonance, exiting from a dark psychedelic portal on a weekend morning and walking out onto a street where everyone was window-shopping. But it wasn't only hedonism; we were all there for the music, too, and it wouldn't have worked to put the same people in the same rooms except with awful music. The music was the foundation on which the whole thing was built, and if the music didn't meet the drugs, none of it would have held up. These were mind states that desired complexity—the drugs did not make us stupid, they made us more demanding—and many of us were there because we had found we couldn't eat what everyone kept trying to feed us. The parties made us feel as if we were participating in an art form rooted in self-expression and freedom, one that was a little bit secret but in no way walled off. It defined itself by a shared commitment to fun and artistry. The fashion was meant to cause estrangement rather than to make us look rich or hot. I would not have been at ease in a scene that demanded expensive clothes or connections. The best raves knew how to hide themselves. The parties were protected by something other than exclusion, by an agreement not to blow everything out on the internet, or to experience the thing through your phone camera. I couldn't write about them, which meant that for me they were also a refuge from work. Cameras were often forbidden, but even where they weren't, it helped that videos of the best parties looked terrible, and all you saw were some sweaty people in fog and a fragment of tinny and repetitive music. The experience could not be mediated on the screen any more than it could be in words. It was also in the spirit of protection, and to create the illusion of a separate reality, that the parties happened in the deep dead of the night, when the rest of the world was suspended.

In that year every weekend one could choose between "location

TBA" parties according to one's taste in music, sexuality, devotion to fashion, and age. There was Sublimate, a house-music-centric party usually thrown in a small warehouse in Bed-Stuy, where everyone spent as much time hanging out on the roof as dancing. There was Groovy Groovy, thrown by a crew of young people who were into hard techno; GHE20G0TH1K, the by then long-running party started by Venus X that attracted a fashion crowd; Mutual Dreaming, the party Aurora threw when she wasn't focused on Sustain; the Bunker, which connected the younger scene to a coterie of Gen X promoters who had kept dancing during the more subdued years for raving in the 2000s; Ova the Rainbow, the queer glitter-fest; Carry Nation and Wrecked for the gays. For people who liked darkness and leather there were Bound and Aphotic. There was Bushwick A/V, the sketchy after-hours party/drug market that would collect whoever was still awake at ten in the morning. These roaming parties typically happened once a month or every season or so in the same handful of venues: Market Hotel (the venue down the street from our apartment above Mr. Kiwi); the Gateway, a multilevel space a few blocks farther down Broadway with the most disgusting bathrooms; the Dreamhouse, a converted banquet hall with mirrored walls and chandeliers on Wyckoff Avenue in Ridgewood; the Sugar Hill Restaurant & Supper Club, the forty-year-old Black-owned discotheque in Bed-Stuy; Brooklyn Bazaar in Greenpoint, which had a mini golf course in the basement; the back room of a fried chicken place on Broadway across the street from our apartment; warehouses on Ten Eyck Street and Johnson Avenue and Scott Avenue where Bushwick bordered Maspeth. And then there was Bossa, where since it had opened in 2012 pretty much all the DJs from every sort of party would occasionally play, along with newcomers trying to break into the scene, and which, with its smaller dance floor and

seven-days-a-week schedule, gave a lot of people chances to build a reputation.

The Ghost Ship fire had threatened the existence of some of these venues, which were regularly raided by police and charged exorbitant fines that could shut down a place. And the truth was that even those of us without a strong instinct for self-preservation had been scared by what happened at Ghost Ship. The fire came to my mind when I entered the confinement of the basement in the Gateway or the second-floor loft space of the Dreamhouse, which seemed always to have a tangle of wires hanging from the ceiling, and where a promoter had gotten electrocuted. The aboveboard venues had licenses and financiers, but health and safety tended to come at the expense of the good kind of social mixing. Output, the large club in Williamsburg with a Funktion-One sound system, booked many great artists but was unfortunately more of a glorified drinking environment where the cover charges were high, a bottle of Corona cost nine dollars, a bouncer made sure nobody went into the bathroom with their friends, and merely sucking on a weed pen on the dance floor could get you kicked out. Their "no photos" policy, which gestured toward Berghain, seemed aspirational, since it was more likely to be a place where someone from New Jersey kept hitting on your friends than one where anything libertine took place.

That year, following the release of his record, Andrew played Good Room in Greenpoint and the Panther Room at Output; he played Halcyon Records, Jupiter Disco, and Bossa. In 2017, after a campaign encouraged in part by Frankie Decaiza Hutchinson, the founder of Discwoman, and John Barclay, the owner of Bossa, the Cabaret Law was successfully repealed. For the article I wrote about this, I had gone to a hearing in the chamber of the City Council, where club kids who had partied in the 1990s recalled an extinct culture: the

Palladium was now an NYU dorm, the Limelight a gym, Electric Circus a Chipotle, Paradise Garage a depot for Verizon trucks.

After the Cabaret Law's repeal more venues opened, and many parties that might have taken place in a warehouse pre–Ghost Ship started migrating to these new, fully permitted places. Mood Ring, the astrology-themed cocktail bar with a small dance floor that opened across the street from Bossa, became an NYU hangout that I avoided because I was too old. Elsewhere, the giant venue in the industrially zoned part of Bushwick, I thought of as more of a pedestrian normie club. The drinks were too expensive and there was nowhere to sit and take a break in the main room, but it was fun when Andrew played there, and we could hang with our friends in the greenroom. We liked going to parties at H0L0, a small black-walled space in a basement in Ridgewood, but the best of the new venues that opened that year was Nowadays, which crowd-funded the money for its hundred-thousand-dollar sound system and installed it in a warehouse on the fringe of Ridgewood known for the radioactive soil of a nearby Superfund site. Nowadays, with its large speakers, its dance floor decorated with plants, its libertine bathroom policies, its nice drinks and reasonable cover charges, and its commitment to local artists, finally got the formula right. My only complaint was that the biodegradable plastic cups they had out for water tasted like heavy industry when I was on acid—on the other hand, they didn't charge for water. Nowadays understood that it was important to give the heads time to get comfortable, and would have twenty-four-hour parties that gave them a chance to cycle into their flow state after the normal weekend people went home drunk at two. As much as I loved the freedom of a ware-house party it was also nice to sometimes go somewhere reliably climate-controlled and with flush toilets. The licensed venues were

good for the artists and lighting designers and bartenders, who benefited from having more places to work. The good venues generally found ways to accommodate the difference between people who went out on Saturday because it was Saturday and the people who wanted to avoid them. We mostly went to Bossa on weeknights; we went to Nowadays on Sunday mornings; if we went out on Friday or Saturday nights it was usually still at a warehouse.

FOR THE CROWD I HUNG OUT WITH, THE YEAR WAS ANCHORED BY TWO big events that broke down the more party-specific boundaries and brought everyone in the scene to the same place: Sustain-Release in the fall and Fourth World in the summer (or perhaps I should say three—there was also the queer festival Honcho Campout, which, since I wasn't queer, seemed more respectful not to attend unless invited, but it also brought a large part of the scene together in one place). Fourth World was an eighteen-hour party held every year on the weekend closest to the Fourth of July that booked only local artists. Some of the DJs were on the international touring circuit but many were not. It was a neighborhood affair. The party would begin Saturday afternoon and go until the morning of Sunday. The promoters served free hot dogs and wrote their online flyers in ornate, nineteenth-century English interspersed with ASCII art.

In 2017, the first time I went, Fourth World was held in an enormous warehouse on Johnson Avenue in Bushwick. "A MESSAGE TO ALL PAST PATRONS & THE GRANDER CONSTITUENCY," the announcement for the party began. "THE 4TH ANNUAL CONGREGATION OF THIS ILLUSTRIOUS OCCASION WILL HERETOFORE COMMENCE, WHILE NOW PROUDLY FEATURING WHAT ALL NEW YORKERS CRAVE SO DEARLY. . . . SPACE."

YES, SPACE. AND BOY DO WE MEAN IT.

| | | |||| | | | ENVISION IF YOU WILL | | | | ||||| | | |

▉ ▪ ▌ ▪ 22,000 METRIC TONS ▪ ▪ ▪ ▌

»»⟶⟶⟶⟶⟶➤ OF CONCRETE & STEEL

//////\\\////////// TOWERING ABOVE AND BELOW \\\\

EXPERIENCE THE WORLD ANEW ╱人 ◕ ‿ ◕ 人╲

AMIDST A RUSH OF SIGHTS, SOUNDS

& THE EVER ENDURING TOTALITY OF

|||||| |||||| INDUSTRIAL ZONING |||||| |||||| ||||||

├──┬──┤ ·ω·)/ ├──┬──┬──┬──┤

>>>>>> > > >> YOU WANT INDOORS?

>>>>> > >>WE GOT INDOORS. >>>>>>>>

YOU WANT OUTDOORS? >>>>>>>>>

>> > > > > GUESS WHAT ...

GOT PLENTY OF THAT TOO ;) ;) ;)

☁▪▓◌☼‿☼◌▪☁▪▓◌☼‿☼◌▪☁▪

WHY, IF IT GRABS YA, YOU COULD:

- PARK A BOAT

- BUILD A BLIMP

- START SOME SLAPDASH SEGWAY TOUR EVEN

¯_(ツ)_/¯ ¯_(ツ)_/¯ ¯_(ツ)_/¯ ¯_(ツ)_/¯ ¯_(ツ)_/¯

AIN'T NO MATTER TO US!!

JUST BE MINDFUL AS U DO IT!

〰〰〰〰〰〰〰〰〰〰〰〰〰〰〰〰〰

★★★ RESPECT FOR OTHERS ABOVE ALL ★★★

〰〰〰〰〰〰〰〰〰〰〰〰〰〰〰〰〰

ALL STRIPES ALL CREEDS + THE BIRDS & THE BEES

IF YOU DON'T MIND ANOTHER'S PERSUASION

THIS HERE'S CERTAINLY YOUR OCCASION!!

BUT YES INDEEDY, U HEARD RIGHT,

THESE BOYS R OFFICIALLY ✓✓✓ BONAFIDE ✓✓✓

SO GATHER ROUND THE FOILAGE PEOPLE
♪ ♫ ♬ AND FEEL FREE TO TAP A TOE OR TWO ♪ ♫ ♬♪
//////// // // /// TO WHAT MAY VERY WELL BE THE MOST
🏋️ HEAVILY ESTEEMED 🏋️
ASSEMBLAGE OF OPEN MINDED INDIVIDUALS
THIS FAIR CITY HAS EVER SEEN !!!!!!!!!!!!!!!!!!!!!!!!
ʕ•ᴥ•ʔ*ʕ•ᴥ•ʔ-ʕ•ᴥ•ʔ**ʔ-ʔʕ•ᴥ•ʔ*ʕ•ᴥ•ʔ-ʕ•ᴥ•ʔ**ʔ-ʔʕ•ᴥ•ʔ**
ʕ•ᴥ•ʔ-ʕ•ᴥ•ʔ**ʔ-ʔʕ•ᴥ•ʔ*ʕ•ᴥ•ʔ-ʕ•ᴥ•ʔ**ʔ-ʔʕ•ᴥ•ʔ*ʕ•ᴥ•ʔ-
ʕ•ᴥ•ʔ**ʔ-ʔʕ•ᴥ•ʔ*ʕ•ᴥ•ʔ-ʕ•ᴥ•ʔ**ʔ-ʔʕ•ᴥ•ʔ*ʕ•ᴥ•ʔ-ʕ•ᴥ•ʔ**ʔ-ʔ
-ʔʕ•ᴥ•ʔ*ʕ•ᴥ•ʔ-ʕ•ᴥ•ʔ**ʔ-ʔʕ•ᴥ•ʔ*ʕ•ᴥ•ʔ-ʕ•ᴥ•ʔ**ʔ-ʔ
♪ ┏(°.°)┛ ┏(°.°)┛ ┏(°.°)┛ ┏(°.°)┛ ┏(°.°)┛ ♪ ♪
BE PREPARED TO FEEEAAASSST UR HUNGRY LYPZ
★★★★★★ ON DOG AFTER DOG ★★★★★★★★
AS WE COLLECTIVELY BARE WITNESS TO THE TRUE

```
          ) ☆ ☆ ☆.
    `٧´☆.₊°○*”˘˘˘*○•☆
    ..☆.₊°○*”˘˘˘*○•.☆
  ☺/ໆ°•°*ໆໆ°°☆˚.★*°₊ໆ°°*°ໆ°•★*°.ໆ°
1*°    G R A N D E U R    °☆*★
/\°.★*˚ໆໆ*☆˚°ໆ°*˚ໆໆ°☆*°★ໆ°₊☆•*°ໆໆ''

  ★★★★★ OF THE HUMAN SPIRIT ★★★★★★★
  AS IT FREES ITSELF - EVER SO GRACEFULLY - FROM
  👏 THE DOCTRINES 👏 TO 👏 WHICH 👏
  👏 IT 👏 HAS 👏 BEEN 👏BOUND 👏 🎆
```

The warehouse was so huge that the dance floor had to be limited by blocking off a small corner with walls of speakers and amps and filling the cordoned-off spaces with fog. As at many parties, including Sustain-Release, the lighting was designed by a collective called Nitemind that earned money from doing light installations for corporations like Google or Infiniti but used the rave scene as their playground, experimenting with minimalist purple and blue lasers that carved pyramids and tunnels out of walls of fog. The portapotties were lined up on the other side of the warehouse, as far away as possible from where people gathered. Outside was a small, fenced-in yard where a pop-up tent sheltered the DJ booth in case it rained, which it did, which meant that as the rain stopped and I was coming up on acid, the sky was wreathed in rainbows. We had arrived in late afternoon and stayed, as had become our habit, until nine in the morning the next day. As a DJ named Turtle Bugg played joy-

ous gospel and house music to celebrate the morning, the lingering dancers in their sunglasses and dirty clothes mustered the remaining dregs of their energy to sway from side to side, reborn with the new day. The tiny plastic bags had been ripped open to get the last bits of powder, the ground scores had all been discovered. The small group that made it to the very end were given posters as a prize.

That summer, Trump announced the country's withdrawal from the Paris Climate Agreement. The president's tweets were declared official presidential statements. The CEO of a private student-loan company was appointed to lead the Federal Student Aid program. A climate change denialist was appointed to lead the Environmental Protection Agency. A former oil executive was named secretary of state. Regulations meant to protect clean drinking water and air were rolled back. Trump banned transgender people from serving in the military and appointed an anti-trans activist as an advisor at the federal Office of Gender Equality and Women's Empowerment. Trump reportedly said in a meeting that Haitians "all have AIDS" and that once Nigerians saw America they would never "go back to their huts." He threatened war against North Korea. There was a rally of white supremacists in Charlottesville, Virginia, protesting the decision to remove a statue of Robert E. Lee; after one of the neo-Nazis drove his car into a crowd of counterprotesters, killing one of them, Trump remarked that there had been "very fine people on both sides." When a reporter asked the president if he planned to go to Charlottesville, Trump reminded the press corps that he owned a house there, a winery.

I went to a literary festival in Australia and sent Andrew postcards of the koala bears I saw on a bus tour of the Great Ocean Road. I sent him selfies from the Leaning Tower of Pisa and the Venice Biennale. I made appearances on BBC Radio 4 and *The Brian Lehrer Show*. Andrew and I got to know each other's families: we visited his mom

in California and my parents in New Hampshire. We went camping in Joshua Tree and took selfies in front of piles of rocks. His family had more money than mine—he had gone to private school, and on family ski trips, and had a trust fund—but I liked to picture our parallel childhoods, him growing up in a beautifully restored Craftsman house amid the roses and golden light of California, me in our crappy vinyl-sided Tudor with shag carpeting in subzero Minneapolis; me older, him younger, both of us listening to the same underground hip-hop, not knowing we would one day meet each other. He came with me to literary festivals in Norway and Amsterdam. We went to Berlin and spent our first night in Berghain together, consummating it with a sex act in a dark booth in Panorama Bar. I alternated between jet lag and hangovers and colds picked up on airplanes or at parties. When I traveled without him I would send text messages from the taxi or the J train as I came home from LaGuardia or JFK, and he would be there opening the door next to the cat meowing her greeting. In late summer, Andrew and I visited the Pacific Northwest, where we went for hikes and saw a giant owl in the forest and an osprey bathing in a creek. The air was opaque with the smoke of wildfires burning all over the West. In mid-September we went back to Sustain-Release.

This time, I knew what I was doing. I understood the music: Turtle Bugg and Jayda G opening with easygoing house and disco sets, giving everyone time to greet their friends and settle in before getting ready to concentrate; Avalon Emerson's set like a land-speed race in the Bonneville Salt Flats, with revving engines, desert UFO landings, beats, and fog that ended magically with arpeggios of strings, the lights golden and red, McDonald's colors. At the end of the first night, Kiddo and Nick, performing outside as Pure Immanence, sat on pillows, smoked joints, and delivered a sunrise ambient set in which it was impossible to discern the recorded sounds from the

natural ones. Nick later told me he had "downloaded every cricket sound on the internet" with the intention of "making all the birds and slugs wet" and had limited his drug intake to "speed, weed, and chlorophyll." ("I boofed a piece of celery," he joked.)

The next day Andrew played in the basketball tournament, which was organized in teams of three, in seven-minute games, and each team had to have at least one player who identified as female or non-binary. Andrew's team was called "Just Win BBs." He had done a line of coke and now scored basket after basket. I watched with joy as "Just Win BBs" beat a team called "Constant Anxiety" to win the tournament.

At the pool party we lounged in the golden afternoon sun, the lawn around the pool scattered with picnic blankets and people stretching and napping. Ravers swayed in mankinis and kimonos, mosquito-net hats and fishnet shirts, to songs about praise and joy and love played by Josey Rebelle, drinking Aperol spritzes. The bubble machine chugged away next to the fog machine, making fog bubbles. On LSD it all seemed so vivid: the green grass, the dancers, the still pond. We followed a path past an area where everyone seemed to be playing different lawn games: badminton, tennis, croquet. Green lawns, ravers playing in the fading golden light, across the bouncy bridge over the pond and into the forest grove. The ground was soft with pine needles; the trees thick with moss; the late-afternoon sun filtered down through dust motes and ferns. As I walked the dead leaves and needles unfurled before me. We reached the end of a trail we had followed to what turned out to be the waterfall of a small dam, and there, across its crystalline cascades, a couple was sharing a bottle of prosecco, looking like an advertisement for menthol cigarettes. We came out of the woods into the tent village, the tents like an upwelling of rainbow mushrooms, as anthropomorphic as Japanese mascots, each mushroom with a raver or two napping inside, pixelated mosses

and spores still floating behind their closed eyes. We stopped at the café and I ordered an iced drink made of lemonade, espresso, and activated charcoal. It was as black as asphalt and had a Lipton-yellow circle of lemon floating in it like a safety raft on an oil slick.

It began to get dark, and as we wandered down the path of wet leaves, solar lights lit our way. The forest was loud. Crickets, frogs, every insect and living thing droned into a chorus. It was dark. I went and lay in a damp hammock. The stars were coming out; the frogs were croaking. I tried to write it down, the chlorophyllic ecological totality of it. The word "totality" was still in my mind from the solar eclipse a few weeks before, not that I saw it, but from reading the accounts—a long shadow racing over the landscape; the wind picking up; the confused birds bursting into song; the three-hundred-and-sixty-degree darkness. I went to the beach in the Rockaways that day. Some people had set up a kind of science fair around a towel strewn with colanders that filtered shadows of tiny eclipsed suns through their holes. A photo circulated of Trump looking directly into the sun. As the sun dimmed, a school of dolphins had leapt offshore, and when I went into the water a flock of plovers skimmed the surface around me.

Now, as I sat in the amphitheater of the summer camp thinking of all this, the frogs and the crickets began to sound angry. I understood that; I was upset too. Here we all were, descended from the same basic life-forms, such that it was hard to poison another species without poisoning ourselves—even plants had this problem—yet we kept trying to murder not only ourselves but every living thing on the planet.

The music began and I settled in for it. I danced to Helena Hauff, a vinyl-only German DJ whose techno pounded and scintillated like a migraine with aura. I danced to Wata Igarashi, a Japanese DJ who could induce a microtonal trance state. The layers of consciousness were coming off; I was entering the nothing that I craved. The closing

DJ that year was PLO Man, a Canadian expatriated to Berlin who played an endless supply of vinyl, wearing a hockey jersey. He was supposed to wrap up at six in the morning but instead kept going: seven o'clock, eight o'clock. We did a little ketamine. We went back to the dance floor. We did more ketamine off a key and I took too much. My vision receded. I was alone on a glittering plain. I had no body. I asked Andrew where I was, unsure. He led me off the dance floor. He lowered me down to sit on a step. The sun was out now. It was nine or ten in the morning on a Sunday in mid-September. I was lost in a corridor with no walls. I tried to remember what drug I had taken. Was I on ayahuasca? But ayahuasca was not a drug you took at a rave. . . . A memory of England surfaced with the sound of a rushing kettle about to boil. Orange train tickets, pale winter sun on a shorn green lawn, the faded carpet of my room with its white John Lewis coverlet and the view out onto the garden, the electric whir of the train as it accelerated, the black birds picking at the fen—I gasped and shoved it away. I couldn't remember where I was or what I was supposed to be doing. I was walking down the wrong hallway. Andrew was with me, reassuring me, the only tangible matter in the world. Without him there was no world, no self, nothing but this empty coordinate plane. I kept asking him what was happening to me. "You're in a k-hole," he responded, calm, holding me close. Was I supposed to throw up? I pushed him away and vomited. Tears rolled down my cheeks. It took a long time to come back, but the loss of self wasn't accompanied by a loss of memory. When I returned I could remember every detail of the place I had been. Nobody judged me. K-holing was a known hazard; it wasn't dangerous, just unpleasant, and my friends watched with pity, most of them having been through it themselves. As Olga said laconically, "Everybody slips on the banana peel sometimes." I made it back to the dance floor as PLO Man played his final track. My mind wasn't

sound but it remembers the shimmering distortion of "Life's a Gas," by Love Inc. When I got back to Brooklyn that day, I decided it was time to take a break from drugs.

IT DID NOT SEEM OVERDRAMATIC TO CONTINUE TO READ BOOKS ABOUT Europe in the 1930s: Christopher Isherwood's *Goodbye to Berlin*, Rebecca West's *Black Lamb and Grey Falcon*, Gregor von Rezzori's *Memoirs of an Anti-Semite*, Friedrich Reck-Malleczewen's *Diary of a Man in Despair*, the essays of Natalia Ginzburg. The parallels between then and now were nationalist hysteria and a political class that used populism on behalf of wealthy industrialists. Before Hitler was responsible for the murder of six million Jews, these writers had hated him for the same reasons we hated Trump: because he was so tacky and vulgar and used populism and anti-Semitism as a pretext to consolidate personal wealth and enrich his cronies. Hitler had become a symbol of the depths of human evil but at the beginning had been easy to take for a joke, a clown. Other people studied other dictators, especially Putin, looking for clues, but having recognized all the signs of a totalitarian threat in our own politics, there did not seem to be a lot you could do with them besides make yourself upset.

Later that fall I broke my sobriety for an ayahuasca ceremony, a way to remind myself again of my old life. I went alone. It was my first time doing ayahuasca since I had met Andrew. As I thought of him, my mind flooded with smiley-face emojis and hearts, but another image then appeared, of a darkened mine shaft covered with black-and-yellow-striped barriers, "Do Not Enter" signs, and floating skulls and crossbones. Danger, the plant was saying to me in flashing red lights, but hallucinogenic plants say a lot of things, and this was a warning I ignored.

We celebrated the end of that year with a New Year's Eve party at

our house. We adjusted the lights to a red tint and I went to Party City and decorated the columns of our loft with Mylar gold streamers. The refrigerator was stocked with eight-dollar bottles of sparkling wine, and three pizzas were in an oven set on low. Our apartment filled with people, their coats piled in our bedroom. The cat hid under our bed and whenever I went in and peeked she was there, glaring, her eyes beaming pure hatred. At midnight we listened to "Born Slippy." We danced. We went to bed around five. A friend passed out in the spare room. In the morning the three of us woke up. Our friend ran to the bathroom to throw up, then slowly returned to life. We fortified ourselves with some leftover Filipino barbecue someone had brought over the night before. We listened to "Halcyon and On and On," by Orbital, from the *Hackers* soundtrack, then we dropped acid and took a car to UNTER, which was holding an all-day party at Nowadays. Ed Sheeran's "Shape of You" played yet again in the air-freshener-scented interior of the black Toyota Camry, and the acid began to flicker inside me. We tumbled out into the cold winter morning, received at the door our lecture on consent on the dance floor, then lost ourselves in the warm chaos of the club. The windows were blacked out; there was no difference between night and day. We stayed until the very end. Despite all the evidence, 2018 started with an upturn.

Part II

12

I WAS IN A HAMPTON INN & SUITES OFF THE SAWGRASS EXPRESSWAY in Tamarac, Florida. I was looking at a remote control that advertised antimicrobial properties. It was mid-February in 2018. An air-conditioning unit under the window turned on and off according to an automatic sensor. It would be nice, in South Florida in February, to take in the air, but the tinted window was as sealed off to the soft, subtropical night as an aquarium. The climate-controlled box by the highway was standardized and would have been the same whether the hotel was in Coral Springs, Florida, or Billings, Montana. The profit motive was evident in every design choice, and in the disposable dishes on which our breakfasts were served every morning, and in the way the Chase Sapphire Reserve Ultimate Rewards Program integrated with the Hilton Honors Guest Loyalty Program. I had closed the polyester blackout curtains on the view of the parking lot and the swimming pool a couple of floors below. I was here because, on Valentine's Day, a former student from the high school a few towns over had shot and killed seventeen people, most of them teenagers, with a Smith & Wesson M&P 15 rifle. I had interviewed for a job at *The New Yorker*. Now they had sent me here to cover the story. I didn't know what to say.

I wondered whose particular sense of danger was appeased by the antimicrobial remote control. I couldn't shed the suspicion that the chain hotel built at the urban development boundary where the lawn fertilizers of Broward County drained into the Everglades was a symptom of the same problem as the shooting in the high school. I didn't know how to describe the problem. The problem was too large. I knew that whatever I was going to write wouldn't address it.

Last Thursday evening, I arrived at Pine Trails Park, in Parkland, Florida, just as the candlelight vigil to honor the dead was ending. The cars were still arriving, in long lines that gleamed under halogen streetlights, waved through intersections by officers of the Broward County Sheriff's Department. Flashlights and phone lights bobbed along the sidewalks that bordered the road as families passed on foot or on bikes. It was just past eight o'clock, darkness had fallen over the palm glades and cul de sacs and strip malls of this city at the edge of the Everglades, and, if you hadn't known the circumstances, you might have expected a Fourth of July celebration.

Instead, the people here had gathered for a different kind of national ritual. After the fatal shootings at Marjory Stoneman Douglas High School, on Valentine's Day, the aftermath had at first a familiar pattern: the initial news alerts; then the psychological profiles of the killer; the repetition of "thoughts and prayers"; the news scrum; this vigil. The funerals would begin the next day, but the long-term prospect was of another lull in the debate until the next act of spectacular violence—a routine so predictable that a couple of days later I saw that someone in Fort Lauderdale had drawn it in imitation of the Krebs Cycle and printed it

on a T-shirt. The first hint that something might be different this time came the morning after the shootings, from a Douglas High School sophomore named Sarah Chadwick, who informed the President of the United States, via Twitter, in words that quickly went viral, "I don't want your condolences you fucking piece of shit, my friends and teachers were shot." In the hours that followed, others joined Chadwick in rejecting the platitudes. On social media, and on live television, the victims were not playing their parts. They were not asking for privacy in their time of grief. They did not think it was "too soon" to bring up the issue of gun control—in fact, several students would start shouting "gun control" within the very sanctum of the candlelight vigil. What was already becoming clear that night, less than thirty-six hours after the shootings, was that the students were going to shame us, all of us, with so much articulacy and moral righteousness that you willed the news anchors to hang their heads in national solidarity. It was a bad week for a lot of reasons, but at least we had evidence of one incorruptible value: the American teenager's disdain for hypocrisy.

Thus went the first article I filed about the event. The ring of false optimism, the horror-normalizing machine. The press descended on Parkland first for the tragedy, then for the uplift. It was only a few days after the event that the initial outburst of anger had taken all the attributes of an episode of *Oprah:* evocative montages of trauma, celebrity endorsements, corporate sponsorship, and "gratitude." Las Vegas, where a shooter firing from the thirty-second floor of the Mandalay Bay Hotel had killed fifty-eight people and wounded more than four hundred more at the Route 91 Harvest country music

festival just a few months before, had offered no such catharsis. That massacre, the deadliest mass shooting carried out by one person in American history, had simply happened, like a weather event, and there had been no meaningful political response to be identified in its aftermath. The glare of the desert sun continued to shine off the flanks of the Luxor Hotel's glass pyramid, the dancing fountains leapt and sparkled, and the casinos saw no downturn in visitors. Which is only to say that the press could not have been more delighted by the determined anger of the Parkland students. Dozens of adult reporters vied to befriend the teenagers, under pressure to get "scenes" of their bedrooms and conversations, to generate character-driven nonfiction narratives that stirred the soul and might muster the collective will to pass federal gun control legislation for the first time since 1994 (although Democratic politicians urged us to use the euphemism "gun safety" rather than "gun control," which they thought would lose them votes).

Parkland was a city of gated communities, the kind of suburb people moved to for its good schools. At night, waterfalls tumbled over floodlit coral rocks at the entrances of Banyan Trails or Heron Bay or Chateaux at Miralago. A gleaming Tesla or BMW or Porsche would roll through sliding gates. Streetlights reflected off their burnished exteriors; tires purred over smooth asphalt. Lawns of St. Augustine grass, darting lizards, palm trees rattling in the wind, screened pool enclosures, marble floors, chandeliers, dinette sets from Costco. This part of South Florida was a real estate brochure laid out on a flat surface, the swamp water channeled into canals, banks of clouds towering overhead, the days numbered until the big one brews in the Atlantic and rips it all apart. The developments that gave the city its uniform visual character had been built between the late 1990s and the early 2000s, which meant that many of the students were probably as old as the houses they had grown up in, houses built from a

stock set of templates at the bleeding edge of ecological destruction. They rose up with a uniform color palette of beige and terra-cotta, with garage doors that softly opened and closed, cupboards of paper towels purchased in bulk, ice machines that rumbled and purred.

In the aftermath of the shooting the suburb was transformed into a stage set. The television correspondents doing stand-ups next to the angel-shaped memorials in Pine Trails Park were as lurid in their makeup and bold-colored sheath dresses as exotic birds; the students kept having to ask the news organizations to stop flying helicopters overhead, since it reactivated memories of the response to the shooting. In a matter of days, the student leaders who started what became the March for Our Lives movement were household names: David Hogg, Cameron Kasky, Jaclyn Corin, each of them preternaturally telegenic, having skipped over the awkward phase of adolescence. The students, who quickly understood the power they held over the reporters vying for access, urged us not to give the shooter notoriety by naming him. (His name was Nikolas Cruz; he was nineteen; he'd had serious behavioral problems since childhood; the police had been called on him at least twenty-three times in a decade; a recent tip to the FBI identifying him as a threat had been ignored; and he'd had no difficulty acquiring the semiautomatic rifle with which he had killed seventeen people.) In the shade of the Broward County courthouse, a high school junior, X González, gave a speech whose anaphoric refrain "We call BS" repeated itself on cable news networks for an entire day. With their shaved head and green khaki jacket they channeled the androgynous xenomorph-slayer energy of Sigourney Weaver in *Alien,* avoided social media influencer gimmicks, and seemed uninterested in celebrities or getting into Harvard. These qualities only served to make them the most sought-after trophy for the television reporters, who thronged them whenever they appeared in public.

Despite their youth, the students soon became the focus of right-wing conspiracy theories—a video claiming Hogg was a "crisis actor" made it into the "Trending" list on YouTube; on Infowars, Alex Jones called Parkland a "deep state false flag operation." But most of them took pains to avoid looking radical, and the fact that they had grown up in a wealthy suburb helped. Cameron Kasky, who shared that his father was a reserve law enforcement officer, stood on top of a car and said, "We're not trying to take anyone's guns." David Hogg posted a photo of a corporate donation of granola bars. "Thank you so much @KINDsnacks for their support! I love having so much food ☺." It quickly became cliché to point out the difference between the way the political establishment and the media paraded the pain of these wealthy suburban children versus their treatment of the young founders of Black Lives Matter a few years earlier. This was the era of quibbling about microaggressions, yet the racism was so obvious. The grief and rage of the white suburban children was treated as sacred and moving. Surviving a school shooting gave them moral supremacy, the right to speak against a society that had failed them, the right to ask for special protection and care in the aftermath of the event, and the adults would perform gestures of care while failing to fix what everyone agreed was a uniquely American problem. The Billy Graham Rapid Response prayer team had set up in Pine Trails Park to "pray people up"; Broward County organized counseling centers for the children and the teachers of the school; volunteers arrived with therapy dogs. Politicians invited the children to Tallahassee and to Washington.

In five weeks, the students had organized a march on Washington, culminating in a televised rally. One group of Stoneman Douglas students traveled to Washington on a plane lent by the New England Patriots. They were received as heroes by politicians on Capitol Hill. The Washington Wizards invited them to basketball practice. Stu-

dent journalists held a panel at the Newseum. A concert the night before was thrown in their honor—Lizzo's backup dancers twerked in fury, Shake Shack sponsored a sign-making party. The student leaders were grateful, thanking George and Amal Clooney and their corporate sponsors on social media, posing in front of the little blue bird at Twitter's Washington offices. There were interviews on *60 Minutes*, NPR's *Morning Edition*, *Dr. Phil*, and the late-night news shows. There were major "interactive packages" in *Teen Vogue*, and a *Time* magazine cover. There was, in short, so much consensus about the message of the student movement that it had to be one of the least antiestablishment social movements in American history. What the student leaders seemed to be saying is that they didn't want trouble, and had a person not arrived at their school with a gun they would have kept their heads down and scored high on their standardized tests. They had been as polite and as popular as protesters can hope to be. Adults at the march talked about "standing out of the way" and provided snacks, like it was a chaperoned after-prom party.

The Parkland students, who were aware of their advantages, started trying to move the narrative away from themselves and their suburban lives. In the aftermath of Valentine's Day they had met with a group of youth anti-gun activists from the south and west sides of Chicago, a meeting arranged by Arne Duncan, who had been secretary of education under Barack Obama. The students of North Lawndale College Prep, a majority Black school on the west side of Chicago, had now also come to the march, to tell stories of what the press tended to think of as "ordinary" gun violence—the ordinariness of fifty or seventy people sustaining gunshot wounds on a summer weekend in Chicago, which failed to activate the national televised grief machine or the Billy Graham Rapid Response prayer team. In the press tent the day of the march, the Parkland students had started a practice of deferring questions to their Black and Brown

peers from bigger cities, often taking interviews in a buddy system. They spoke with reporters, then retreated to drink hot chocolate in a VIP tent next to the stage where the celebrities were stopping to pay visits.

At the rally that day, Common, the rapper and the star of many Microsoft ads, rhymed "When they go low, we stand in the heights," with "I stand for peace, love, and women's rights." Yolanda Renee King, the nine-year-old granddaughter of Martin Luther King Jr. and Coretta Scott King, said, "I have a dream that enough is enough, and that this should be a gun-free world." After video montages and speeches, Jennifer Hudson, whose mother, brother, and nephew had been shot and killed by her sister's ex-husband, and who would regularly show up and sing gospel songs at a church on the South Side of Chicago known for its activism against gun violence, performed the concluding song, "The Times They Are A-Changin'." It was beautiful; she was perfect. Then the rally ended. I was freezing. I walked back to the hotel, where Andrew and his mom were waiting. In the article I wrote about the event, I pointed out how slickly produced the made-for-TV rally had been, which the magazine framed in the headline as a "radical new model for youth protest."

I struck the right rhetorical tone, of resolve and hope, telling this story; *The New Yorker* gave me a job. A publisher asked if I might like to write a book about the Parkland students. I couldn't bear the thought. They had already learned how feckless the adults in the room could be, the politicians posing for photos with the students with ribbons in the high school's colors pinned to their lapels. The young people saw through their instrumentalization and I didn't want to insult them by perpetuating it further. When the next school shooting happened that May, in Santa Fe, Texas, they opted out of commenting. "If you wanna talk to someone, please go to Texas," one of them responded when I texted asking for a quote.

13

WITH THE NEW JOB, A ROUTINE BEGAN. FLY SOMEWHERE, REPORT, AND
file the articles from the hotel room; come home and let myself forget
about America and its problems until I was sent away again. I would
take a car back from LaGuardia and drag my Travelpro suitcase up
the four flights of stairs to the apartment and Andrew would be there,
and the cat. If we weren't too tired we would walk a block down
Broadway to Skytown, a bar that served vegetarian tacos until after
midnight. Sitting under its brick walls at its wooden bar I would drink
a Manhattan if it were winter and a Negroni if it were summer, and
it would work and I could forget.

Getting to witness history was accompanied by the disappoint-
ment that, as had been the case in Parkland, I could only contribute to
the noise and never shift any outcomes. In that time the news of some
injustice broke each day like a dull wave. Trump moved to expand
oil drilling in United States waters. Trump rescinded protected status
for immigrants from El Salvador. Trump shrank the protected areas
of Bears Ears and Escalante National Monuments. Trump signed a
kleptocratic tax bill. Trump was separating children from their fami-
lies at the United States–Mexico border and warehousing them in
over-air-conditioned tents in the desert. I wrote as part of an anxiety-

producing machine. No rhetorical register seemed to have the power to break through.

I understood it was impossible for any writer to see outside the contours of the history they inhabited. I often thought about Edward Said's explanation that we still read Joseph Conrad in the twenty-first century not because he had been capable of condemning racism and imperialism but because, as someone trapped within a totalizing ideological system in the nineteenth century, he had been a master of the only tools a writer has at his disposal when he suspects something is very wrong: observational detail, self-consciousness, unease, doubt. This was the opposite of what was asked of us in journalism, which required a tone of authority, facts, and a confidence in right and wrong. The profession rested on the faith that in presenting accurate information the world would correct its mistakes in consequence. Going around the country and seeing what was going on was interesting; trying to think of anything remotely intelligent to say about it was impossible.

Wherever I went, some member of the extremely online right seemed to appear as well, with a conspiracy theory or a gun. At a student-led march against gun violence on the South Side of Chicago, a high-clearance pickup truck with a rifle mounted on its bed and an advertisement painted on its side for a classifieds site called the Utah Gun Exchange drove behind the teenage activists as they gathered for their public events. A campaign event at the Holy Land deli in northeast Minneapolis, for Ilhan Omar, the Somali American refugee running for Congress in Minnesota, was interrupted by an anti-Muslim activist named Laura Loomer recording herself shouting incoherently about female genital mutilation. On that afternoon I started to laugh, the performance was so chaotic and absurd, but Omar, who was standing next to me, gave me a severe look. "You can laugh at this?" she asked, as her interns started to cry. When I flew back to

New York the next day, Loomer was just a few people ahead of me in the security line at the Minneapolis–Saint Paul Airport. She wore a hooded sweatshirt, a nondescript participant in security theater. I could have approached her, but I didn't. I left the scene of her at the deli out of my article, telling myself something about "not giving her a platform," and only later seeing that this interruption was likely the reality that mattered more than the one I had described.

These provocations seemed to be more about the performance and the confrontation than the convictions they claimed to support. The goal was the viral moment that would live for a day and then die and be forgotten. It was possible to make a career this way. I knew the actors but I had trouble picturing the audience, and what they believed about the world and about themselves.

Had any other people ever been so disingenuous? It was very difficult to know what people believed versus their performances. To describe it, which was my job, seemed only to perpetuate it. The disingenuousness could have a soft and sentimental side as well. "What was it like for you?" John Neely Kennedy, the Republican senator from Louisiana, asked Brett Kavanaugh about his time at Georgetown Preparatory School, the Jesuit boys' high school, in a clip from C-SPAN of Kavanaugh's Senate confirmation hearings to the Supreme Court that made the rounds. "I can tell from your testimony that those were formative years for you," Kennedy said in his Southern drawl.

"Very formative," said Kavanaugh, who had referred to the Georgetown Prep motto, "Men for Others," in a statement following his nomination to the Supreme Court.

"Were you a John-Boy Walton type, or a Ferris Bueller type?" Kennedy probed. Kavanaugh laughed, encouraged by others laughing around him, but he didn't answer.

"I loved sports, first and foremost," he said.

"You left out the trouble part. I was waiting for that," Kennedy said.

Kavanaugh looked uncomfortable. "Uh, right," he said. "That's encompassed under the friends." He tried smiling again.

"Now, see, I was going to ask the judge, if not him but any of his underage running buddies tried to sneak a few beers past Jesus or something like that in high school," Kennedy said. "But I'm not going to go there." Kavanaugh smiled.

Ten days later, Christine Blasey Ford, a psychology professor at Palo Alto University, publicly accused Kavanaugh of sexually assaulting her at a high-school house party in Bethesda, Maryland. I went to Washington, where women blew rape whistles and got arrested in the halls of the Senate Office Building. Kavanaugh was confirmed anyway.

THE PHOTOS IN MY PHONE FROM THESE MONTHS ARE OF CANDLELIT memorials and piles of flowers and protest signs and people carrying rifles; of the view of the Doha airport as seen from the window of a descending Qatar Airways flight; of myself holding the cat on my lap on our couch in Brooklyn; of Andrew eating a bowl of ice cream. I was still getting invited to places for my book. That year I went to London, to Lyon, to Arnhem, to Berlin. I went to Nairobi, to Medellín, to Seoul.

The 2018 midterm elections were looked upon as a referendum on the direction of the country. I spent the days leading up to them on an endless drive around the state of Texas: El Paso, San Antonio, Dallas, Austin, as far east as Lufkin, covering the Senate campaigns of Ted Cruz and Beto O'Rourke. One cloudy evening I went to a Trump rally in Houston. Trump had been on tour all this time, galvanizing his base, giving the excitement of presence to online emo-

tion. His supporters now caravanned along with him like Deadheads, tailgating in parking lots, an industry of kitsch and graphic design springing up in their wake. On the Monday I saw him in Houston, his supporters started lining up downtown more than twenty-four hours before the event. According to the organizers, a hundred thousand people had signed up to attend the rally, at the Toyota Center, where the Houston Rockets played and which had a capacity of nineteen thousand people. By midday, the line to enter stretched all the way to an Embassy Suites several blocks away. A propeller plane flew over Houston's towers of glass and across its leaden sky, towing a banner that had the name "Beto" in a circle with a line through it and the words "BECAUSE SOCIALISM SUX!"

Vendors sold MAGA hats and banners depicting Trump standing in his suit and tie on an amphibious vehicle as it plowed through waves, an AR-15 in one hand and an American flag billowing behind him, lit from above by the rockets' red glare and surrounded by fluttering hundred-dollar bills. The gathered crowd waited patiently, in lawn chairs, with coolers. The fashion choices, which seemed to have cohered since the 2016 election, had a lot of red, white, and blue. Many of the men had beards or long hair and dressed in Under Armour, or hunting camouflage. Women wore jeans with rhinestones on the pockets, pink MAGA hats, and T-shirts that read "Adorable Deplorable" or "Trump Girl," with a flag-patterned high heel. Many wore T-shirts referring to right-wing internet memes—Pepe the Frog, Wojak, and the QAnon slogan of WWG1WWA ("where we go one we go all")—or Infowars. The crowd was overwhelmingly, though not entirely, white. I interviewed people along the line outside, confirming from one supporter after another that love of country and God were under attack and that foreigners were flooding into America to loaf, steal, and sell fentanyl.

Having sufficiently cataloged these opinions, at 5:30 p.m. I took

my place in the "press pen" at the center of the Toyota Center, a bar-ricaded square on the arena floor where the organizers had ordered us to stay until the end of the president's speech, well positioned for the crowd to jeer at us. The Trump campaign handed out a multitude of signs: "Finish the Wall," "Veterans for Trump," "Buy American Hire American," "Keep America Great," "Promises Made Prom-ises Kept." Women swayed to Elton John's "Rocket Man," holding "Women for Trump" signs. The crowd started the wave. It had the collective excitement of a rave except instead of gathering to listen to music and dance the appeal was to get riled up in anger and self-righteousness. Even fellow-Trump supporters weren't sufficiently patriotic for Trump supporters; as the Pledge of Allegiance was announced, men erupted into angry shouting at people who were too slow to remove their MAGA hats.

A local pastor opened the rally with a prayer. "The question before us is: Which way America?" he said. "Will we continue to be a republic under God or will we slouch toward godless socialism?" Then the ladies of the Deplorable Choir led a quavering rendition of the national anthem. Trump came out to Lee Greenwood's "God Bless the USA" and a collective roar. Through sustained cheering he waved and squinted and nodded and looked thoughtful, then shook his head in amazement and turned as if on a divot and waved and nodded some more. "Wow," he said. "Wow." He pushed both hands upward, encouraging an upswell of even more love and enthusiasm. "Do we have a great country or what?" he asked.

Then, in his incantatory way, he spoke for well over an hour with-out flagging. He spoke of faith and family and freedom and jobs and borders. He spoke of sacred values and religious liberty and the right to keep and bear arms and law and order and the incredible men and women of law enforcement and that judges should always interpret the Constitution as it was written. He spoke about how we should

be proud of our country and respect our great American flag and that we are a nation that kneels in prayer and stands for the national anthem and knows that faith and family, and not government and bureaucracy, are the true center of American life. In America, he said, we don't worship government, we worship God.

He told us how the radical Democrat mob was taking a giant wrecking ball and destroying our economy and our country. The country of ranches and small businesses, where thanks to him you could now leave your ranch to your daughter without having to pay an estate tax and the approval process for pipelines was sped up, the oil would flow fast and thick and the trade imbalances with Europe would be righted and America would be rescued from the corrupt power-hungry globalists and the radical Democrats.

The crowd knew every cue. When Trump said "the fake news back here" (gesturing to us) they booed and yelled "CNN sucks." When he said "We want people to come into our country but they have to come in legally and they have to come through merit," the arena erupted into chants of "Build the wall, build the wall." And at the first mention of Hillary Clinton they screamed "Lock her up," even though Clinton had been in the dustbin of history since 2016. In every instance Trump would pause and step back from the podium and beam.

He told us that the Republicans would bring the high-paying jobs and rising wages and a booming economy, and $6 billion to fight the opioid epidemic, and the Space Force, and the travel ban. He told us that for the sake of our children we are going to fight and we are going to work and we will not bend, we will not break, we will always fight on to victory because we are America and our hearts bleed red, white, and blue and we are one people, one family, and one glorious nation under God and together we will make America wealthy again, we will make America strong again, we will make America safe again

and we will . . . And here the crowd again knew what to say and they chanted, "Make America Great Again."

Then it was over. "Thank you, Texas," he concluded, and the Rolling Stones' "You Can't Always Get What You Want" began to play.

The next day I drove to San Antonio, where Senator Ted Cruz was speaking at the Buckhorn Saloon & Museum, an Old West–themed tourist attraction with walls that bristled with the antlers of mounted hunting trophies. Cruz spoke in a room on the second floor, just past a display of bovine grotesqueries that included a stuffed and mounted lamb with one eye like a cyclops, and two sets of conjoined calves.

He was accompanied by John Cornyn, the senior senator from Texas, who was ruddy and white-haired and dressed in a studiously casual outfit: a plaid shirt tucked neatly into belted jeans, with cowboy boots. Cruz wore a sport coat, a shirt without a tie, and jeans. The standard cheer to greet him was to repeat his name quickly in a low voice, like he was the quarterback of a football team, as he came bounding into a room.

Cruz was the valedictorian of his high school, went to Princeton and Harvard, and still had the aura of a Young Republican debate nerd, but now his party preferred its candidates more macho and he occasionally wore a beard. His rhetorical flourishes were televangelistic: growls and whispers at the scary parts, tenderness for the sorrowful moments, illustrated standoffs between the forces of good and evil. He spoke of his opponent, Beto O'Rourke. "I understand," he said, "that Beto thinks that if somebody comes into your home and tries to attack your family that the answer is to take out your skateboard and hit them." The crowd laughed. "Well, that's not true, maybe you throw your triple mocha latte." More laughs. "Joe Biden says if anybody attacks your house just go outside with a double-barreled shotgun and fire both barrels in the air, which is very good

advice, if it so happens that you're being attacked by a flock of geese," Cruz said. "But in Texas, we happen to think a little bit differently."

Like at the Trump rally the night before, Cruz let the audience voice most of the insults. He shared the president's habit of responding with a smile and a shrug, as if to say, "You said it, I didn't, but we all know it's true." Audience members shouted that O'Rourke looked like a squirrel, that he wore a dress, that he'd had a DWI, that he was a socialist. "Faulty thinking!" a woman next to me kept yelling out, as Cruz criticized O'Rourke for supporting NFL players who had protested police brutality by kneeling during the national anthem.

He laid out two possible paths for the country. An "alpha world," where Republicans held their majority in the Senate and the House and kept cutting taxes, repealing regulations, and appointing more "constitutionalist judges" to the court, with the result that "wages go up, prosperity goes up"; or the "Beto world," which would be "a world of paralysis and mob rule" and "an absolute partisan circus, and when we say 'partisan circus' we're talking Mad Max at Thunderdome, with Beto in the role of Tina Turner."

On the day of the vote, I was in El Paso. The magazine wanted the appearance of a frenzy of activity, a war room, constant updates. I drove my rental car around to different polling places, interviewing people. In El Paso I could only find Democrats, so I drove to the outskirts of town. The desert seemed to have an effect on acoustics and the atmosphere had a muted quality. In the long November afternoon, the air was soft and warm, the light was pinkish on the brown flanks of the mountains, and I fantasized about never going back to New York. I chose an elementary school polling site near Fort Bliss. Outside, a woman sitting in a mobility scooter and her husband took turns holding a sign for their son, who was running for reelection for county commissioner. The voting site was otherwise deserted.

"We're married," said the woman, whose name was Myndy "with

a *y*," and who wore a floral shift and whose faded pink hair I was not sure whether to interpret as intentional or an accident.

"And that's your son," I said, pointing at the sign, which had a photograph of a grown man in a cowboy hat.

"He's my baby," she said fondly.

We talked about the border.

"I don't think people can understand, really, so many people's stance on immigration, because they don't live at the border," said Myndy.

I asked what it was that people didn't understand about it.

"They don't understand," she repeated. "They're all for it. 'Let's have open borders. Let's just . . .'"

"It's like NAFTA," said her husband, George. "All the jobs go down there for five bucks a day. Our car jobs. El Paso used to be full of boat manufacturers."

"All the clothing manufacturers left," said Myndy. "They're all over there. And most of the poor murdered girls worked in those factories."

"In Juárez?" I asked.

"Mm-hm. It's still going on. The mothers are digging every Sunday."

They reminisced about a better time.

"Back when I was a little kid we used to go over there to get haircuts; my dad would take us over," said George.

"When I was in college I used to get my hair done over there," said Myndy. "My grandmother, she used to smuggle my grandfather's cigarettes, and she wasn't even five foot tall. She drove this Chevy where you looked through the steering wheel, all you saw was her white hair and her hands, going over the border, once a week."

"The Kentucky Club was the spot," said George.

"Ah, yes, miss that," said Myndy.

"The Wine Bar. The Caverns."

"If you wanted to go dancing you went to Mexico."

What changed was "five thousand murders a year," said George.

"The drugs," said Myndy.

"They slowed things down."

"It's the drugs."

"Our secretary went over there in her pickup and was carjacked."

Someone walked up from the parking lot. "Excuse me, where's the voting?"

"Over there," said Myndy. We were quiet as the person walked inside the school to vote. Cars sped by on the highway nearby. "Have you seen the tent city they have?" she asked me.

"Where?" I asked. "In Tornillo?" (Fifteen hundred immigrant teenagers were being detained in Tornillo, thirty miles away. Some of them had been there for months.)

"It's air-conditioned," she said.

"It's the same tents we had when we were going over to Iraq," said George. "I mean, they're certainly not inhumane."

"No, they're not."

"They're not *Marriotts*."

I asked about the family separation policy.

"Don't come," said Myndy.

"What part of illegal don't you understand?" said George.

"But they don't say 'illegal,'" said Myndy. "They say 'undocumented.'"

"If you're here illegally you know what happens? You go to prison. So what are you going to do?"

"This used to be a country of laws," said Myndy. "It's not anymore."

I was supposed to listen, not argue, but I pointed out that the United States had one of the highest rates of incarceration in the world. "What's not being enforced?" I asked.

"Immigration," said Myndy. The argument was turning circular. Myndy told me she was libertarian, which she defined as "no new laws" and "enforce the laws we have." We stood there for a minute. "I'm surprised *The New Yorker* would have someone talking to Republicans," she finally said.

I thanked them for their time.

"You make me feel bad about separating the families," said George.

"Well, I'm not," said Myndy.

Beto O'Rourke lost the election. I filed my dispatch about his concession speech and flew home.

14

THE WEEKEND I GOT BACK FROM TEXAS AFTER THE TRUMP RALLY, Andrew and I went with some friends to a rental house in the Catskills. They took acid; I couldn't bear to. I sat alone in a bedroom with my eyes closed but was unable to sleep. Andrew was annoyed that I was in a bad mood but Texas had been enough of a collective hallucination; I didn't need a psychedelic. I knew our life in Brooklyn did not constitute any form of political resistance. In Brooklyn I woke up each morning, showered with heated and chlorinated and fluoridated water, moisturized my body with endocrine-disrupting chemicals, and placed small lenses of silicone hydrogel on my eyes so I could see. The tank of the toilet automatically filled after I flushed it; the electricity burned steady and true through the dozens of wires accumulating dust in tangles on the floor. It might be hot or cold outside but I could turn on the air conditioner in my room or open the valves on my radiator. I bought my food in discretely packaged petrochemical receptacles that I used then threw away. I threw them away thinking of the Great Pacific Garbage Patch and of plastic microbeads accumulating in seabirds, but anything I needed I had, anything I wanted to buy I could buy. I had a credit card that accumulated frequent-flyer miles. I held a portal in my hand that delivered information and images of people. To live was to experience every day as the long his-

tory of technological miracles and human triumph: the molded plastic seats of the subway; the chemical fog juice that fed the fog machine at the club; the stores where I could buy "ceremonial grade" matcha green tea, or trash bags scented with air freshener. I had everything I needed and I lived a happy, comfortable life. My concerns were not material but existential, and if I had not read the news I would not have known the cost of all of this material wealth. I would not have known that a single drop of the oxybenzone in my sunscreen could be deadly to coral reefs, or that four hundred migratory birds had crashed into a glossy skyscraper in Texas, or that the president had resumed the sale of plastic bottled water in the National Park System.

At the political rallies in Texas, the conjuring of an unnamed threat was a powerful force. There was an insistence on a mysterious menace that was always on the point of invading and taking everything away. If this threat were repeated to you enough, the phantasm began to seem real. Hannah Arendt wrote of "the curious contradiction between the totalitarian movements' avowed cynical 'realism' and their conspicuous disdain of the whole texture of reality." The imaginary home invasion or an influx of people born in other countries was scarier than the real mass shootings that happened on a regular basis, or than the state-sanctioned murder of people by the police?

I stopped going to parties in 2019, at least for the first half. Andrew had some family matters to take care of that year, and we sublet our apartment in Brooklyn and went to California for four months. For a season we lived in a two-bedroom apartment in Southern California with wall-to-wall carpeting and a patio. We brought the cat and let her go outside during the day. The sudden immersion in suburbia was jarring but also an interesting experiment in leaving Bushwick behind. We had started talking about having a child—was this what it would be like to live in a nuclear family? We drove our rental car for groceries at Trader Joe's and took weekend trips to San Luis Obispo

and Joshua Tree and Anza-Borrego. I addressed the imaginary conservative in my mind as we playacted family and didn't do drugs. "Are you happy now?" I asked the conservative. "Are we doing it right?" But the separation from our friends and our scene took a strange toll. The more time we spent alone together the more isolated I became from Andrew. Among the roses and the sunlight life took on a surreal and timeless quality. The days were repetitive and featureless and I had trouble thinking of anything to write about. I seemed to be sick all the time; my body was leaden. I started exercising at the Pasadena SoulCycle, which was in a strip mall I called "Basic Bitch Plaza" (it had a Williams-Sonoma, a Drybar, a smoothie shop called SunLife Organics, and a fast casual restaurant called Lemonade). The SoulCycle had a word cloud on one wall as decoration that said "ADDICTED" and "OBSESSED" and "RELENTLESS." "Your only commitment is to the rhythm," yelled the instructors as we cycled in place to Beyoncé remixes.

We went back to New York that June. Planes from the West Coast land late and it was after midnight when we got back to the apartment at Myrtle-Broadway. I felt so sorry for the cat, who had been in paradise, and now had to return to the screeching of the train. We decided to walk and find something to eat. We ran into friends on the street under the bright lights of the gas station on Myrtle and Bushwick Avenues; we got tacos; we went to Bossa until it closed and then went back to our apartment with more friends until the sun rose. The question of New York or California was settled for me: I would never leave Brooklyn.

I wanted something to change, though. I wanted to have a kid with Andrew. The idea made me feel trapped but it was a trapped I was ready to concede to. The state of the world wouldn't matter if I had him and we had a child to pour our love into together. I went to the doctor and got all the prenatal tests. I noticed Andrew was aloof

and distant, but that seemed all right; it was a scary prospect. But then I seemed to be gone all the time or too busy; the timing was never right. On his birthday I was covering a protest in Puerto Rico; then I went to New Hampshire to write about the presidential run of the New Age guru Marianne Williamson; I watched Greta Thunberg sail into New York Harbor after crossing the Atlantic in a carbon-emission-free sailboat. In late summer we had a big fight about his pot smoking but it was really about something bigger, I wasn't sure what. In the aftermath of this fight he sold his ticket to Sustain-Release while I was covering Hurricane Dorian in the Bahamas, flying with a volunteer for a charity who flew a manually controlled Piper Seneca low over the Caribbean Sea to see where a village called Sweetings Cay had been wiped from the face of the planet. Even in the Bahamas the same forces seemed to be converging: at airplane hangars wealthy owners of private planes clogged the runway, showing up with pallets of water and taking selfies; there was talk of packing sidearms and confronting looters, and about which billionaire had donated the use of his airplane. The Duggar family, whose nineteen children had been the subject of a reality television show on TLC, had incorporated their visits to the Abacos into their Instagram stories. Dorian had been one of the most powerful Atlantic storms in recorded history. Not one person I met said the words "climate change."

The day after I got home I went to Sustain alone for the first time. The first night there I called Andrew on acid, sobbing, telling him I loved him and begging him to rent a car and show up anyway. He didn't. The second night I forgot about him. I forgot about everything. In the colorless light of the gymnasium dance floor I danced to the television static and white noise of DVS1 until I had no more thoughts. Powder, the Japanese DJ I had seen in Berlin in 2016, closed the Bossa stage that year, an hours-long set when we danced so hard the wooden floor caved in and a corner of the room had to be

cordoned off. By 2019, the closing set of Sustain had evolved into a tradition where anything might happen musically, especially after a certain point in the morning. Powder played a remix of "Hope Road," a song from the 1980s by the English poet and singer Anne Clark, which told a story of false expectations (the narrator meets a nice guy at a party; he gives her his address and invites her to dinner; the address doesn't exist—there's no Hope Road). Around me people started crying.

At the end of the party they opened the kegs and I drank beer in the sunshine with all my friends. I had a sense of completion, thinking that by next year life might be completely altered. When I got back to New York, Andrew and I reconciled, but the baby question lingered unanswered. I left again—I went to Paris Fashion Week to profile the designer Telfar; I went to a writing residency. While I was away, Andrew had started going on dating apps, or he told me about it once. Maybe it was only that once. We were in California at the end of the year. I remember a plane that wrote out "Happy New Year 2020" against a clear blue sky, and a sunset that burned red.

In late January I went to Richmond, Virginia, to attend a gun-rights rally that was scheduled on the holiday commemorating Martin Luther King Jr.'s birthday. The day before, I signed up to attend a meeting at a Hilton Garden Inn near the Richmond airport, sponsored by an organization called United in Strength for America (USA). It was called "We Won't Back Down! Citizens Rights and Responsibilities in Times of Government Overreach." The meeting was not specifically about gun rights—it touched on the threats of a US government takeover by the United Nations; socialism; the problems with public education; and the decline of shame as a motivating principle—but guns kept coming up. I watched a PowerPoint presentation entitled "Government Schools Are Sexualizing, Perverting, and Confusing Children," where a photograph of David Hogg, the

gun control activist from Parkland, was captioned, "Government schools are indoctrinating children such as David Hogg of March for Our Lives against God, guns, and freedom, and then using them to transform America." Yes, it was the government schools that had turned Hogg against guns, not a gun massacre.

The bishop of the New Life Harvest Church in Richmond anointed the attendees with holy oil in advance of the rally. "They will be the interventioners that will stop evil and stop confusion and stop antifa and stop white nationalists and stop anybody who wants to do evil on that day," he intoned. "Use us Lord for your glory! Let there be a boldness in our mouth."

The conference-goers discussed whether to wear Virginia militia hats or to "go gray." The consensus was to tone down the militancy, to not give the left any reason to suspect the demonstrators of being anything other than law-abiding gun owners, even as groups promoting the rally had included the antigovernment militia organizations the Oath Keepers and the Three Percenters, and several organizers of the Charlottesville Unite the Right rally in August 2017. The FBI had already arrested three members of a neo-Nazi accelerationist hate group called The Base. ("The defendants believed that a pro-firearms rally in Richmond, Virginia, on January 20, 2020, would begin the collapse of the United States government, which white nationalists often refer to as the Boogaloo," a Department of Justice memo later explained. "The defendants believed that at the rally on January 20, they and other like-minded confederates would begin systematically murdering and destroying to force the capitulation and demise of the U.S. government.") In the Hilton Garden Inn, one speaker dismissed these arrests as "a Reichstag fire of sorts," forgetting, perhaps, who had exploited the Reichstag fire. "They are looking for any excuse to slander law-abiding gun folks," he told us. A theory circulated

that if there were violent people at the rally they would be left-wing agitators wearing NRA T-shirts and MAGA hats.

That night I went to the Westland strip mall, where the Virginia Citizens Defense League held a pre-rally dinner at the Hibachi Sushi & Supreme Buffet. There were prawns glistening under heat lamps on steam tables, sweet and sour sauces, stainless steel vats of quivering Jell-O, a koi pond with pebbles, weapons worn in holsters. The gun-rights activists ate from plates piled with egg rolls, breaded shrimp, and lo mein. The central talking point of the evening was that reducing the number of guns in America does nothing to keep people safe.

Look at Chicago, I was told, which has strict gun laws and where three or four thousand people are shot each year. Look at Britain, where guns are banned but they have a knife crime problem. I was reminded that people die in car accidents. They die in pools. The overwhelming majority of gun deaths are by suicide, it was emphasized, as if that were not also indicative of a problem caused by easy access to firearms. I was told the Democrats campaigning on gun control issues may have won in the most recent state elections, but that their success did not reflect the will of the people. They won because the turnout was low, because a Virginia judge had ordered redistricting, and because Michael Bloomberg had flooded the airwaves with anti-gun propaganda.

The activists told me about Jack Wilson, the church security guard who had stopped an attempted mass shooting at a church in Texas in late December. I was told that violent felons will get their hands on guns despite any laws; that felons who have served their time should have the right to a gun; that if you make a lot of rules that stop law-abiding citizens from having their guns then only criminals will have them, and how will we protect ourselves? Guns are just a tool, people said, "a piece of metal," said an activist from Georgia.

"I don't understand why people hate guns. What are you scared of? It's not going to jump up and hurt you."

I learned that the problem with universal background checks was that you couldn't pass a gun on to your family members. The problem with red flag laws, which allow the authorities to preemptively remove guns from people they find dangerous, was a low evidentiary standard that would be used as a tool of oppression to accuse people of "all kinds of things." I was told to look at Venezuela, and Nazi Germany, at the situation of the pro-democracy demonstrators in Hong Kong, at the Uighurs in China. The prospects of home invasion, sexual assault, and government coups were raised. I was told a story about a man who had shot a bear and was charged with unlawful discharge of a firearm. I was told that you can only implement socialism by disarming the people. "Whether the anti-gun people know it or not one day they will be under the thumb of the government and we're trying to prevent that from happening," someone told me. He wore a T-shirt that said "My Governor Is an Idiot" and he carried his baby daughter, who grabbed at my pen as we spoke.

"The majority of us don't believe in violence," he said. As a Christian, he added, he was "commissioned and commanded to love everybody whether I disagree with them or not." If there were violence at the rally the next day, he said, the police and the gun owners would immediately stop it. "I would definitely protect everybody and the majority of us gun owners feel that way." People discussed how peaceful the next day would be, while also discussing tourniquets.

The day of the rally dawned cold. In the early-morning darkness, the Virginia State Capitol glowed white atop its hill. By seven o'clock, the line to get into the fenced area on the capitol lawn, where demonstrators had to be unarmed, was already long. Across the street, armed demonstrators gathered, many of them bearing assault rifles and wearing tactical gear. A group held up a banner with an

illustration of an AR-15 and the words "Come and Take It." Buses rolled past filled with visitors from out of town. An RV festooned with Trump signs drove by to applause from some of the crowd.

The demonstrators swelled in numbers to twenty thousand people. Helmeted men dressed to blend into marshes, deserts, or jungles stood against the buildings, ornamented with clips of ammo, gas masks, radios, sidearms, flashlights, and pepper spray. Heavily armed packs of men distinguished themselves with different colors of tape tied around their members' upper arms. One group marched behind a color guard to the recorded sounds of a military fife. The most menacing pseudomilitary getups got the most photographic attention. Rallygoers posed for photos with a guy lugging around a five-foot-long, .50-caliber sniper rifle.

The typical attendee was white, male, and conservative, but a small group from the New Black Panther Party, which when I looked it up later was described by the Southern Poverty Law Center as "a virulently racist and antisemitic organization whose leaders have encouraged violence against whites, Jews and law enforcement officers," attracted the attention of conservative social-media influencers, who were seeking evidence that the gun-rights movement didn't have a race problem. The claim that the overall movement was not racist was belied, however, by the open presence of racists—Proud Boys in yellow sweatshirts, Alex Jones ranting from the top hatch of his black armored truck, far-right internet personalities, including the neo-Nazi Jovi Val.

I was not used to covering this kind of story, and did not want to die in the crossfire of accelerationist neo-Nazis trying to start a race war. The magazine had sent a photographer along with me; his friends were combat reporters who had started coming home to cover the drama. I was the only one who was scared, and started getting embarrassed about it. The day passed without incident. "Everyone

is treating you cordially, right?" a nice man bearing an AR-15 said when I asked for an interview. I gave my phone number to Stewart Rhodes, the founder of the Oath Keepers, who was recognizable by his black eye patch. That night he texted me an image of a meme that, he wrote, "sums up why we are armed and will remained armed." The text of the meme read, "Somewhere in a forgotten village, an 8-year-old girl lying on her humble bed prays through her tears that Jesus would send his mighty angels down from Heaven to save her and her family from evil men . . ." Beneath this was a photograph of a heavily armed paratrooper of undetermined nationality flying through the sky and the words "ETA: 2 minutes."

"Bottom line is sheepdogs have teeth because wolves have teeth," Rhodes texted me. "And if you try to pull a sheepdog's teeth don't be surprised if you get bitten."*

A few months later, nobody else seemed to notice or remember this assembly of twenty thousand people with guns on the steps of a state capitol. It was not a story that got a lot of interest or attention. It was at the time very alarming, and seemed somehow new, but then it faded into the backdrop of the events that followed. I chastised myself for getting so scared.

While I was in Richmond, Andrew and I talked about taking a trip upstate, maybe one where we didn't log on to the internet for a week. The plane back to LaGuardia took the flight path over our apartment, and as we crossed over I made a little secret wave to him, knowing he was waiting to have dinner with me down below. On the ride home I sent him a picture of the pink and indigo sunset over Queens.

* "You, sir, present an ongoing threat and peril to this country," a federal judge would later tell Stewart Rhodes when he was sentenced to prison for eighteen years for his involvement in the invasion on the US Capitol on January 6, 2021.

When I think about late January of 2020, it's as if I am looking at a miniature diorama of a life inside a glass ball. I am looking back at an intact self who does not know something is on the verge of ending: a city as one knew it, a relationship, a social world that showed no signs of faltering, a pattern that gave no indication it would not keep repeating itself. I understood that the people you love could get sick and die, that relationships could end, that a person could lose a job, but I didn't understand yet that a whole life can fall apart and not reconstitute itself again. I didn't know what that meant, or how it might be possible.

Part III

15

THE LAST RAVE WE WENT TO WAS ON MARCH 6, 2020. IF IT WEREN'T for what happened later, I don't think it would have stood out in memory. Leading up to that Friday I'd had a long month of disciplined professionalism. To maintain mental clarity I had avoided alcohol, slept consistently, limited my coffee intake, and done everything else necessary to finish a mediocre magazine feature. I had bought my ticket to the party weeks in advance, and looked at it as the opportune blowout between two periods of discipline. I would party, I would finish some more articles, and then I would take April off from the magazine, go to Brazil, and begin research on the book I wanted to write about the Amazon rainforest. I had been monitoring the prices of American Airlines flight 1265, direct from Miami to Manaus. I had read about ocean currents and trade winds, about "mycorrhizal associations" and modal trees, about Jair Bolsonaro and the Belo Monte Dam. It was a half-baked plan; it was just that I was interested in humanity's determination to irreparably alter the biological conditions in which we had evolved.

I finished my article on Wednesday, the fourth of March. The next evening I met a friend at the movies. We saw *Portrait of a Lady on Fire* at the Brooklyn Academy of Music, another unremarkable experience

that later became lodged in memory, like all of the last experiences of those weeks. It was the first night I saw someone trying to open a door with his elbows. I saw a person in the grocery store wearing a mask, goggles, and gloves. My friend and I ordered separate popcorns as a hygienic precaution. I remember someone behind us coughing, and being aware of it. After the movie, we had a drink in a crowded Mexican restaurant where we could still pretend everything was as it had been. The server seated us at a table. We ordered beers. We complained about the scene in the movie where the wealthy patroness takes her maid to get an abortion. Weeks later, with the city locked down, when it was no longer possible to go to the Brooklyn Academy of Music or a crowded restaurant, and I had to live with the fear that a sentimental movie about eighteenth-century French lesbians would be the last film I ever saw in theaters, I would find a chocolate-covered pretzel from the candy I had bought for the movie in the bottom of my backpack, like a relic.

The next day, for the first time in weeks, I had nothing to do. I didn't have to wake up early, or present an attitude of professionalism, optimism, enthusiasm, or intelligence. I didn't have to think of something interesting to write about the world. I didn't have the burden of representing another person. I could be myself, as stupid as I wanted to be. I began that night at a birthday party at Clandestino, a bar on the Lower East Side. I didn't go out in Manhattan very often, where the success of a party was measured by the number of minor celebrities in attendance. The indie actors Tavi Gevinson and Hari Nef were there. The bar was so crowded it was hard to move. The coats were piled on hooks. I drank a glass of white wine. I left before ten, took the J train home from Essex Street, got a slice of pizza, and put a single drop of LSD into a glass of water. I drank half and Andrew drank the other half. For the next couple of hours, while Andrew worked on music in his studio, I lay in bed with my

eyes closed, listening to a mix by Andrew Weatherall, a British DJ who had recently died. Weatherall had been there at the beginning of the UK rave scene, in 1988, "the second summer of love." He had recorded the mix I was listening to six weeks before dying of a pulmonary embolism on February 17, 2020. The tracks on the mix had titles like "Jagged Mountain Melts at Dawn" and "The Descending Moonshine Dervishes" and "Lightning and the Flight of Birds." I listened to the tabla drums and birdsong of this "cleansing and focusing ritual," as Weatherall's voice described it.

I sat up in bed and, as the waves of the acid broke over me, I wrote down some thoughts. I wrote that the problem with trying to write about the Amazon rainforest was that I always wanted to picture it as an unending sea of green, like it was in the television programs I had been watching since I was a child, a vast expanse wreathed in vapor clouds of mist broken only by the crowns of the tallest trees. It was a place that in its most intact state was much better left alone, like Everest, or the moon, or the bottom of the ocean. That was the idealized version of the place, whereas the reality was a biome damaged with dams, wildcat mines, cattle farms, and soybean fields. Did I just want to go on a vacation in the jungle because I had some fantasy of liana vines and army ants? I wanted Manaus, the industrial city on the Amazon River, to be a tiny cluster of white high-rises in a sea of green, as small as a barnacle on the side of a whale. I looked over at the cat, who was sitting on her ottoman with her paws tucked under, her eyes two glowing lamps of annoyance. It was time to go to the party.

I got Andrew from his pounding, smoke-filled music studio. He untangled himself from headphones and cords and walked around for several minutes, patting his pockets and picking things up and putting them down again. He found his sunglasses, his keys, his wallet, his phone, his earplugs, his nicotine gum, his vape pen, the ketamine. He

put on his coat. We did two lines of cocaine to gather our thoughts, then walked down Myrtle Avenue to Bossa.

It was a damp night, the default weather of a winter that had never gotten cold and that already had a hint of spring in the air. Drag queens teetered on platform shoes in front of Happyfun Hideaway, and drunk goths waited for their tacos at the counter of Regalo de Juquila. It was already almost two and there was no line at Bossa, just a group of smokers next to the plywood walls of the construction site of the prefab condo that was going up next door. People dressed in black climbed out of hired Toyota Camrys and jumped over the giant puddle that stagnated permanently in front of the bar's unmarked black facade. We fumbled in our pockets for our membership cards, Karen at the door waved us in, and we made our way down the corridor into the fog.

The DJ who played at Bossa that night was a guy who went by He Valencia, from Indiana. He was known as much for his outspoken political views on techno Twitter as for his music. I had never heard of him but he was carving it up, it was so much fun. The bar was full, the dance floor was frenzied. There was exactly one woman in the scene who was taller than Andrew, and she was there, swaying from side to side in front of the DJ booth. Kiddo was bartending, looking orderly in a button-down polo shirt. We ordered cans of Modelo and shots of tequila; we danced; we went to the bathroom together. We stood around the water cooler and gossiped with our friends. At 3:30, with a half hour left before the bar closed, we went outside and caught a car to the rave.

The party we went to that night was called Club Night Club. It was a newer party, maybe a year old. Some young promoters had bought a sound system. The rumor was that the speakers had come from DVS1, the Russia-born midwestern party organizer and Berghain resident who had spent the mid-1990s throwing raves

around Minneapolis and who I had just seen at Sustain. I had never gone to Club Night Club before. The last one had been in the back room of the fried chicken place on Broadway, near our apartment. This night's party was in a basement in a warehouse on Wyckoff Avenue. The location, next to the Jefferson Street L train stop, across the street from Hana Natural deli, was in a part of the neighborhood I considered an extension, in terms of the people and their brunches and their Spotify playlists, of the L train corridor from Williamsburg. It was the last time any party would be thrown in this particular basement, I had also heard, because construction was going to begin on a fancy bowling alley.

Now that so many nightclubs had opened, illegal parties were more rare, but my horizons had also shrunk. In that last year, if I went out, I had preferred seeing the artists I already knew in places where it was nice to be on acid. I never went to Good Room because it was in Greenpoint, a beer cost nine dollars, and the venue was somehow uncomfortable. I never went to Mood Ring, across the street from Bossa, because the crowd was so young I looked like a chaperone at a school dance. I had meant to go to Public Records, a new audiophile club in south Brooklyn that had brought in some of my favorite musicians, but it was in south Brooklyn, an hour on the train. I hated Elsewhere; Basement was fine. Mostly when I went out now it was to Bossa or UNTER or Nowadays or to the once-a-year-experiences of Fourth World and Sustain, plus the occasional Bunker, Mutual Dreaming, or Sublimate. These were the parties where the people who went tended to care about the music, and where I knew I would see friends. On the night of Club Night Club I looked forward to going back to an unlicensed venue, an increasingly rare experience.

From the outside, the building looked dark, the front door was locked, and the only indication of what was going on inside was the sound of the bass vibrating up from the storm drains. As we had

been instructed in an email, we entered through a gate that led into a parking lot to the side of the building, where a bouncer stood to make sure that whoever went in already knew what was going on inside that night. We walked toward a loading dock, where a small group of people stood smoking cigarettes and shivering as the sweat cooled off them. Inside, the lobby of the building, with its concrete floors and high ceilings, had the atmosphere of a tech start-up. A line of people with smeared eye makeup and dilated pupils snaked out of the bathrooms next to a wall of fake plants, laughing and flirting. Some ticket-takers sitting at a folding table stamped our wrists, then gestured toward a fog-filled stairway which emptied out onto a basement dance floor.

I had been anticipating a crowded and sweaty party, but the room was vast and dark, with narrow columns and gray-painted floors. The crowd in front of the speakers occupied maybe two-thirds of the space. The primary sensation was the physical experience of the bass, which reverberated in a deep and dislocated center of my being. The music was made for the basement, for fog, for night. I thought of the sound of when a smoker left a metal door of the roof of my apartment building open on a windy day and it would squeak open on its hinges and then violently slam; of the drill of the Second Avenue subway line tunneling into bedrock; of the CGI frame of a skyscraper groaning and toppling in a disaster movie; of a horn blowing a Mayday signal from a foundering ship; of honeybees replaced by scuttling micro-drones programmed to pollinate. The DJ went by Bruce; he was from Bristol. He was invisible behind a crowd of moving people, flanked at his table by two towers of speakers wreathed in fog and glowing with blue light.

We passed through the dance floor into a large, windowless room lit a soft convivial pink. A bar was set up behind a table, staffed by friends. We hung up our coats on a rack filled with hangers. Some

haphazard furnishings of stackable plastic chairs and a ripped white pleather couch were concentrated in one poorly lit corner. Clusters of friends laughed and sipped beers or crouched around the furniture, dipping their keys into tiny plastic bags. That night the room was full of the familiar faces I always saw. It was nice to once again be at a party in a spacious and libertine environment, with a room to sit and talk, and where the bathrooms weren't disgusting. At that pre-mask point, the hygienic guidance about COVID was all about handwashing. Responding to the needs of the moment, the promoters appeared to have stocked the sinks with the soap section of an entire bodega, and I dabbled between mango-and-pomegranate Softsoap and "waterfall"-scented Method, Colgate-Palmolive's nightmarish imagination overwhelming my LSD-sensitive nose. I smoked weed to turn up the acid and lost myself in movement and sound, but something was off that night. I couldn't find the right drug balance; I couldn't quell an omnipresent anxiety.

At around seven in the morning, I went up again to the floor where the bathrooms were and at the top of the stairs was startled by the sight of two uniformed police officers interrogating a dissipated man with long hair.

"What's going on here?" one of the cops was asking.

"Nothing man, nothing's going on here," the guy said, gazing floorward with a sardonic grin.

"Is this a group of friends hanging out?" the cops asked. I couldn't understand how they had gotten in unnoticed. They appeared not to have passed through the entrance with the security guard in the back. Maybe the front entrance had been propped open to let in some air, or maybe this confused raver had let them in.

I thought about retreating back down the stairs, but then they would know where the party was, so instead I continued toward the bathroom through the lobby, which at this late hour was now mostly

deserted. On my way I stopped at the folding table, where languid promoters were still waiting for any very late arrivals, and told them about the cops. A young man who seemed to be in charge suddenly appeared with a cell phone.

"Were they inside?" he asked me.

I was confused—were the cops, like vampires, forbidden entry without an invitation? I was, in that moment, peaking on a bump of ketamine.

"They were inside . . . the front door?" I said, not sure if he was asking if they had gone down to the dance floor (they had not). "They were just at the front door." I gestured in what I thought was the direction I had come from. I was very sorry that I was failing to relay the information in a more efficient manner. When I returned from the bathroom in a cloud of Procter & Gamble's idea of lavender and chamomile the cops were gone, but a few minutes after I went back downstairs the music abruptly stopped. In the next room, the bar was dismantled in a matter of minutes. We found our coats where they hung on the racks and walked home under the gray clouds and wind gusts of a Saturday morning, trash blowing through the empty streets of Bushwick.

16

THE EVENTS OF THE NEXT WEEK HAPPENED SO QUICKLY. WE SPENT that Saturday in bed. We watched *Nora from Queens.* We got delivery twice. On Sunday, our friend Diego offered to make burgers and a dozen people came over for an impromptu dinner party that turned our apartment into a hot box. On Wednesday I spent an afternoon reading the Google docs being circulated about the new virus on social media from Italy and China, which sufficiently scared us into thinking we should stay home. But instead, against better judgment, I went out to dinner in Manhattan for what turned out to be the last time. On the train home I read the news that Berghain had canceled all events until late April. I didn't go out again.

We could have, that last weekend. The bars were still open, but limited to half-capacity. Looking in their windows, one still saw flickering candles and groups of friends having cocktails. The subways still ran below our fire escape. Bossa was open, and posted a meme that Friday: "CDC recommends to ban all gatherings of two hundred and fifty or more people. Guessing your DJ night is still happening!" But by Sunday even Bossa had stopped joking, and by Monday every venue in the city had gone dark.

In the weeks that followed I gained weight, my glasses broke, I watched two different neighbors doing surya namaskars through

windows that needed to be cleaned. When I went out for walks, I saw disposable latex gloves among the food wrappers and plastic bags in the gutters. The number of planes flying into LaGuardia diminished and finally stopped, and Broadway turned into a long corridor of drawn metal shutters. Spring came with a burst of birdsong that was loud in the absence of traffic, and then an uptick of dead migratory birds on the sidewalks below the windows of the new condo developments. In those first few weeks, sirens filled the vacuum of ordinary city noise. I would read accounts of people applauding for medical workers each night at seven, which seemed as misguided as singing a Toby Keith song as the troops shipped off to Afghanistan. Americans loved an act of cheap, self-congratulatory patriotism as a cover for a botched response, for systemic failure. Bushwick at seven o'clock at night was silent, a silence I perceived not as a lack of gratitude but as the only correct response to what we were experiencing, which was disgust.

The panic of the first weeks gave way to monotony. I donated money to the bartenders and staff of UNTER, of Nowadays, of Bossa. I gave money to the laid-off salespeople of McNally Jackson Books, to the staff of the nail salon I went to, to the Seattle *Stranger*, to Bushwick Daily, to Baby Skips coffee shop, to my yoga teachers. But more than anybody else I gave money to DJs, because in those weeks I had trouble reading anything but the news, I did not have the attention span for any television, and the only movie I managed to watch was *Contagion*. All I could do was listen to music.

Nowadays had started a nightly stream that became my solace. Other musicians I liked broadcast from The Lot Radio. One night I got a text message from a friend about an online dance party to the soundtrack of a live set from the Bunker resident Mike Servito. I had quickly learned, in the first days of the pandemic when videoconferencing as a social medium was a novelty, that I didn't like online

dance parties, but this one was different. The grid of people were on mute. There were familiar faces. Someone had once made a joke about their "*plur*tonic friends"—the people you only knew at the rave. These were my friends but I had no idea what any of them did for a living, what had brought them to New York, and whether they were still here. There were gays in harnesses, a woman working out with hand weights, a bearded man in a hot tub rotating through a variety of thong mankinis. Two women made out in front of a strobe-lit venetian blind. Another danced in her underwear and a Korean beauty mask. Someone took out their dick as they writhed before the camera. These were people I recognized from the party circuit. They weren't trying to be cute, or performative. They were taking this as seriously as they always had.

I had always known that the past few years of going out and music might be a phase of my life, and that one day, even if I didn't start a family, my attention might wander on to the next thing and it would end. Like a lot of people in New York I daydreamed about a less enervating life in a less expensive city. I still had a year, maybe two, to try to have a child. I knew my most transcendent drug experiences were probably behind me. There were times . . . I remember once, at Sustain, watching someone undertake an intensive ritual of nasal self-care: first a squirt of saline spray in each nostril, then a gentle blow into a tissue, then a deep swabbing of the nose with an ointment on a Q-tip. Something about watching the cotton swab pushed all the way up the nose provoked a visceral reaction in me. So yes, there was a place to which I did not want to take this, and I pictured the point in my life where I would let go. People dropped out of the scene almost as a matter of course. Someone would be there reliably for years and then all of a sudden you never saw them anymore. They left the city, or they got sober, or they had kids, or they decided they wanted to be more responsible and productive after all.

"At some point I stood back and went, 'Hold on, the only thing I've got in common with these people is that we're in the same room and on the same drugs—I've tried talking to them outside, we've got nothing in common,'" Andrew Weatherall had told *The Guardian* in 2016, in an interview I read before I had gone out that last night.

At other times I thought the scene would die out of its own accord, as most of the things I had ever cared about had disappeared in New York, usually for reasons having to do with the rent going up. But music scenes are always cyclical; they rise, then lose their reason for being as the culture changes or they do. They either become nostalgist or they die. My mood at that last rave had been that I was already experiencing a wave of nostalgia for something that was ending. We were a diminished group of friends in the basement of a building on Wyckoff that was going to become a yuppie bowling alley frequented by people who interpreted their interior lives through binge-watching television. It was already different from a few years before, in the abandoned office building in Greenpoint, with the sun rising up over Manhattan and the red curtain blowing out the open window.

Regardless of whether the thing had already been dying, it was definitely gone now, and with it the illusion of health and safety. The purveyors of security, so diligent in jailing people for drug possession, and policing sex work, and shutting down a bar that sold liquor after four in the morning, were in disarray when the actual danger arrived. The cult of wellness evaporated in a cloud of Lysol. Over the course of a few weeks, almost twenty thousand New Yorkers died of COVID-19. Refrigerated trucks were parked outside the hospitals to store the bodies. Woodhull Hospital still gleamed pink in the sunset, but what was happening inside in those weeks would probably never be fully known. The death rate for hospitalizations at that time was around thirty percent.

I watched the livestreams on my laptop, the music calming me, the

chat rooms a kind of mini-reunion. Club music without the club was devoid of so much of its purpose, but the DJs knew what we needed, as they always had, and wove tapestries of music that offered the only narrative I could handle then, which was one of abstraction. I knew the digital gesture was a false solace, that what I was missing was not going to simply reconstitute itself when all of this ended. Watching the streams I thought of a satellite that had been launched into space, that was traveling to the outer reaches of the galaxy. For now it still sent us signals but at some point, in the near or distant future, the signal we still scanned for would be too far away to receive.

But it wasn't even the pandemic, in the end, that destroyed it all for me. It turned out that Andrew and I had gotten it wrong, that I had written it wrong when I wrote that it was easy in the beginning to see how things would end. The way it ended was not something I could have anticipated, because it was unimaginable, and outside my realm of experience. I have gone through the events in sequence over and over, and still they do not make sense.

I hadn't minded the first few weeks of staying home. I liked being with Andrew every day after so much time apart, and the sense that the only safe enclave you could build in the world was with the people you loved was only more heightened by the pandemic. But in May, I'm not sure when, or when I noticed, Andrew started having difficulty doing things. He would sit on the couch working on his laptop for eighteen or so hours a day. I'm not sure what he was working on at the time—his music or a freelance engineering job he had taken—or if he was working on anything at all. He lost all desire to leave the house, not even for the short walks I suggested might make him feel a little better. He stopped taking his clothes to the laundry; he stopped showering. He dropped the pretense of waiting until the afternoon to start smoking pot, and kept a vape pen next to him on the couch, drawing on it all day. He lost interest in sex, and I had to beg him to

pay attention to me. I was scared. Something was wrong. I watered the plants, did the dishes, took out the trash, kept the litter box clean, did the grocery shopping, and invented little excursions to make myself happy while everything was closed, like biking to the fish store in Greenpoint, or to the French bakery near Myrtle-Wyckoff to get us bread. I bought us wine, but he would just drink it all, so I stopped. I oscillated between sympathy and frustration, which would bring out his anger, which was irrational and intense. He was not only angry at me. He was angry at an artist with whom he was producing music, at a relative who had not responded to an email, at the friends with whom he ran a small music label, at his job. He was angry all the time. I tried to stay calm: being depressed and irritable seemed like a normal response to the state of the world. I didn't understand what was going on, but I thought it would pass.

By mid-May New York started to open up a little bit, and one warm spring day we met up with some friends at Maria Hernandez Park, our first time seeing a group of friends in two months. We had set a time to meet them, but Andrew had trouble leaving the house. I could see it was hard for him to shower and get dressed; everything had been hard, but he made it outside and we had an evening sitting on the sidewalk with friends and eating tacos. It was the most normal we had felt in a very long time. At the end of the night, biking home, we were both elated, and I decided our problems were just the strain of the times we were in.

But something was wrong. When I look at text messages from this time, I see I sent him a recipe for Sichuan noodles, a real estate listing for a house in New Mexico, a link to a mix of Japanese pop music from the 1980s, pictures of the cat—little missives that were the currency of our day-to-day communication. We were on different sleeping schedules, but when he woke up, a few hours after I did, he would make us smoothies. But things were bad. We started to argue

loudly enough that the neighbors would call. It was the same fight we'd always had and managed to recover from, but the tenor of it was getting increasingly vicious. When he was high and unresponsive to the point where he was almost catatonic I would say terrible things, trying to get him to react. Because music was his excuse for shutting himself into a room and smoking weed for days at a time, I had started to attack his idea of himself as a producer. I called him a dilettante and a loser and accused him of making us both miserable for what I called a hobby. I told him that he was pitting a fantasy of himself against the reality of our life together. I said that I was no longer capable of supporting what was really just an excuse to get high, that I couldn't live with someone who passed out on the couch most nights and slept until midafternoon. I was saying things that I knew I would not be able to take back, but nothing I said was harsh enough to get his attention or make him change. One afternoon he locked himself in his studio when I asked him to take out the trash and I kicked a hole in the door. He opened the door and came out, blowing weed smoke in my face to spite me. He said I resented his happiness and that it was my fault he wasn't producing music. He didn't have enough room in his studio to work, he said, and was going to set up everything in the living room instead. "Fine," I said. He ripped cords out of sockets and began piling all of his synthesizers and mixers on the dining table. He knocked over a bottle of gin from a bookshelf and it shattered. A puddle of gin seeped slowly past the shards of glass on the floor while he stalked around the apartment in fury. I went into my office. He followed me in, making a point of blowing more smoke around the room. He looked at the couch against one wall. We had recently moved it there from his studio. "If we're doing everything equally, I want my couch back," he said, and he started dragging it out.

The music equipment sat unused in the living room for the next ten days, until he finally put it back in his studio. I moved a couch that

had been in our bedroom into the office instead. There was the anger, and then there was a sullenness, an evident not-caring that hurt more than anything I had yet to experience with him. It was not an unfamiliar attitude, but had previously only appeared in rare and fleeting moments. Something was different. I looked online to see if there was some kind of Al-Anon for family members of weed smokers and found a group called Mar-Anon, but I couldn't convince myself that he had what I understood to be a "real" addiction—it wasn't heroin or alcohol. I wrote a long letter to myself to remember the reality of the moment as best as I could. I argued it out on paper, trying to figure out if it was time to leave. Living with him in this state was like living with a black hole. He was stoned virtually all the time.

But was I really going to end things with the person I loved the most over weed smoking and dirty dishes? Why not just do the dishes and not make a big deal out of it? I resolved to do so. His depression would pass, and for now I would fix things. We could open a shared bank account and stop worrying about who was spending more. When the pandemic stopped we could hire a house cleaner; I would stop complaining about the division of labor, stop trying to keep accounts. Andrew was right: I needed to be less concerned. If we shared everything, we were in this together. I was much too obsessive about equality.

17

ON MEMORIAL DAY, MONDAY, MAY 25, A WHITE POLICE OFFICER NAMED Derek Chauvin murdered a Black man named George Floyd outside a convenience store in south Minneapolis, kneeling on his neck for nine minutes and twenty-nine seconds while three other police officers stood by and watched Floyd die. Later that night, a high school junior named Darnella Frazier, who witnessed the murder, posted a video recording of it on Facebook. I never watched the video. I saw the news on Twitter that night, when someone I followed in Minneapolis politics posted a link to a local news article, adding that the murder had happened a few blocks away from his house.

The protests started in Minneapolis the next morning. I wrote my editor asking if I should go and the answer was to wait and see. In the end I missed my chance. One of the combat reporters who had been drawn back home by the growing violence got in a car in Michigan, where he was reporting on right-wing militias, and drove to Minneapolis through the night. I wept on the phone with my editors when they told me, hating myself for being indecisive, and for a tendency to wait for permission that I coded as female and that seemed to be at the root of every professional failure. I knew it was unseemly to be self-centered in a moment like this. Andrew, ever on the lookout for the low-hanging moral callout, disdained how I tied

my professional ambitions to horrific events—he had pointed out to me before the depravity of journalistic practice, the way journalists made their names by piggybacking on acts of violence and injustice. This was such a stupid and obvious point of view I didn't have the energy to argue it out, but he had national opinion on his side. And what was my claim, anyway? I had grown up in Minneapolis but had not lived there for twenty years. In those first few days of the uprising there were two things that did not surprise me, however: The first was that that when America finally brought itself to the barricades, it was a Black-led rebellion and it was not about gun control or climate change or women's rights but about racism. The second was that this rebellion reached its galvanizing apotheosis not in Ferguson or Staten Island or Los Angeles but in Minneapolis.

It wasn't just my familiarity with the place—an uprising against racism happening where I had learned about racism, which is to say the place where I had been a child in the United States of America. I think also it had to do with the politics of the city, but every time I tried to articulate what those politics were I could only come up with decades-old memories—of being one of the only kids on the school bus on the day of the Million Man March; of the eighth-grade teacher who went to Rainbow Gatherings, assigned us Howard Zinn, and had invited anarchist punks as guest lecturers; of Rhymesayers showcases at 7th St Entry full of teenagers wearing puffy coats and bobbing their heads in unison, sketchpads of graffiti designs in their backpacks; of the camp counselor who would feed her plants with the wash water of her reusable menstrual pads; of the May Day parade each spring in Powderhorn Park, where puppet effigies of bankers and pharmaceutical executives were chased away by the pagan gods of spring; of my childhood classmates who became Five Percenters in high school, wore headscarves, and explained theories of Black nationalism; of the militant vegan, the daughter of a member of the

Replacements, who had converted me to vegetarianism at fourteen; of KMOJ, "your *power* station"; of our childhood friends who had gone on to chain themselves to trees and fight in the Battle in Seattle, the antiglobalization protests of 2001; of the crust punks and bicycle punks and straight-edge punks and freight-train punks and antiracist punks. My parents were Clinton Democrats and boomers from the East Coast for whom *The New York Times* was the mouthpiece of reason. Exactly none of this exposure to radical thought came to me from them. It came from the city. We read Fanon, we read Baldwin, we read Alice Walker, we read Angela Davis, we took a class trip to the University of Minnesota when Cornel West came to speak. Our soundtrack was A Tribe Called Quest, Black Star, Dead Prez, De La Soul. The commencement speaker at my high school was Clyde Bellecourt, one of the founders of the American Indian Movement, which had been started a few blocks away as a response to police harassment of American Indians in the public housing project of Little Earth. These memories mixed themselves up with other, more sensory recollections—my patent leather shoes slipping on the ice of the parking lot of Saint Mark's on a Sunday, my toes hurting from the cold; the way the streetlights made the sky purple during the months of snow; the click of my stereo each morning when the morning alarm started the first track of *Do You Want More?!!!??!* or *The Downward Spiral*.

After I moved east for college, I stopped being a vegetarian; the conscious hip-hop made me cringe; I started wearing makeup and shaving my legs. I stopped thinking all the time about whiteness. I no longer had to experience the particular burning shame of it that one had in high school, where we were not yet stratified into our lanes in life (for shame and self-disgust are the charmed white experiences of racism, rooted primordially in childhood memories of things you did and said before anyone told you how to act right, which is why

the racists are so committed to eradicating any text or history that might introduce even a quantum of shame). From the vantage point of the East Coast, Minneapolis and its politics started to look earnest and naive, and I did not see that I was merely conforming to a more conservative culture and learning to navigate its rules. But now, as the great eye turned on Minneapolis, I had to admit that all of this personal interference would have only impeded the journalistic task at hand. I couldn't even explain my reaction to Andrew, who had grown up in an utterly different socioeconomic reality.

In any case, I was in New York that Wednesday night, two days after the killing, sitting on the couch and watching the livestream broadcast by a Minneapolis-based collective of reporters called Unicorn Riot ("our commercial-free platform operates non-hierarchically, independent of corporate or government control"). Unicorn Riot streamed in real time as the demonstrators wandered through the halls of the Third Precinct of the Minneapolis Police Department and torched it. On my laptop I watched the camera record the red "fuck you" spray-painted on the cinder-block wall. The cameraperson continued down a hallway past a Pepsi vending machine, then stopped to record the flames seen leaping from a wheely black chair through the glass window of an office. The fire alarm went off; the sprinkler system activated. There was shattered glass on linoleum, a haze in the air, figures in gas masks and hoodies, unseen bangs and explosions. The alarms buzzed like the cicadas in my drug hallucinations. My heart was pounding. Finally the response was proportional to the outrage. "This is the Third Precinct right here," the voice behind the camera explained to me, as I sat on my couch in New York City. The pandemic-empty J train rumbled outside below the window opened to the soft night. "It just got ran through."

The streamer went back out into the night. I drew my laptop closer, nonsensically, searching for faces I might recognize in the

crowd. I'd lost contact with the people I'd known growing up, I didn't know what kind of people they were anymore, if this was the sort of event they turned out for. A police riot helmet was being held aloft like the severed head of Macbeth we had made out of papier-mâché for a fourth-grade-class production. There were hundreds of people gathered in the night yelling, "I can't breathe."

"This is an organic uprising from the belly of the beast of America," the streamer said. "This has been bubbling, bubbling, for four hundred years." Somehow in that moment that was the most Minneapolis kind of thing to say.

Minneapolis. After my dad was laid off from his job at Minnesota Public Radio in 2002, while I was in college, my parents had sold the house I'd grown up in and moved away. The last time I'd been back was to cover Ilhan Omar's congressional primary in 2018. Then it had seemed that not all that much had changed. Omar was a progressive Democrat in the political tradition of Paul Wellstone, the iconic liberal senator of my childhood, and Keith Ellison, the first Muslim elected to Congress, who was then vacating his seat to run for attorney general. I followed Omar around and what I noticed was how nice things were, how spacious and airy the designs in the coffee shops and microbreweries where Omar held her meet and greets, how green the city's parks were.

Omar had campaigned on addressing Minnesota's indices of racial inequality. The state ranked as one of the most racially unequal places in the country, with a high quality of life for white people and dramatic differences in outcomes for Black and Native American Minnesotans on income, home-ownership rates, graduation rates, school-suspension rates, infant mortality, criminal sentencing, and unemployment. The police forces of the Twin Cities and their suburbs had a long history of killing and harassing Black men. Philando Castile, the thirty-two-year-old school cafeteria worker who was shot

and killed by a police officer during a traffic stop in a suburb of Saint Paul in 2016, had been pulled over by the police forty-six times since he first received a ticket for a supposed violation of his learner's permit at the age of nineteen.

When I sat on my couch and watched the Third Precinct burn I knew that the particular political sentimentalism of the city was finally converging with the empirical reality of inequality, segregation, and police murder, and that it was extremely likely that at least some of the people setting Lake Street on fire that night were white kids—not accelerationist outsiders but people equally enraged in the moment. (Of the four people later convicted of arson, two were Black and two were white. All four said they had been motivated by their anger that the police had killed George Floyd, although one of the white guys later told Al Jazeera that he had been in the middle of a prolonged manic episode at the time.) In the days that followed I saw commenters from elsewhere impose all kinds of theories and paradigms on the city's rage and what had fueled it, and draw from conclusions that seemed divorced from the specificity of the place. That was to be expected, but it also bothered me. The uprising had been spontaneous, but it had also come from a city with a long tradition of radical activism, and people on the coasts always had trouble computing that the people in the middle could live radical lives; they could picture it only as a volcanic eruption of emotion. I don't know, or maybe I'm wrong. It just bothered me later how New Yorkers put the whole thing into their own frame of reference, as New Yorkers always will.

The Third Precinct of the Minneapolis Police Department was a mile or so from my high school. That night and over the next few days I could see from the footage of the ransacked neighborhood that very little had changed since then. There was the Wendy's on

Lake Street that we would go to at lunch sometimes, on fire; there was the Town Talk Diner, where my friends took me for breakfast on my eighteenth birthday before school, burnt to cinders; there was Uncle Hugo's Science Fiction Bookstore, its collection destroyed. Now things had changed.

18

THE PROTESTS IN NEW YORK BEGAN THE NEXT DAY, THURSDAY, WITH A much larger one planned for Friday outside Barclays Center in Brooklyn. I was asked to cover it. I expected a protest like most of the ones I had seen in New York City, where the police would use metal barriers to corral a crowd, some protesters would perhaps sit down and block an intersection in an act of civil disobedience, the police would wade in and arrest them one by one, et cetera, but when you protest the police themselves, the rules change. By the time I reached downtown Brooklyn, the NYPD had already been on the attack. More than two hundred people were beaten and arrested and pepper-sprayed and now were being loaded onto MTA buses to be taken to central booking, their clothes torn and their eyes red. In one wave of arrests by the police, a plainclothes officer shoved me to the ground. My camera was broken, my knee was injured, but I saw much worse than that.

I went home and wrote down what I saw, then followed a protest that started in Harlem the next morning. Andrew met friends at another protest in Lower Manhattan. I ended my day in Flatbush. The photographer on assignment with me wanted to see a cop car set on fire, so we stayed here as night fell. Demonstrators dug up the rocks around the trees and threw them at NYPD vans moving in to try to cut off the street. An MTA bus got stuck in a nearby intersection, its

driver flashing a message on the signs that alternated "EMERGENCY" and "CALL POLICE" until the bus went dark and just sat there, a hulking shadow ignored by the protesters at the same time as just behind it another police car was set on fire. The photographer got the photo she wanted, and we went home. I stayed up late to write. I woke up the next morning and wrote some more. When I finished my article, Andrew and I had what seemed like an ordinary domestic argument about the mess that had piled up as I had worked, except that it ended with him telling me my clothes were ugly. The sense of estrangement, a prickling sense of shock, flared again. The next day, the mayor announced that the city would be placed under an eight p.m. curfew. The days continued like this: protests, then writing.

Except for security guards, and workers at the few fast-food restaurants that were still open, much of Manhattan seemed utterly deserted as thousands of marchers took to its streets. The Financial District looked abandoned. "This location of Au Bon Pain will close on May 17," photocopied announcements on a shuttered bakery read. The city's signage remained frozen in its old context. It was hard not to notice how much of the advertising insisted on goodness and detoxification, on ethics, heritage, and authenticity. "The coffee you're about to enjoy was roasted: 5.2 miles away," advertising on the darkened windows of a coffee shop read.

I trailed marchers down a traffic-free Madison Avenue, past the emptied store windows of Bottega Veneta and Celine and Dolce & Gabbana and Hermès. In Midtown they walked past the Eugene O'Neill Theatre, its marquee still advertising *The Book of Mormon*, past Just Salad and Starbucks, into Times Square, where a small and relatively calm line of police officers stood to protect Hershey's Chocolate World and Olive Garden from the marchers' anger. Most of the protesters were teenagers from the Bronx and Harlem. I watched as they paused, knelt, and, bathed in the flickering lights

of a hundred video billboards, read out a long list of names of Black men, women, and children who had died at the hands of the police in recent years. As they raised their hands and said "Hands up, don't shoot," a giant anthropomorphized blue M&M smiled down upon them. An animated wand of Cover Girl mascara endlessly separated eyelashes above messages about rejecting animal cruelty. Someone threw a water bottle at a billboard. "Don't throw anything!" another protester shouted.

At the end of that week my editors told me to take a break, but there was one more demonstration I wanted to see, in the Bronx, where I hadn't yet gone. This was not for an assignment; I just did not want to stay home. I hadn't yet shown up to a protest as a civilian, only as a journalist. That night I thought maybe I would just go protest. I asked Andrew to come with me. He didn't want to go but I persuaded him. "We'll go home before curfew," I promised. "I just want to see." I relive this moment. I think I will forever. You can ruin your own life in an instant, by not paying attention.

We drove to the Bronx in my dad's Toyota Corolla, which I had borrowed. The protest, which was not apologetic in calling itself "FTP," was leaving from the Hub in Mott Haven. As we walked toward the meeting place, we saw throngs of riot police on bicycles, the kind of police who had been the most violent in the preceding days. The police presence was heavy for what was a relatively small group of people, compared to the thousands that had been gathering in the streets earlier that week. As we arrived at a small plaza in front of some shops, cops monitoring the scene from the rooftops above, Andrew and I stood near each other. My press pass was in my bag. The impulse to record detail was too strong. I took it out and put it on. As the rally started and the speeches began, I turned on my audio recorder, took out a notebook, and began taking notes. Andrew watched me. He knew of my internal conflicts about the illusion of

journalistic objectivity; about being a "tourist" who only observes rather than participates in first-order experience; about having a job that transforms political uprisings into spectacle. He did not understand that this was the only way I knew how to participate in the world. I could not be otherwise.

We walked down the street, following a banner that read "Punch that cop!" All week I had been thinking back to some teenagers I had met in Chicago two years before who had relatives killed by guns, and who had repeated to me the Kingian principle that "Nonviolence resists violence of the spirit as well as of the body." The radical scolds on Twitter dismissed such philosophies as "respectability politics."

The police followed at a distance. I was separated from Andrew as they began to circle closer and the organizers put out a call for "white allies" to come to the front. Andrew moved up to the front. I lost sight of him. Shortly before the eight o'clock curfew, the police kettled the group onto a cross street and would not let anyone out. The clock had not yet struck eight when they began beating, pepper-spraying, and arresting everyone. The violent beatings by the police outdid anything else I had seen in that week of seeing people beaten.* I looked for Andrew in the chaos. I could not find him. I was pressed against a fence on the sidewalk; all around me people were getting pepper-sprayed and arrested, pushed in groups against one another. A teenage girl was hyperventilating. A pregnant woman was screaming. I took out my phone and started recording video, my hands shaking. As the arrests began, I started posting on Twitter. Legal observers were handcuffed and arrested. Medics were handcuffed and arrested. Two police officers pushed against a group I stood with. One grabbed

* In 2023, New York City agreed to pay at least $21,500 to each of the people arrested at the protest in the Bronx that night as part of a settlement after a class-action lawsuit was brought against the city.

my arm. I reflexively showed him my press pass. "I'm press!" I yelled. "I can't hear you with that mask on," said the cop. He shoved me. "You're not supposed to be here," he said, which was what the cops had been saying to me all week. But they let me go without arrest, along with two young Black women, sisters, it turned out, who later told me they suspected they were let go because their mother had worked as a prosecutor in the South Bronx. We were disgorged on the sidewalk outside the ring of cops, where a handful of other reporters had also been let out, all of us stunned by the violence. I looked for Andrew but I knew he had been arrested. I had made him go to the protest and I failed him.

By now my editors were calling me. They had seen my posts online. The police pushed us down the street. There was nothing to do but leave. I walked away from it all, back to the car. As I walked, I overtook a demonstrator leaving the scene. I noticed he was wearing a T-shirt from Dweller, the Black electronic music festival. A head. I acknowledged his T-shirt and introduced myself. He lived in the neighborhood. He had gotten out of the arrests by jumping over a car. He seemed calm about what he had seen, unsurprised. We walked back together, him toward his house, me toward my car.

I sat in the Corolla, unsure what to do. I called the protest helpline set up by the Bronx Defenders to report what I had seen. They told me they would call back when they knew where the protesters were being taken. Andrew, with his long arms, had managed to reach his cuffed hands into his back pocket and text me from his phone. He had been arrested, he said. They were in some kind of transport van. They had just passed signs for LaGuardia Airport. *"LaGuardia?"* said the lawyer on the helpline when I called her to report it.

I didn't know what to do, so I went home. The cat was distressed about Andrew's absence. She paced and meowed, then came and sat on my lap. It was almost eleven when a call came through from the

legal observers. Most of the arrested protesters had been taken to Queens Central Booking, near Flushing Meadows. I got back in the car and drove there.

It had started to rain. The air was damp and chilly, the streets dark. The demonstrators had set up a jail support station sheltered from the downpour by some construction scaffolding. As the protesters were released into the rainy night, the support group beckoned them over to offer snacks, hand sanitizer, and cigarettes. Legal observers took names and interviewed the protesters about what had happened to them. Volunteers ordered Lyfts and Ubers to transport the released ones back to the Bronx. Jail support was supposed to be a place of de-escalation: reporters, slogans and signs, and confrontation with the police weren't allowed. I was absolved of journalism; here I could just help. The arrested demonstrators slowly trickled out one by one into the rain. It was dark, and cops had not allowed the jail support team to go near the entrance. I volunteered to step out in the street, stand under my umbrella, and wave as people came out, to catch their attention. They came out bloodied, their clothes torn, looking stunned. I stayed until three in the morning. It was clear Andrew would not be out that night. I went home and went to sleep for a few hours.

I spent the next morning trying to locate him. Some protesters, I heard, had been taken from Queens to Brooklyn Central Booking. Nobody was answering the phone at either place. I decided to drive back to Queens. As I rounded the corner of the courthouse, I saw Andrew striding purposefully out of the jail, in what seemed like miraculous timing. I double-parked the car, ran out of it, hugged him. He did not react. He was smoking a cigarette and speaking with a lawyer. His black T-shirt was encrusted with blood. I pulled the car into a parking spot. When he finished his interview with the lawyer, he got in the passenger side and slammed the door.

I asked if we should offer anybody a ride.

"We're going home," he said, staring straight ahead.

I understood then that he was angry with me. He saw what had happened—his getting beaten, forced to sit with the pepper spray burning his face and eyes for hours without access to water, sixteen hours in police custody, a broken finger, a scratched eye, a bloody nose—as my fault. It would not have been helpful in that moment to argue that the protest had been about something much bigger than him or me. I had made him go, and I had gotten out unscathed.

WHEN WE GOT HOME, ANDREW STRIPPED OFF ALL OF HIS CLOTHING, got into the bathtub, ran the water, and asked for his bong. I brought it to him and sat next to him as he smoked weed and told the story. He had been at the very front when the police had surrounded the group. He told me he had started goading the police, and they had attacked him in turn. He was one of the first people arrested, a target because of his size and aggression. The more than three hundred people who had been arrested had waited in line for hours to be processed. Then he was put in a cell full of men, some of whom were freaking out and shouting at the police. Nobody had slept.

He got out of the tub and dried off. I took photographs of his injuries for documentation: the abrasions on his elbows; his irritated eye; his swollen finger. Then he crawled into bed. He plugged in his phone and began looking at reports of what had happened. In jail the men in his cell had agreed on a hashtag, and he began looking through their posts, pointing out to me the people he knew. He looked through videos and photographs of the scene trying to identify the cop who hurt him. He was too amped up to sleep. I ordered us Mexican food and we lay together in bed and ate it. Finally, he fell asleep.

For the next few days, Andrew became hyperfocused on learning about the squadron of bicycle cops who had descended on the

protest, using their bikes as a shield, sending me a 2017 article from *The Guardian* about a police strategy that had its origins in the Battle of Seattle. He talked rapidly about everything he had learned. He wanted to order protective body armor on Amazon: kneepads, elbow pads, a vest. His speech was accelerated. The stagnation of the previous month had lifted but now had been replaced by a new, vicious energy, and a righteous political anger that I could not seem to sufficiently meet or respond to.

A few days later, on a Tuesday, Andrew borrowed the car to go to the beach with some friends. It was a perfect, sunny June day. I had to write about a City Council hearing where protesters would be testifying online about the brutality they had experienced the previous week. We decided he would take the car and go, and I would take a train to the Rockaways to meet him later. We had a little argument before he left. I don't remember what it was about but I remember that afterward we looked at each other in fear. What was going on with us? Why were we fighting all the time? We held each other. "I love you," he said. I buried my face in his chest. "I love you so much," he told me.

The hearing lasted for hours. I watched testimony after testimony about police violence until I had trouble concentrating. I thought about Andrew with his friends at the beach and about how he reserved all of his aggression and anger for me, and his fun side for others. I sent him a snide text message about having borrowed my car. I wrote that I was feeling left out, that I wanted to come join them. He said it was probably too late, that by the time I took the train there they would be leaving. I responded that if that were the case I would be upset if he stayed out late. I was picking a fight.

"It's rude that you keep texting me, not allowing me to enjoy the beach, because you feel left out," he wrote. "You could have come but you chose not to. Now you're doing this because you want me not to have fun, as revenge. It's annoying."

"I have a job," I wrote back. I was feeling sorry for myself. "You never go anywhere with me," I wrote. "You live on the couch."

"I am currently sitting away from my friends just to talk to you because you are having a little fit," he wrote. "This is what you always do, and always have done." I told him I would stop ruining his day. "Why does it make you upset if I have fun and feel good about myself?" he responded, angry now.

He kept texting as he dropped off his friends. "I had some time at a stoplight to say fuck you."

I made dinner and opened a bottle of wine, hoping that when he got home and ate I could apologize and smooth things over. He came in and slammed the door. "It's over," he said. "Are you going to move out, or am I?" I didn't say anything. I could see by the expression on his face that this was outside the realm of any normal conflict. For once I knew to keep my mouth shut, but it didn't help. Andrew grabbed a handful of the rice on my plate and dropped it into my glass of wine. I began to tear up.

"I'm going to harass you for an hour the way you harassed me today," he said.

I took my plate and tried to walk away. Andrew served himself a plate of food. He poured himself a glass of wine. Then he followed me. "I'm not going to leave you alone."

I don't remember everything he said. He wasn't coherent, he was yelling. I knew I had to get away. I ran out of the apartment.

I didn't want to tell my friends about the situation I was in. I sat in my car and booked an Airbnb for the night. I drove into Manhattan to the apartment. Messages from Andrew kept arriving on my phone. I wrote him that I knew the fight had been my fault.

"You are right," I pleaded. "Please leave me alone now."

"I know I'm right," he responded. "I'm not asking you to tell me I'm right." He told me he was demonstrating to me why I was wrong,

and that he hadn't yet given me "the full forty-five minutes of misery I had promised." He told me that I had fucked up something special, that he guessed I had fallen out of love. He told me that he didn't feel safe being in the same space with me. He claimed that I had hit him before. I sarcastically encouraged him to call the cops.

"You would say that," he wrote.

"I'm being facetious."

"Yeah, but you would think that would be a potential solution to a conflict as a Karen," he wrote. "Your mind heads there first as a Karen." That I had used my press pass at the march stung my conscience again.

I asked why he was trying to fight it out if it was over.

"Because if I don't act like an asshole you won't go away and leave me be."

In Manhattan, the owner of the apartment never showed up with the keys. It was late now; the city was shut down and the streets were deserted. I asked Andrew if I could come back. "No," he wrote, bringing up the time I had not let him come back home after he stayed out all night. "You have kicked me out before. Now you get to experience it." I said that I couldn't find a place to stay, that everything was closed and it was not a choice.

"The door is locked," he wrote. "Sleep in the car." He told me to find a friend's couch, and that he doubted I had looked especially hard to find a place.

"Not only are you an asshole, but you're lazy," he wrote. I replied that I no longer cared what he thought of me, that he could keep insulting me. "Okay, I will," he wrote. "Thanks for the consent. Now you can't claim harassment."

He told me he was calling a locksmith to change the locks ("Amazing the service you get in New York—be there in fifteen minutes"). He told me I could retrieve my things from the street the next day. He

told me he felt liberated. "How does it feel to have your day intentionally ruined by the person who is supposed to love you?" He told me he'd had sex with someone while I was at a writing residency a few months before and had never told me about it.

I WAS LESS ANGRY THAN BAFFLED. THE HOSTILITY AND DESIRE TO hurt me was not like him. I was having trouble processing that this was real, that all of this was really happening, that Manhattan was shut down and empty, that a global pandemic had changed the fabric of reality, that protests had overtaken the city, and that I had just watched the NYPD violently beat three hundred people and the mayor had not issued so much as a reprimand. When I got back to Brooklyn, Andrew had changed his mind about the locksmith. The door was open, he had written; I could come in if I wanted to, "Just don't expect to sleep much." When I arrived back at the apartment he was waiting, wild-eyed and angry. I walked into my office, where I could sleep on the couch. There was a dark stain on it. He had peed on it. I stared, trying to process what was happening, while Andrew hurled insults I no longer remember. I started calling friends. It was late. The first one didn't pick up. I called another friend, shaking.

"I'm having a problem and I need someone on the phone with me," I told my confused friend.

"She's exaggerating," Andrew yelled, so that my friend could hear.

My friend was calm. She told me I needed to leave, that I needed to leave now.

"She's being dramatic," Andrew yelled. "She's the one who hit me. Did she tell you she's hit me?" he said. "That she punched me?"

I had never hit him or punched him. He was six foot four and strong. I ran out of the apartment for the second time. As I drove

through Brooklyn, the texts kept coming even though I stopped responding. He took screenshots and emailed them to me in case I had blocked him.

"Like most liberals the thing you were most upset by is property damage," he wrote, with a laughing-until-crying emoji, referring to the couch he had peed on.

"Pretend to be about the cause only because it might net you a book deal."

"Hide behind journalistic objectivity so you don't have to take a stance."

"Flash your press card while Black people get beaten in front of you."

"Don't even take the time to donate to anything because 'you're too busy.'"

"You are the problem."

I STAYED ON MY FRIEND'S COUCH THAT NIGHT, THEN FOUND AN apartment to sublet. I waited to hear from Andrew, hoping for an apology. He did not write the next day, or the next, or the next. Finally I wrote him. I had left with no clothes, and needed to go home and get some. I asked if he could leave the apartment for a few hours so I could get some things. I told him that he had not seemed like himself when I saw him last and that I was worried the arrest had caused some mental distress. I wrote him that I was sorry I had held a grudge about the car, and sorry that I had bothered him at the beach. I waited for him to respond with an acknowledgment of what had happened but it didn't come.

"I don't know, I snapped," he wrote. "It just seemed so mean, what you did." I told him I was sorry. Finally, after more messages where he made it clear I had brought his anger upon myself, he apolo-

gized. "I just want to say in a clear and straightforward manner that I am sorry for abusing you on Tuesday," he wrote. "You are right. I came home furious with the intention of terrorizing you. I have never acted like that before in my life and I need to address it. You didn't deserve that, regardless of whether our relationship continued or not."

He wrote that he was not sure if it was any consolation but that he had forgotten to put sunscreen on his ankles that day at the beach and sustained second-degree sunburns. "Maybe that will make you feel better about your Airbnb situation," he wrote. This response gave me the chills. The person I knew was more self-aware than this. It was as if he had regressed into a childlike state of grievance. He showed no care for me at all and only seemed worried about how he might be perceived by others. He told me he was upset that I was telling my friends and family that he was an abuser. I told him I had done everything possible not to let my friends know he was kicking me out of the house, and that in any case I had not used the word "abuse." Most of my friends and family were simply shocked and concerned. Because it wasn't normal what was happening. It wasn't normal at all.

THE POSSIBILITY THAT ANDREW WAS SUFFERING A MENTAL BREAK AS a reaction to having been arrested, or that he was possibly having a manic episode, stayed in my mind, but he had never spoken of having had something like this happen before. I went back home on a Saturday to get some clothes. Andrew had said he would leave. He had planned to go to a bike protest but on the way had gotten into an altercation with a driver who threw a plastic bottle out of his car. Andrew had thrown it back into the window and then the driver had tried to race him down in his truck.

"I have just been so angry recently," he texted me. I told him I

didn't feel safe around him so when I returned home he waited on the roof. In my absence he had moved everything I owned into one room of the apartment. He had also, I noticed, as I began packing a few clothes into a suitcase, done all of the drugs in the house. But he had also left flowers, and written a letter.

"I have been so angry I haven't been able to process my feelings and understood what I've done," the letter read. "I don't want to break our family apart. I love our life. I love you. I will never love anyone the way I love you. I don't know if we can fix this but we need to try." My anxiety dissolved. Everything was going to be okay. He just needed a good night's sleep; everything was going to be okay.

"I want to make this work," the letter read.

I wish I had stayed in the apartment that night. Instead, I went back to Manhattan. It was the last time he showed care for me, the last glimpse I had of the person who loved me. A few weeks later, in another one of his rages, he rooted through my things, found the letter, and threw it away.

THE NEXT TWO MONTHS PROCEEDED LIKE A NIGHTMARE I COULDN'T wake up from. Because the person who attacked me was so different in personality from the person I knew, I had trouble accepting the new reality. For the first few weeks after his initial episode of extreme rage, I stayed away from our home, but we continued to communicate. He told me he had shaved his head. He had cut up his clothes, rearranged all the furniture in the house, and built a ramp for the cat to climb on. When he asked me for the landlord's phone number I thought he was going to try to take me off our lease, but it turned out he wanted to install an internet antenna on the roof as part of a community Wi-Fi initiative. He went to a bike protest and had sex with a former coworker afterward. I thought bitterly of the direction

his version of the protests had taken, that an uprising against state-sanctioned murder had been reduced to gentrifiers promenading their bicycles around the city and cheating on their girlfriends. He made it clear that he still believed I had deserved all of his anger. He did not ask where I was, or whether I had found a place to stay, or how I was feeling.

I was in a borrowed apartment in Manhattan, which felt like exile. I missed my home. In Bushwick, fireworks overtook the sky every night that summer, murals were being painted on the plywood of construction sites, dance parties were happening in the streets, and the city was livid with sorrow and rage. Andrew was going to the beach, and to Bossa, which had opened its backyard. It was a summer of passion and catharsis lived exclusively outdoors and I was stuck in Manhattan, which now had the quality of an abandoned mall. One night I missed him so much and was so upset about not being in Brooklyn that I just went home. On the phone he had talked about how good he was feeling, but when I walked into the house it was clear how deluded he was. The apartment was wrecked. Dirty dishes filled the sink. The litter box was full of shit. The ramp he had built for the cat was a two-inch-wide piece of Styrofoam attached to the wall. It looked insane. He had moved all of his music equipment into what had been our bedroom, where he planned to reinstall it, but until then it was a small mountain of synthesizers and cords. The mattress had no sheets on it. Broken glass littered the floor. He had gone on an internet shopping spree, and unopened Amazon boxes were stacked in the living room. He had brought home new plants, a projector, pieces of furniture he had picked up on the street from the exodus of people leaving Bushwick. He had hung mini disco balls and wind chimes from the ceiling fans. Instead of taking out the trash he had piled it all in one room. "What does it matter if the trash is inside or outside?" he asked me. "I've been busy. I'm redecorating. It doesn't

happen all at once." In his redecorating I could see my presence, my place in our home, being slowly erased. Everything I owned was still stacked in one corner.

He had been at the beach all day again, had taken acid and gone to a dance party in Bed-Stuy, and now was in a state of heightened emotion and anger because I had dared once again to demand his attention. He had lost weight, and with his shaved head he was physically unrecognizable. The light in his eyes had changed. He was not the person I knew. I stayed the night anyway, relieved to be home again despite the chaos. He slept in the living room on the couch, or rather didn't sleep. When I woke in the morning he sat there, weeping with emotion, and announced that he was going to give away his trust fund, write an article about it, and inspire a generation of millennials due to inherit their parents' wealth to do the same.

I decided to go stay with my parents, who lived in New Hampshire. After ten days, I wrote him that it seemed like he wanted a different life. He wanted to date other people, he didn't want to be with me anymore, I was ready to let go. "I haven't decided whether I want to break up or not," he responded, so I came back to him once again.

I was cognitively unable to accept that his cruelty toward me was real. Why did it take me so long to understand? He continued sleeping with the person he had hooked up with. He told me that he was thinking he would rather be with someone younger, that he wasn't ready for kids after all. "I would be lying if I said I didn't think about dating this person instead of you," he said of the other woman. "My feelings have changed for you." Then he would backtrack and say, for example, that he would stay with me if I started having sex with other men too. He started texting me fantasies about people he wanted to pick up at bars, or sending me dick pics, asking me to send him photographs of people I'd swiped on the dating apps I'd downloaded at his request. "I'm in the Bossa stall where you fucked me,"

he wrote, sending me a picture of himself inside the graffiti-covered bathroom. But he knew sexuality was another way to hurt me. My campaign of not getting angry ended when he told me the sex was better with the other woman. I picked up one of his synthesizers and threw it on the floor. He billed me $200 for it on Venmo. Later, he tried to walk back what he said. "I was just trying to hurt you," he said. "It wasn't true." I had no idea what was true anymore. A lot of things had fallen apart between us. Sex was not one of them. I could not bear the thought of losing his body, but if he didn't want to have sex with me anymore nobody was making him stay. If he was in love with someone else, all he had to do was end the relationship.

In August, the pace of his speech and the intensity of his energy began to accelerate again. His epiphanies and his expressions of grandiosity came more frequently. After two months of disarray, he finally installed all of his music equipment. He decided to start working again and convincingly channeled his political fervency into getting a new job at a nonprofit with a social justice mission. He announced that he wanted to be healthy, and that he had decided to be sober in the fall when the job began. "Why not be sober now?" I asked, hopeful. I had not done a single drug since the last night we'd gone out in Bushwick before the city shut down. When the pandemic arrived, and now with his mental state the way it was, any desire to alter my consciousness had utterly vanished. Reality had gotten so weird it was as if I'd entered the wrong portal, like I'd gone out of the world I knew into its bizarro parallel twin. He told me he wanted to wait a few more weeks, until after a party that had been planned with friends in the Catskills. On another day, after getting off the phone from therapy, he shared an insight. "I talked to my therapist today and he asked me, 'Why do you think Emily keeps forgiving you?'" He smiled. "He just asked the question and let it sit there until I could

see the point he was trying to make." He paused, his eyes filled with meaning. "And I said to him, 'Because I'm worthy of love.'"

I had to go for a walk.

The last night we slept together in a bed, I woke up in the middle of the night, agitated with sexual longing. Given his state of mind, it was important that he slept as much as possible, and I did not want to wake him. I lay next to him, pressing my body against him, willing him to wake up, almost weeping with longing, until I finally fell asleep. In the morning, when he fucked me for the last time, my longing was gone. The sex set off a series of menstrual cramps so intense that I ran to the bathroom and started retching into the toilet. Andrew stood behind me, watching, uncaring.

That day he was filled with energy. He called a car to go play golf, then he went back out in the afternoon and played basketball. At night I met him at Bossa. He texted me and asked me to buy cigarettes for him on the way over. Again I felt the twisting feeling inside—he had never told me to buy loosies for him before; the maintenance of his addictions had been his own affair. At Bossa he ordered pizzas for the bar as a grand gesture and talked in a rapid clip, his eyes wide and his pupils dilated. In gratitude for the pizza the bartenders gave him his drinks for free. He didn't tip them. As we walked home, my brother called me. Andrew was on his bike, and he rode in circles around me, impatient. Once we were home I went into a room to continue my phone conversation. Andrew would periodically open the door and look in. When I finally got off the phone, he was anxious to show me something. He wheeled out his bicycle, which had been leaning against a table. He had attached all of his golf clubs to it with zip ties. I looked at it, uncomprehending.

"I just rode it around the block," he said.

He was sweaty, breathless, bleeding from one ankle.

"It's a prototype," he explained. "Instead of using golf carts people will be able to use their bicycles. There are all these people like me who feel guilty about playing golf, and this will make golf ecologically sustainable. It will change everything." I nodded, panic growing inside me. I wish I had just indulged the fantasy. I didn't mean to say it out loud, but I did. "I can't take this any longer," I said, and I walked into another room and shut the door.

Andrew's excitement turned to fury. He would show me, he said. He was going to patent his invention and manufacture it on a large scale. It was going to change everything. "Joe thought it was an amazing idea," he said. Joe was the man who cleaned the bar downstairs.

I sat in my office in the air-conditioning, trying to stay calm. Andrew went up to the roof to smoke. I didn't hear the doorbell when he came back down, and now he insisted I had locked him out on purpose. I begged him to understand that I hadn't heard him; the exact same thing had happened earlier that day. I tried not to meet his anger. "I'm going to go to bed," I said. "Please, let's go to bed, we can talk about it in the morning." I lay in bed. In his rearrangement of the apartment he had moved the bed into the room closest to the train, which made sleep impossible. He came in and stood in the doorway, then walked out again. At some point he took off all his clothes, I guess to take a shower, and every five minutes he would open the door and stand there, naked, ranting about the bicycle golf cart. "You're acting insane," I pleaded. I was so disturbed by his behavior I started recording a video. I have it still. He stands naked in the doorway, gesticulating wildly, arguing incoherently, until he finally notices me. "Are you filming me?" he says. "Are you *filming* me?" He breaks off his stream of speech, looking at me with anger. "That is so cruel. We are *done*. I am *never* speaking to you again."

Throughout the night he continued to text me. "I'm going to make at least a few hundred thousand dollars in revenue and have a

major mainstream publication write about me and my golf bike bag within one year," he wrote.

My phone buzzed again.

"On the side of everything else I do."

"Without feeling overwhelmed."

"That is how easy this is."

"I am only texting you now (and taking a screenshot) so I can send it to you in a year."

I woke up in the morning around six and he was gone. I sent him a picture of the cat, who was sitting on the windowsill looking up at the pigeons sitting on the bird feeder. He responded with a picture of a cat from the golf course. "I think you should come home, there's a thunderstorm," I wrote. I hoped for the last time that when he came home things would be different, but they weren't. He had taken the zip ties, now littering the floor, off the bicycle, and instead made a kind of sling out of a laptop bag through which he had balanced his golf clubs on his bike. He had posted on Facebook asking if anyone had experience fabricating prototypes.

He walked in glowering and accused me again of having locked him out of the house. I told him I hadn't, that the night before I just hadn't heard the doorbell.

"Then you emotionally locked me out," he said.

This was becoming absurd. "Andrew, you're unwell," I said.

"You're gaslighting me," he responded.

I didn't know what to do. I called his mom. I wrote an email to his therapist. This made him furious.

"You're a Karen," he said to me. "You're a cop. Why don't you speak to my manager." That night, he went out for a drink with the woman he'd been sleeping with, intent on hurting me. I begged him not to go, to wait until I had moved out of the house. I told him he was causing me pain. I stood in the doorway, pleading. He shoved me

violently and I stumbled and fell, weeping. "That was your fault," he said as he went out the door. "You were blocking my way." The door slammed and I heard his footsteps retreat down the four flights of stairs until there was only the humid roar of New York City in mid-August coming through the windows. I lay on the floor, sobbing. What a joke my life was. I thought of women who seemed never to lose composure. I pictured, hysterically, Beyoncé, then Simone de Beauvoir. How was this me? How was this happening to me?

When he came home he told me that the other woman he was seeing had thought the bicycle golf cart was a great idea, that it was "funny." I asked if he could leave the house for a few days so that I could move out. He refused, saying he had things he needed to do. Finally, he agreed to go to a friend's, but then kept putting it off. I didn't know what to do.

The next day he left his phone out, and I watched as texts from the woman he was dating came in. I picked up his phone and wrote out a message, asking her to stop texting as long as Andrew refused to leave the house. I put the phone down and left the apartment without waiting to see if there was a reply. "You're a horrible person," Andrew wrote when he'd discovered what I'd done. "Do you really want to get in a war?"

I came back home late that night. His volatile presence filled every room but he was finally gone. Cigarette smoke hung in the air. The bag where we kept condoms was conspicuously left out. So he'd had sex with someone, I thought. I went to sleep. I heard him come in, late at night, and then leave again. Early in the morning, not having slept, I wrote him an email with the logistics of my moving out. I asked to have time by myself in the apartment until I found a new place to live. He replied immediately, saying he needed to be back by the end of the month. "While I respect your time and space you can absolutely

find a place in two weeks," he wrote. "You have a car, you can go see multiple apartments per day." He told me that if I was not out of the apartment by the thirtieth of August he would hack me.

"I am extremely smart and talented with computers," he wrote. "You have no idea what I can do to your life, and I can do it without a trace, completely undetected." He told me that I was fooling myself about finding a nice place to live, that I would inevitably live somewhere shitty, since I had no design sense or taste in interiors.

"You can't even use a screwdriver," he said. The apartment I had lived in when he met me, he added, was "the saddest I had ever seen," that I hadn't even put art on the walls. I thought of his roach-infested apartment in Ridgewood, the mattress covered in cigarette burns and hardened pieces of Nicorette that fell out of his mouth after he passed out, the coffee table scattered with ashes, the reeking bong water. I hadn't minded. I had loved him.

He kept sending emails. He told me I was boring and basic, "just like our sex life." He let me know about an anonymous sexual encounter he saw as proof of his spiritual liberation from convention. He told me to enjoy my "boring, basic, irrelevant life."

He switched from email to text messaging. He texted that his therapist didn't think he was manic, and his mom didn't either. "You are weaponizing mental health against me despite the fact that you're not a doctor and have literally no qualifications to suggest you'd be capable of diagnosing a mental health issue," he wrote. If everything was fine, I responded, why did he need to attack me? Why not end the relationship in a humane way? He ignored these questions. He said I deserved all the insults because I had tried to sabotage his new relationship and make a woman call him and scream at him. The plan had failed, he let me know: "You actually just brought us more closely together."

"Just don't be an asshole," I begged. "Try for like five minutes not to do the cruelest thing."

"You're a sad, pathetic person," he wrote back.

"Your words have been violent and cruel and I am asking you to stop," I wrote.

"Why don't you call my manager if you don't like the service?"

He didn't stop. He told me I had no idea what he was capable of, that I was an idiot, that I was incompetent with technology and barely knew how to use Microsoft Word. He said he was going to come and get the cat and that she would forget me in a matter of days. He said I was "toxic," and that his mom had blocked me on her phone and that I should never contact her again. He said I had been acting with deceit and that he could no longer trust me around his belongings. If I touched any of his things, he wrote, "I will rain vengeance and fury down upon you like you wouldn't believe." He repeated that I was sad and pathetic, that I had hit him and punched him. When I again begged him to stop he said he was sticking up for himself.

I called my friends, trying to figure out what to do. What should have been obvious—that I had surrendered my own reason to a crazy person and I needed to get away from him—still wasn't apparent to me. What was hard to remember later was why leaving was so difficult, and why somehow throughout this process I had been utterly alone, that at no point had there been someone who could come over to the apartment, assess the state of things, and tell me what to do. I did not want to make Andrew mad, but that what Andrew said or thought no longer had any relevance to my own reality defied my comprehension. My world had shrunk itself around him. Questions that later would seem silly at the time seemed impossible. Where on earth would I go? Where would I put my belongings? I could not ask my parents to come to New York City, where twenty thousand people had just died of COVID, many of them their age. My brother was in

California. Most of my friends were out of town. Of the ones who knew what was going on, I was ashamed to tell them I'd gone back to him after what had happened in June. But it was also that I knew what I was giving up by leaving, which wasn't only about Andrew. It was about some fantasy of family that had become a delusion months ago, but which until I walked out I could still pretend might be possible. To cut him out of my life would be to accept that I would never have it, that thing that made women so silly and make such terrible decisions, the desire to surrender oneself to another, the longing for love and babies. A middle-aged solitude that had always scared me was looming, and I saw the loneliness of the years ahead, and it terrified me. I was wrong about a lot of things at that time, but I was right to be scared about that. I knew that there would not be another chance, that the door on the fantasy was closing forever. I had always been skeptical of it, yet as it slipped out of my grasp, it was suddenly the only thing that mattered in the world.

I had been lucky in my life; I had never had a partner try to hurt me. It turned out, as I called my friends for support, and finally started telling more people what was going on, that there were several women in my life who had been through such a situation and knew exactly what to do. My friends explained to me that even if he were not physically violent, he would use every logistical conversation and every point of contact as a chance to inflict cruelty, and the only thing over which I now had control was to limit my exposure to him. They said the imperative was to get out. I was told not to wait to find an apartment or until the end of the month, to begin packing immediately, and to rent a storage unit, even if it meant draining my savings and having to pay for the cost of moving twice. I was told to book the movers immediately, and to keep secret until I had gone that I was leaving. My friends encouraged me to take only the furniture and belongings I knew would not be in dispute. They instructed me

not to respond to any insults from him, to let the anger pass through me, to not give oxygen to the fire. Especially now that he was accusing me of physical abuse, it was important to get out and stay silent.

Andrew would not stay away from the apartment. First he came over to put a padlock on the door of the bedroom he had remade into his studio. He recorded a video of it before he shut the room and sent it to me, claiming that I was intent on destroying his things and would be liable for any damage. I could see in the video that he had locked the cat inside. I broke my silence to tell him. "Don't feign concern for the cat," he wrote. He sent me a video of the hole I had kicked in the door in May.

"I have a long, well-documented record of you being a violent, psycho bitch," he wrote me. "If you try anything I have the receipts."

"Take responsibility for your bullshit," he texted.

"Stop acting like a fucking child throwing a tantrum and calling your mommy," he wrote.

He told me our friends would no longer be my friends, "They will all take my side." I'd been protecting him and had not told our mutual friends the details of what was going on. As far as I knew Andrew was also presenting what was going on as a normal breakup. Because of the pandemic we had not seen our mutual friends for weeks.

He picked at every insecurity. He told me I was weak, that I had no resolve. He told me he couldn't wait to see me try to write about the rave scene in Brooklyn and that he looked forward to seeing me get canceled on Twitter. "They will not let a white woman from *The New Yorker* speak for their scene," he wrote. "All you do is ketamine, and dance badly."

On social media he posted advertisements for roommates immediately. He told me he would need to come by and show people the apartment. One evening he arrived unannounced by himself. He unlocked the front door with his phone out, recording me, grab-

bing a golf club and waving it at me as if I were a threat. My hands were shaking as I grabbed my laptop and ran out, staying on the phone with a friend until he wrote to let me know he had gone. But his moods were inconsistent. One day after sending me a litany of insults and accusing me of plotting against him, he texted, "I just want to say that I no longer want to fight. I feel calm and accepting of the situation." On another day he wrote to ask for a drug dealer's phone number.

I didn't reply to any of this. I followed the orders of my friends. I packed all my things. I rented a storage unit and hired movers. Andrew let me know that he would not return my share of the security deposit. "Don't respond," said my guides through this process, "let it go." I moved my suitcases to a friend's empty apartment where I would stay until I figured out what to do next. I patched the hole I had made in the door. I hired a professional cleaner. I couldn't take any chances; everything had to be right. My friends told me to record a video, in case I was accused of leaving the apartment in bad shape. In the video, I narrate my walk through the rooms. I start to cry toward the end. I place my keys on the dining room table. I find the cat and pet her for the last time. I put on my shoes and the door shuts behind me.

I wrote Andrew that I had moved out.

"For good?" he asked.

"Yes," I wrote.

"It would have been nice to know that was your plan earlier," he responded. "But whatever."

He said he would stay on my health insurance through September, then figure something out. He sent me the money for the premium over Venmo, with a cigarette emoji.

• • •

THE WEEKEND AFTER I MOVED OUT, ANDREW WENT WITH OUR FRIENDS to the Catskills and did a lot of drugs. On Sunday, when everyone came home, I started receiving text messages about his state of mind. Andrew's cruelty toward me had been contingent on the compartmentalization of the people in his life and the isolation of the pandemic. He knew that I would not talk to the other people with whom he was having sex, and that they were unlikely to speak to me, and he had punished me for my single attempt to contact one of them. He had told his mother that I was a threat to him. As more people witnessed his behavior, however, his ability to keep people from noticing the change in his personality started to fall apart. In his mind I was to blame for this: It was not that he was doing and saying things that frightened and concerned his friends and family, it was that I had conditioned everyone to see him that way. I had orchestrated all of it. I had planted the idea in everyone's minds that he was not well, and now he couldn't convince them that he was fine. I understood that, from there on out, I would be the scapegoat for everything bad that happened to him. My mom, who followed him on Instagram, told me he had posted a video, that he had set up his DJ equipment on the fire escape and was blasting music over Broadway.

19

A FEW DAYS AFTER I MOVED OUT OF OUR APARTMENT IN BUSHWICK, *The New Yorker* sent me to Kenosha, Wisconsin. On August 23, a twenty-nine-year-old Black man named Jacob Blake had been shot in the back and side seven times by Rusten Sheskey, a white officer with the Kenosha Police Department responding to a call about a domestic dispute, while Blake opened the door of a car in which three children were waiting. In the next two days, protesters filled the city, coming from Milwaukee and Chicago. The demonstrators were met by the Kenosha Police Department with tear gas and rubber bullets, but in their anger and frustration they damaged and burned more than thirty businesses, along with a Wisconsin Department of Corrections Probation and Parole office.

Two days after the shooting, a group of self-styled militia members convened a Facebook group called the Kenosha Guard, which posted an event titled "Armed Citizens to Protect our Lives and Property." Facebook moderators had allowed the group to remain on the site, despite the fact that it was flagged by users as dangerous 455 times.

That night, Kyle Rittenhouse, a seventeen-year-old Donald Trump supporter and an aspiring police officer from across the state line in Antioch, Illinois, drove to Kenosha, where he shot and killed

two white protesters, Anthony Huber and Joseph Rosenbaum, and wounded another white protester, Gaige Grosskreutz, with a Smith & Wesson M&P, an AR-15-style semiautomatic rifle that had been purchased for him by an eighteen-year-old friend because Rittenhouse was underage. After the killings, Rittenhouse, who was also white, walked past a phalanx of police officers with his arms raised and drove home to Illinois, where he turned himself in to police the next day. Later, video emerged from before the shootings, in which police officers gave Rittenhouse bottles of water and thanked him. "We appreciate you guys. We really do," a police officer could be heard saying.*

My flight to O'Hare was the first I had taken since the pandemic began. I met with the photographer at an empty LaGuardia airport, then sat on a half-empty flight to the empty airport in Chicago. By the time we arrived in Kenosha, the violence had subsided. Jacob Blake Sr., the victim's father, told CNN that his son—who, as a result of the shooting, had kidney and liver damage and a severed spinal cord, had part of his colon removed, and would likely never be able to walk again—had been shackled to his hospital bed. Sheskey, the officer who shot him, was placed on administrative leave.

We left our bags at the Kenosha Wyndham Garden. While I was checking in, I looked at my phone and noticed an email with the subject heading "K2" from Andrew. We had talked about my interest in

* In 2021, a jury acquitted Rittenhouse of homicide and every other criminal charge against him. On the grounds that Jacob Blake had held a knife, state prosecutors found that Rusten Sheskey had acted in self-defense and declined to press charges. Federal prosecutors found insufficient evidence that Sheskey had violated federal civil right statutes and also did not press charges. The Kenosha Police Department saw no grounds for disciplinary action and Sheskey kept his job.

writing about the drug scene at Myrtle-Broadway. Now he wanted to let me know how unqualified I was. "Have you ever talked to anyone that has taken K2?" he asked. "Last night I hung out with homeless people on our roof and smoked K2 with them and learned the entire history of the drug." He said he now had the phone number of the primary distributor on our block. "In six hours I did more investigative reporting than you will ever be capable of," he wrote. "I'm going to write your book better than you can."

There was a second email, where he described K2 as a "shifty ketamine high." This was nonsensical; the two drugs had nothing in common except the letter K. He announced that he was going to write his own book, which would be about "the simultaneous rise of ketamine and K2 and the differential treatment by police and white people."

"Your book is going to suck compared to mine," he continued. He posted his analogy on social media, where his posts had become increasingly deranged. "Cocaine: crack:: ketamine: K2." My stomach tightened into knots. I put my phone away, got my notebooks and my helmet, left the Kevlar vest the magazine had supplied me with, and met with the photographer downstairs.

Civic Center Park, where the protesters were hanging out, was a leafy plaza surrounded by limestone Classical Revival municipal buildings, an example of the kind of high-minded public spaces that proliferated in midwestern cities during the progressive reform movement of the early twentieth century. Now the windows of the Kenosha County Courthouse and the Kenosha Dinosaur Discovery Museum were boarded up with plywood. A few dozen mostly white evangelical Christians in shorts and T-shirts and baseball caps stood with their arms upraised before a sound system where a Christian rock band drowned out all the other conversation in the square. The Christians swayed gently, their eyes closed in ecstasy. In another cor-

ner of the park, a group of forty or fifty mostly young people, many of them dressed in black and carrying Black Lives Matter signs, at least one wearing a "Fuck Trump" T-shirt, looked on. An organizer, an older Black man, sat on a bench in the shade, ignoring a dough-faced proselytizer in a "JESUS" T-shirt who was standing next to him monologuing about his love of the Lord. The organizer waited until his personal missionary finally desisted and wandered off.

"The community said to let them come in and do this," he said to me then, gesturing in the direction of the swaying Christians. "I'm not with it, I'm sick of it, I mean Christianity has kept us in slavery for so long." He paused and looked at the ground. "I don't know. I'm just a follower right now. An organizer, but I'm a follower." A report of some arrests nearby circulated among the protesters. "Get us some lawyers down here, man," he said to a young man asking for advice. "I need to know what charges they got so we can bond them out."

The gathered crowd decided to start marching again, as it had for the past three days. Kenosha, scraped flat as a griddle by a glacier during the Pleistocene, had wide, deserted streets. The marchers had very little audience. The city had the languid, depopulated atmo-sphere of the upper Midwest in late summer; half the houses looked unlived in. They walked past telephone poles and unmown lawns and barbecue smoke. They walked by people sitting on their porches drinking beer. They passed by the burned-out shells of buildings and an auto-body shop where a minivan with its windows smashed had been spray-painted with "ACAB." They stopped for shade under a freight train bridge. They marched back to Civic Center Park.

Night was falling. I returned to the hotel. I saw Tucker Carlson's face frowning on Fox News through the window of a second-story apartment. The previous night, he had talked about Rittenhouse on his show. "Are we really surprised that looting and arson acceler-ated into murder?" Carlson had asked. "How shocked are we that

seventeen-year-olds with rifles decided they had to maintain order when no one else would?"

In my notebook there's a scribbled set of notes after this, a non sequitur. Back at the hotel, I called the New York City mental health wellness helpline. A kind person answered. She asked my first name. I told her about Andrew. I told her about the email about K2 and about him smoking it with the homeless people on the roof and the book he wanted to write. I told her I was worried. The city could send someone to check on him, she said. No, I said. No, it's impossible. She gave me a list of outpatient clinics, and I let myself fantasize that he would finally call me and ask for help. I wrote down "Community Healthcare Crown Heights" and "Kingsboro Psychiatric Williamsburg Clinic" and their phone numbers. I thanked her and hung up without giving any identifying information. Then I reprimanded myself. It was over. If he wanted to kill himself there was nothing I could do. There was nothing I could do.

The next day I went to a skate park, where Anthony Huber's friends were meeting to memorialize him and "skate it off," as one of them put it to me. Some of Huber's friends had witnessed his death on live-streamed Facebook videos. Huber, who was twenty-six and had grown up in Kenosha, was known around town as a committed skateboarder. The videos showed him trying to take on Rittenhouse, who had already shot Rosenbaum, with the deck of his board before Rittenhouse shot him in the chest. I thought of what Ted Cruz had said at his rally almost two years before, his joke about liberals using skateboards instead of guns. One of Huber's friends told me, "If he had used the truck"—he turned his own board in his hands, to show me its metal axles—"it would have been another story. He would have been alive." Huber's girlfriend sat on a bench. She didn't want to talk to me. She wore a gray beanie and was surrounded by a tattooed and pierced group of friends with scrapes on their elbows and gauges

in their ears. Later that night, I clicked through Facebook memes of Anthony Huber clutching the fatal gunshot wound on his chest, photoshopped as the cover of the PlayStation game *Tony Hawk's Pro Skater 3*. These memes, along with others—one of Jesus guiding Kyle Rittenhouse to shoot his rifle; comments of "Die Commie Scum" and "skate off a cliff you Marxist refuse"—were posted on the wall of the deceased's girlfriend. A GoFundMe had started for Rittenhouse's defense. "Don't beat yourself up, you did what you had to do, and it was the people who attacked you who determined your actions," wrote someone who donated fifty dollars.

At the skate park, a scrappy-looking blond skateboarder approached me to talk about Huber. I quoted him in my article. A few days later someone wrote me on Twitter to let me know I'd quoted "a local Nazi known for drugging women and taking advantage of them." I was confused—I'd seen the skateboarder at a march for Jacob Blake the following day, which didn't seem like a local Nazi thing to do, and couldn't find any evidence substantiating the other accusations against him. She sent me a screenshot of him wearing a T-shirt with a phone number on it. "That's the phone number to report 'illegal immigrants' to ICE, I'm pretty sure," the stranger wrote, "and the flag is obvious." The flag, which was green and white, was not obvious. I looked it up, and clicked through entries on Know Your Meme and Wikipedia about Kekistan, 4chan memes, Pepe the Frog, the Nazi Iron Cross, *World of Warcraft* slang, "shitposters," "Normistan," "Cuckistan." I looked at his Facebook profile, where he'd posted a photo of my *New Yorker* business card with the caption "Guess who might be in the news." Above it was a meme of a frog wearing sunglasses that said "Yeah, I'm a F.R.O.G.: Fuck Racism Overthrow Government." Below it was a photograph of a pile of sticks: "So.many.fucking.sticks." The method by which I had been taught to gather information was not equipped to deal with this. Since

when were skate punks Nazis? (The right-wing trolls had been in Minneapolis, too—the Boogaloo Boi from Texas who was later charged with emptying thirteen rounds of an AK-47 into the Third Precinct while demonstrators were inside; the member of the "Aryan Cowboy Brotherhood" who smashed the windows of an AutoZone and spray-painted "free shit for everyone zone" on it.) I thought of an interview in *November* magazine I'd read earlier that summer with Frank B. Wilderson III, the Afropessimist writer and critic. Wilderson had grown up and lived as a young adult in Minneapolis, and was of a school of philosophy that followed the sociologist Orlando Patterson's argument that slavery was not a relation of forced labor but of social death, such that the end of forced labor had not resulted in Black liberation because it did not address the true nature of the societal exclusion of African Americans. In Wilderson's memoir, *Afropessimism,* his experiences of being one of the only Black kids in a wealthy Minneapolis neighborhood called Kenwood inform his philosophy, the argument of which he summarizes as "Blacks are not Human subjects, but instead structurally inert props, implements for the execution of White and non-Black fantasies and sadomasochistic pleasures." The book, which came out in early 2020, had become one of the interpretive texts of that summer. Its unyielding negativity was either a dismal framework of no escape or one of the only explanations that pierced the spectacles of Nancy Pelosi kneeling in the Capitol rotunda dressed in kente cloth; or Chevron posting on social media that "we stand in support of the Black community and all those seeking systemic change"; or white polyamorists putting "ACAB" in their dating profiles; or partygoers in Berlin drinking in rafts in the canal under a sign that said "I Can't Breathe"; or the way it seemed mealymouthed to me every time I heard a white person use the term "uprising" with the same piousness with which they spoke of their "partners" (even as I used it too).

As Wilderson had said of the demonstrations in Portland and Minneapolis in the interview I read, "They start off as insurrectionist projects authorized by Black grammars of suffering and end up being about all kinds of other shit, like White suffering, White exhibitionism, non-Black immigration issues, and how to make the police accountable rather than how to destroy the police. They do to Afropessimist rage what White boys in the suburbs do to hardcore rap, what White folks did to jazz. They use the intensity of Black affect to mobilize the agendas of Human desire.

"What happens is that non-Black people get off on the fierce explosion of affect that emanates from Blacks," he continued. "This lasts for a hot minute (it's now July 21st and the minute is ticking down to its last seconds). We then see the world rush in to claim the insurrectionist space that we have opened up after our blood is spilt. It's like the year of the locust, times two: the first wave of parasites are the pigs, the second wave of parasites are our putative coalition partners. We are the host of two swarms of locusts: and the mise-en-scène of fire that we ignited has us walking in a daze as refugees in other people's political projects; projects that were sparked by our blood being spilled. The mind boggles."

It was all starting to fold in on itself: the murders committed by police in Ferguson, Staten Island, Louisville, and Minneapolis; the teenage shooters of Parkland and Santa Fe, Texas; the Unite the Right rally in Charlottesville. The right-wing militia movement was now making itself a presence at protests for racial justice. I was writing the same story over and over; and recent history was mutating and becoming recombinant. Kyle Rittenhouse was like a Muppet Baby version of George Zimmerman; in the trolls who slandered the dead online was a little bit of Westboro Baptist Church and a little bit of Alex Jones.

In Kenosha, political affiliation did not determine who had a gun;

I saw holstered sidearms on all sides. And in Kenosha, as in other places I'd been, calls for calm were seen as either paternalistic admonishments or just ignored. The property damage had been necessary and justified, but I think what I was starting to see was that the rage could not be relied upon to channel itself exclusively in righteous directions. Jacob Blake Sr. spoke at a rally in front of the courthouse the weekend after his son was shot. He walked with a cane and pulled down his mask to speak. He wore a T-shirt with a photograph of him and his son and the slogan "I AM A HUMAN BEING," a reference, I assumed, to the "I AM A MAN" signs carried by Memphis sanitation workers during the strike in 1968 that preceded Martin Luther King Jr.'s assassination. Blake began by reciting Al-Fatiha, the opening chapter of the Quran, because "There's seven verses; there's seven bullets put in my son's back."

He made a plea. "Good people of this city, understand: if we tear it up, we have nothing," he said. "If you tear it up, then we'll have nowhere to go." The headline of the *Kenosha News*'s coverage of the march instead led with a quote from an unidentified speaker, who took the microphone at the end of the rally: "If you kill one of us, it's time for us to kill one of yours." An editor at the paper who attended the rally quit in protest.

I paid one last visit to Civic Center Park before I left town. A few organizers and hangers-on lingered there. A white man wearing a white MAKE AMERICA GREAT AGAIN baseball hat walked up to the group of protesters. An argument soon began. A crowd gathered. A punch was thrown. The man in the baseball hat began to walk away, then run, as the crowd followed him, taunting. His MAGA hat was swiped from his head. It was stomped on, then someone tried to rip it apart. A police car sped toward the commotion in the street, bleeping its sirens. The Trump supporter ran toward it, to jeers, and was escorted away.

20

ON LABOR DAY, BACK IN NEW YORK, I WENT TO THE BEACH. I POSTED a message on social media with a picture of the shore: "Summer of heartbreak and violence," I wrote. "Glad it's over." My phone lit up within hours. It was Andrew accusing me of libel, even though I had not mentioned him by name. He wrote that he would "happily submit a charge of your assaulting me and we can hash this out in court." He said he knew I was "upset and hurt" but that "waging a passive aggressive war against me on social media is not healthy for you or for me." Then he sent me a screenshot of a tweet he had just posted: "tfw your journalist ex asks you to attend a protest because she feels 'unsafe' and then, when the police start beating you, she flees to the protection of the cops, flashes her press badge, and then writes a series of tweets in order to go viral and promote her own brand." He added, in a text message, "Instead of beating me yourself, because you are physically too weak, you just had the cops do it for you!" I looked at the people who had liked the post, some of whom I'd thought of as friends. But looking at his feed it came as some relief that I was no longer the only villain in his life; he was now accusing other people of abuse. I kept my post up. Fuck him, I thought.

A couple of weeks later I learned that he had been hospitalized in the psych ward at Woodhull, news I took as confirmation of a real-

ity he had denied to me. After that, I didn't hear from him again, and I didn't write him either. I went to Louisville, where protesters took to the streets after a grand jury failed to press charges against the police officers who had murdered Breonna Taylor. Taylor was a twenty-six-year-old Black emergency-room technician who was shot and killed by members of the Louisville Metro Police Department on the thirteenth of March, during a botched raid on her apartment. The killing had happened as the country was going into lockdown because of the pandemic, and her death did not receive much national attention until the protests began after the murder of George Floyd. On the twenty-eighth of May, after the *Courier Journal* published a transcript of Taylor's boyfriend's frantic 911 call in the aftermath of the shooting, and as Minneapolis inspired marches across the country, people in Louisville had started demonstrating to call for the firing and arrest of the officers responsible. That night, the police met the marches with tear gas and paintballs, and seven protesters were injured with bullets from a shooter whose identity was never discovered or, according to the people who had been shot, had never seemed to be investigated.

Over the summer of 2020, Louisville's failure to bring charges against the police who killed Taylor became a bait-and-switch meme on social media.

An example:

"The secret to making shrimp and grits is to start by peeling two pounds of shrimp. Make a stock with the shrimp shells in a carrot, celery, and onion reduction. Finally, use that delicious stock as the base for your grits and arrest the three police who murdered Breonna Taylor."

Or:

"I'm so proud to be part of the LGBT community.

L—Let's

G—Get the

B—Bastards who killed Breonna

T—Taylor arrested and charged."

Oprah Winfrey funded twenty-six billboards in Louisville, calling for the arrest of the officers who killed Taylor, and put Taylor's image on the cover of the August issue of *O* magazine, the first time in the publication's history that someone other than Oprah had appeared there. Now it was late September. The memes had died off and a grand jury had not, in the end, pressed any charges against Myles Cosgrove and Jonathan Mattingly, two of the three officers responsible for Taylor's death. The third officer, Brett Hankison, the only one of the three who lost his job, was charged with a felony count of reckless endangerment for firing his gun without a line of sight.* In the aftermath of the verdict, Trump sent his "regards" to Taylor's family, prayers to the police officers, and added a predictable "LAW & ORDER!!" During the protests that followed the news that the officers would not be charged with murder, two police officers were shot. The election was a little over a month away, and Democratic politicians lined up to make statements "condemning the violence."

"I know people are frustrated and they have a right to peacefully protest," said Joe Biden, "but violence is never acceptable."

When I arrived in Louisville the next evening, I noticed first the presence of right-wing militia members. They were lounging around, armed, in the parking lot of a Hampton Inn where I left my rental car because the police had forbidden street parking. They stood in formation around a Shell gas station, whose owner must have requested their presence. The nine p.m. curfew did not seem to concern them; the police left them alone. Instead the police trailed the protesters, who, that night and the night before, had found themselves confined, after the emergency alerts on their phones blared as the curfew fell, to the

* He was not convicted.

yard of a Unitarian church. There was a clause in the curfew order that made an exception for people returning to and from houses of worship.

The marchers spent an eerie two hours there. Within minutes of their arrival, members of law enforcement and the Humvees of the National Guard had surrounded the church, including a line of officers with their batons out who stood under the streetlights at the end of an alley. Pepper spray from somewhere down the street occasionally wafted over the group, setting off coughing and sneezing. The assembled crowd was small, maybe two hundred people. They were Black, very young, and seemed very vulnerable. Two or three of them were armed with guns; there was one baseball bat; the rest had nothing more than surgical face masks, not even helmets. Some of them told me they had marched every night for the past 120-odd days. For weeks the Breonna Taylor memes had circulated, her name had been chanted all over the country, the celebrities had posted, but now there were just these kids in a churchyard, facing a full battalion of law enforcement. A helicopter occasionally flew overhead, bathing the group in an intense white light that cast high-resolution shadows from the leaves onto the ground, a nuclear moonlight that for a brief second reminded me of Sustain, which in a normal year would have taken place the weekend before. Someone carried a sign that read "Tired: 1619 to 2020 (Been tired)." I had the impression that the posturing online had just been a collective dream, for where was everyone now? News circulated through the crowd that Attica Scott, the only Black female senator in the Kentucky state legislature, had just been arrested in her own district. "I don't see a riot here so why are you in riot gear?" the protesters chanted. After two hours of confusion, the police finally allowed them to return to their cars and go home. When I got back to my car at the Hampton Inn, the militia members were still standing around the Shell station. Their presence hours after the curfew was not deemed a threat.

The night I got back to New York was sultry and humid. I couldn't bear to sit alone in the new apartment I had rented, so I got on a bike and went for a drink at Bossa. As I walked in and my eyes adjusted to the darkness I realized that Andrew was sprawled by himself on a banquette, looking at his phone. He looked up and noticed me. When I turned around and left, he laughed, a scoff of disgust and hatred. That was the last time I saw him.

After Louisville, I stopped writing about protests. Andrew's accusations that I was a fraud hung in my ears. I had been interviewed for a Human Rights Watch report about the violence of the police in the Bronx in June. Before the report was published, they sent me a series of emails asking if I would write about it, encouraging me to call in when it was discussed on *The Brian Lehrer Show*, and to share the report they produced on social media. I did nothing. I was relieved that they had spelled my name wrong in the footnotes of their report so my participation wouldn't be searchable. Andrew posted the summary of the investigation on social media with a note that he had been "beaten and brutalized." Later I received a Human Rights Watch press release in which he was listed as a speaker at a rally outside the 40th Precinct in the Bronx.

I recognized the decadence of his political posturing. He was angry at me for having brought him to the protest, but his beating at the hands of the police had given him an infallible political credential and the excuse of post-traumatic stress disorder to justify his behavior over the summer. But there was also a Trumpian logic at work in the way in which he used his own grievances and sense of injury to justify his hatred and diminishment of me. He could absolve himself of white guilt by saying I was the guilty one. I was the ideal terrain on which to project his misguided virtue signaling, and questioning my right to observe and opine on the world was a way of proving his own goodness. Discarding me had become, for him, an act of ideological purity. He had

cast me as the stand-in for the failure of liberalism; I was its avatar, with my whiteness, my hetero cisgender identity, my elite media job, the fact that I was no longer young and would have all of the usual generational blinkers. If he killed the basic cis white woman in his life, he would free himself to be on the right side of the postgender pansexual future. He spoke not with his own words but in the borrowed vocabulary of racism and trauma—"abuse," "toxic," "weaponize"—which in that time was the most unassailable language a person could deploy. It was as if I had algorithmically generated a millennial edgelord from my own personal data points. I was left to convince myself of the integrity of my politics, which I was incapable of doing, because of course I was culpable. The concerns about our lives and the world that had drawn us together were now the ones he used to attack me.

"When placing an individual with whom he is dealing on the defensive, the manic utilizes directly transmitted information and unconscious cues to rapidly formulate a caricaturized version of the person in question," I read in a research paper from 1970, "Playing the Manic Game: Interpersonal Maneuvers of the Acutely Manic Patient." I had started spending hours on the internet trying to understand what had happened to me. "Although this version may not be accurate in presenting a balanced picture," the paper continued, "the characteristics stressed are usually present in disguised, muted, or defended form. Herein lies the manic's ability to upset those with whom he deals. What he says cannot be dismissed as untrue or unreal, for the areas attacked truly do exist and, indeed, are areas of vulnerability. In relating to an individual, the manic may make covert or unconscious vulnerabilities overt, or, alternatively, may bring into direct consideration, issues which are well known but have been suppressed. Problems related to sexuality, idiosyncratic behavior, prejudices, self-image, feelings of inferiority, aggressiveness, ethnicity, and self-esteem are commonly exposed."

The more I read the more I understood that what had seemed so

confusing was in fact an almost standardized set of symptoms and behaviors. My search terms brought up the same questions over and over on Reddit and Quora:

"Do men with bipolar disorder become extremely verbally abusive when manic, and push their partners away as though they absolutely hate them?" (16,032 views)

"Do people with bipolar disorder push away close ones during mania/hypomania or during depressive episodes?" (67,621 views)

"Do bipolar people ever realize, in retrospect, that they have been unreasonable with people, and that their anger was unwarranted or an overreaction?" (7,302 views)

I would never know if Andrew received a diagnosis of any kind.* A diagnosis had no meaning if the person with the symptoms rejected the paradigm altogether. He didn't matter—the mental health subreddits and forums were helpful in confirming that what had happened was not a figment of my imagination. I followed the testimonies of others who were on the same timeline as me. "I got the hell out," wrote someone who could have been me. "If his delusion was that I posed a physical threat, who knows what he might do. I left and he didn't even reach out to see if I was ok or why I left. He took down all my photos and began behaving as if he were in physical danger from me. I reached out to his friends and they basically treated me like a jilted ex. No one believed that he was delusional or that he had done any of these things." I read about what social workers called DARVO—the acronym stood for deny, attack, and reverse victim and offender. Andrew's threats to sue me for libel or assault were typical from a person who has perpetrated some kind

* In 2024, Andrew told a fact-checker that much of his behavior in 2020 had been symptomatic of a manic episode and that he was eventually diagnosed as having bipolar disorder.

of wrongdoing, as was his insistence that I was to blame for what had happened.

I attentively studied the details of public mental breakdowns, of which there seemed to be an unusual amount that summer and fall. There was Kanye West who, like Andrew, had taken to posting on social media about the predations of the recording industry in ALL CAPS and who also accused his partner of perpetuating white supremacy. I suddenly became invested in the celebrity narrative of Kim Kardashian, who posted a letter about her powerlessness in the face of West's illness after he had accused her of trying to lock him up in a hospital. I followed with avidity the story of Trump's former campaign manager Brad Parscale. Two years before, I had seen Parscale, who is six feet eight, strutting in a basketball arena at the Trump rally in Houston, dressed in a purple three-piece suit like a saloon owner. In September, as the cops dragged him away to a psychiatric ward, Parscale was caught on bodycam video sobbing to the police that his wife had not had sex with him in months, and that she was putting him in the hospital as part of a plot to steal his money. "She knows exactly what she is doing," Parscale says in the video, in which he is shirtless and appears to be drunk. "It is the most baller move of all time. It is the most checkmate, fuck you, move of all time. It is un-fucking-believable."

AS THE ELECTION APPROACHED, I TOOK A LEAVE OF ABSENCE FROM work. I had nothing intelligent to say anymore about America, about the violence, about the protests, if I ever had. There was nothing more to say. The memes and the bicycle protests and the banners hung from windows had not halted the murder of Black people. The cops had not lost their impunity. Hating women would always be in season and adaptable to any shifts in our language.

I was losing it. I could not stop crying and was thankful for the

masks, which allowed me to cry undetected in public. I could not keep on weight. My hair started to fall out. I slept with people I met on the internet to see if it made me feel better, but it was as if I had lost contact with my own body. A friend needed someone to drive a camper van back to Los Angeles from New York and I took him up on the offer. I stopped in state campgrounds on Lake Erie in western New York and on Lake Michigan in Indiana, near a pair of cooling towers. In rural Iowa, the state park where I stayed was a patch of grassland preserved in a sea of crops. In Nebraska, the stench of death from the cattle feedlots swept over the interstate, and the windmills rotated slowly over the industrially modified plains. The van had a small refrigerator; I had brought a giant pot of fried rice and ate my way through it across the country, when I could eat. By now it was mid-October, and in the Rockies a few lingering aspens still glowed yellow like lamps. My mind fell apart somewhere in Utah, as the sun set over a red rock desert landscape. I started sobbing for Andrew to come back, wishing he would hear me, that some psychic channel could be activated, knowing that it wouldn't be. He had severed the cord that had connected us and would never repair it again.

I found a backcountry campsite that was isolated and silent, and I stayed there for three days. My phone had no signal and during the day I walked through slot canyons and climbed up to look at the folds of the land and its patterns of sedimentation and uplift. In the evening I sat outside the van and watched as the darkness slowly seeped down to the horizon line until it got too cold and I went to sleep. I wished I could have stayed there forever, but I ran out of fried rice so I left and resumed driving west.

I was stopped for the night in an RV park when I began looking at his social media again. He had erased his all-caps rants from the summer; in fact he had erased everything since 2013, and every photo of me. He was in a process of renewal. He had left behind the old. It

had been two months since I moved out. His friends had told me he had a new social circle, new roommates, a new girlfriend. As a mutual friend put it to me, "It was as if he had gone to Bed Bath & Beyond and bought a whole new life." He had abandoned the record label that he'd started with his old friends and announced he had started a new one. He had broken ties with the people with whom he had been closest a few months before. Everything old was bad and everything new was good. I watched videos on Instagram of him singing the Oompa Loompa song on a karaoke system he had installed in our living room, of twentysomethings dancing to his music in our apartment. He changed his social media handles. He had "Black Trans Lives Matter+++Reparations" in all of his bios, and was still attentively policing instances of cultural appropriation and perceived injustice, but the fire had gone out. He was communicating in a normal register.

Since he seemed to have come down somewhat, I thought he might be capable of showing a little bit of care, or maybe having a conversation about what had happened. It had been two months of silence when, in a parking lot somewhere between Capitol Reef National Park and Zion National Park, I made the mistake of texting him. I wrote him that I was struggling, that I was hurt, that I was seeking some show of kindness or apology and would like to talk. It turned out nothing had changed.

"Emily, your actions and lies resulted in my forced detainment in a psych ward for a week at Woodhull," he wrote.

I insisted that I'd had nothing to do with his hospitalization. If I had wanted him hospitalized, I would have called the crisis intervention team myself. I tried to convey my sense of loss.

"Oh boo-hoo," he mocked. "Did you get beaten by the cops? Did you get stuck in prison? Did you lose your job? Did you get COVID?" He told me that I was lucky he hadn't sued me for "false imprisonment," and that I needed to confront my "white-bread ver-

sion of passive aggressive violence." I had "weaponized" the mental health system against him, he wrote. He had meant every insult and I had deserved it all. "Like all white women you use institutions to commit your violence," he wrote. We moved from text to email. "I absolutely did things I regret in our breakup and yes, I was violent. I had experienced trauma beyond anything you can imagine and was displaying signs of PTSD," he wrote. "You called my mom, my friends, and my therapist in an effort to convince them of my insanity. Calling you a bitch is one thing. This? This is sadistic."

Was I a sadist? I considered this accusation as if I were checking for broken bones or counting my fingers and toes. I took an inventory. I was close with my family. My friends had helped me when I needed it most. I had a job where I was respected, even if I was not the writer I hoped to be and I rarely met a deadline. I tried to live an experiential life where I examined my own assumptions and pushed the boundaries of comfort, but I did not transgress for transgression's sake. I did not posture as knowing, as rebellious, or as edgy. I was certain I had never hurt anyone the way that Andrew had hurt me. I tried to maintain a politics of integrity, which I did not equate with posting slogans on social media. I had said cruel things in the past but had managed, throughout the chaos of that summer, not to meet his abuse or violence with abuse or violence of my own. I had tried to intervene when he began to self-destruct, and left when it became clear I was not wanted and could offer nothing.

I was guilty of the naive hope that the person I had known would return with some lithium, and had desperately wanted it to be so. And he wasn't wrong: there had been a conspiracy against him, as an increasing number of the people who knew him began to fear for his well-being. He could have died, I told myself. He could have died. He could have died, and it was better to have tried to help and been punished for it than to have done nothing at all. He did not

feel the loss of me or the other relationships he had damaged, and when he damaged his new relationships in the future, he wouldn't lament the loss of those either. His willingness to discard people was a kind of freedom in the end, like eating takeout for every meal and throwing the containers away. I had seen his desire to hurt me as a sign that something was wrong with his brain chemistry, but if he did not see the intensity of his anger as a problem, then it wasn't one. What was true about his life was true because he believed it, and not because it was right or wrong, or fair or unfair.

"I cannot ever be near you again," he had written. He had set a boundary. I had to respect it. He had erased me from my own life. I was literally wandering alone in the desert, weeping, while he was in Bushwick, in our home, happy. "I feel a lot better," he had said.

I never looked him up again. He receded into the world like someone lost in a crowd. He would know people different from the ones we had known, and do different things. If I didn't look for him, he would no longer exist, so I stopped looking, and my life took on its own character once again. The rest of it now stretched before me. It was an empty plain.

WHEN I REACHED CALIFORNIA, I DECIDED TO STAY FOR A WHILE. THIS was why California existed, after all; this was what it was for. The mere thought of the J train pulling into Myrtle-Broadway brought me to tears. For the general election I mailed in my absentee ballot, which was still registered to my old address. I didn't pay attention to the news that day, but when Trump's loss was finally announced a few days later, I wept. All of that death, all of that violence, all of the unnecessary hatred, and the pandemic—I didn't weep because now it would get better, but for all that had already happened, the damage each of us now carried that would not be repaired.

The day after the election I resumed taking Wellbutrin. I didn't need to do drugs anymore. There were no more parties to go to. That fall, as the COVID numbers started to climb again and social life was halted, I was surprised how much comfort I found in day after day of solitude. Now that it all had ended, I wondered what I had been doing all of those years, getting on airplanes, going to bars. I deactivated my social media accounts. If I were lucky, I was halfway through my life. Maybe it was time to retreat from scenes, from style, from the internet.

In nineteenth-century novels, the characters whose lives defy convention end up punished. They die of tuberculosis, or become prostitutes, or throw themselves into oncoming trains. Today, instead of offending the church or the social hierarchy, the heretics violate the ideals of wellness and productivity.

I knew people close to me—especially those who had not understood this season of my life from the outset—could look for a cause for what had happened to me and find it in the drugs that I used. It would be almost formulaic to say that 2020 was a comeuppance and that my having ended up childless and alone in my forties was an outcome I had engineered in pursuing a messy life. Our behavior had been antisocial, and look how it had ended. On a bad day I could almost convince myself to frame my story this way, too. Almost, but not for very long.

Only later could I see that Andrew and I had been doing drugs for different reasons. He took them to turn off parts of himself that threatened to destroy him. I took them to psychically rearrange a world I understood to be so deeply corrupted by moral hypocrisy and the profit motive that I sought a chemical window to see outside of it (also for pleasure, for fun). People my age had been conditioned to mystify drugs; we were so heavily cautioned against them that maybe we gave them too much power, when in fact they were banal. It was not that the drugs I took made stupid things appear intelligent, but

rather the opposite: they set a standard that had to be met, and for a few years I found a group of friends who channeled their intelligence and their artistry into meeting that standard. But the cost of pushing our minds to extremes was high. To get to that place, some minds get lost along the way. The monitors that keep people safe and self-aware get overridden; the chemical override can become more about the drug than the world, and the shade is pulled down over whatever window out to the world the drug might have opened.

What almost undid me was an idea that was itself a bad drug: my refusal to let go of a reverie about the good life. In those years everyone was quoting Lauren Berlant's *Cruel Optimism*, their maxim that "a relation of cruel optimism exists when something you desire is actually an obstacle to your flourishing." It was a popular interpretation for reality in the years between the economic crisis of 2008 and the election of Trump, when the dream of the American middle class ended and we could no longer convince ourselves of "upward mobility, job security, political and social equality, and lively, durable intimacy," as Berlant defined it. I thought that if I stayed with Andrew and believed enough in love that I could make an enclave for two and will the good life into being. I clung to the relationship and the idea of being a householder well past the point when it started to cause me harm. I thought that if I really committed to the bit it would deliver for me. The great rug pull of 2020 forced me back into the world as it was and not as I wished it might be. On my own again, I could no longer retreat into domestic daydreams; instead I was out here, with the dying plants and animals in the brave new world.

We got vaccinated, then got the virus two or three times. We set about forgetting that we had once crusaded and scolded about public health measures. The memory of our mortal fear embarrassed us. The deaths were swept under the carpet, and the dead would not be much recalled. I went back to New York in March of 2021, and I

went back to work. The city still seemed empty; all the bars had to close at midnight.

In April, a few days before my fortieth birthday, I went to Minneapolis to report on the verdict in the trial of Derek Chauvin. Will we remember later how close we were? On that day every police officer in the state of Minnesota appeared to have been called into the city, and even some conservation officers from the Department of Natural Resources were taking a break from managing beavers and loons to come maintain law and order. The city bristled with armaments. Earlier in the month, a police officer named Kim Potter had shot and killed a Black man named Daunte Wright in a Minneapolis suburb. An overzealous response by law enforcement to the relatively small local protests that followed Wright's death hinted at what might be coming.

As the trial's closing arguments began, more than three thousand members of the Minnesota National Guard were activated. The next day, as the news broke that the jury had reached a decision, the commuters began emptying out of their offices and fleeing downtown en masse. Shutters were pulled down, soldiers carrying rifles stepped out into the streets, and armored vehicles started positioning themselves around the Hennepin County Government Center. I drove to 38th Street and Chicago Avenue to be at what one sign called "the free state of George Floyd" when the verdict came through. When the news reached the phones and the guilty verdicts were shouted out, tears fell, and then a party started. But I would not forget how close the city had been to something else. The guns and cops melted away and later nobody bothered much to ask what they had been prepared to do had the verdict gone the other direction, and Minneapolis and the rest of the country had once again taken to the streets.

"Things finally seem back to normal." It was a refrain between verses. It was said after the vaccines and then as the mask mandates were dropped and then when we could drink inside again and then

as commuters trickled back to Midtown. We said it when the curfew for bars and clubs lifted at the end of May and when the parties started up again, and when the borders were opened to European tourists, and when the depopulated subways started to fill up again on the Manhattan-bound side of the track after nine on the weekends. Not that anyone remembers the restrictions now or when they were lifted. I told myself I would never take partying for granted again. Looking at the paper trail, I bought tickets to thirty different raves or club nights in the six months of 2021 in which public health authorities allowed us to gather in person again. I had missed people. I had missed sound systems.

At first the mood was euphoric, and any shyness from before the pandemic was dropped in the gratitude of being united with friends and strangers alike. Going to those first parties was like coming back to New York after a long vacation and wanting to know what I had missed, except that everyone had been gone and nothing had happened. The first DJ I saw post-pandemic was Physical Therapy, who played a drum and bass remix of Toni Braxton's "Un-break My Heart" to a room full of friends at a renegade party in an art studio. In May, when Bossa reopened and I was once again drinking a Tropical Goth and dancing to Mike Servito and Jacky Sommer, it seemed as if the whole thing might simply reconstitute itself. It took a while to realize that the scene was no longer the same. The ascent of a cultural moment can't be replicated once the moment becomes mainstream. Somehow techno got absorbed into the New York experience economy. It became entertainment. A younger crowd who needed to photograph themselves as much as they needed food took over at Bossa, and we no longer knew anyone there. The music got faster and littered with pop edits, and I would go to parties and think that this was what must sound right if you'd been taking Adderall since you were seven years old. The fashion got expensive; everyone was

dressed up. It was disorienting but also the right and natural course of culture in New York City, and it didn't stop us from still going out. Sustain and UNTER met the moment by raising production values—they had to; the homespun, DIY aesthetic would no longer do.* Everything got bigger and sleeker, but also different.

I didn't stay long on Wellbutrin (it seemed like they changed the recipe; it no longer worked). I went back to drugs. I took more of them than I used to, and with an intention perhaps of forgetting. I forgot as I danced to Juliana Huxtable's demonic Barbiecore techno at Sustain that year, and I forgot as Eris Drew and Octo Octa closed with "Little Fluffy Clouds." Before the cops showed up at Club Night Club while I was peaking to Aurora Halal, I forgot. And in an ice cave of sound by DJ Holographic at UNTER High Tea, I forgot. The months went on and I forgot to Regis and Kyle Geiger at Berghain. I forgot to DJ Nobu, to Wata Igarashi, to Kush Jones, to DJ Python, to Blake Baxter, to Livwutang, to Roza Terenzi, to DJ Fart in the Club, to Lydo, to Ron Like Hell, to Clarisa Kimskii, to Spekki Webu, to DJ Plead, to CCL, to Batu, to Patrick Russell, to Erika, to Carlos Souffront. I danced until I didn't think anymore.

Then, when I thought it was no longer possible, a party unlocked a new level. The party was in Detroit, over Memorial Day weekend, in 2022. It was proof that one goes through life collecting bits and pieces of experience and every once in a very long while they get added into a sum that reveals their collective worth. (A few warnings flare in your mind about a person over the course of many years until

* UNTER threw its own funeral on Halloween of 2023, an eighteen-hour party in a four-story warehouse. There were mortuary flower arrangements, and we accessorized our fetishwear with veils and mascara tears. I got there at midnight and left at six p.m. the next day, and that was the end of that.

in a single season the itemized total arrives; glances across a room at a stranger mean nothing until the morning you wake up in their bed.) Memorial Day weekend in Detroit is techno Thanksgiving, when underground rave collectives from around the country and some even from abroad go there and throw parties in the city's warehouses and clubs in honor of the music's roots. Only in America would a great and historic city be allowed to hollow out and nearly die, but Detroit had always insisted on the fact of itself with music, maybe because capital was too distracted with injecting itself elsewhere to impede it. There was Club Toilet, thrown by the queer collectives, and Meta Ta Physika, thrown by promoters from the Minnesota rave scene, and Underground & Black, whose name explained its identity, and many others. At the center of the weekend was a big festival called Movement. Formerly a free-admission event called the Detroit Electronic Music Festival, it had evolved into an aboveground weekend-pass-type festival with beer sponsors in Hart Plaza, a brutalist public space downtown. The festival acted as a cover for all the other parties taking place, and the city had so many parties that people sorted themselves into their niches, the business techno people doing one thing, the queers and misfits doing another, and all of it laid-back because Detroit gave it room to breathe. And then on Sunday night all these parties drained into one party, called No Way Back, which in all those years of psychedelic experience turned out to be the most heads event I've ever been to: the maximization of an LSD trip and the culmination of generational wisdom into best practices for an environment in which to fully lose your mind. The party was held at Tangent Gallery, a warehouse venue with a license to stay open for twenty-four hours, which meant the party could last for fourteen hours without the threat of getting shut down. The decor was soft and dim: camo nets, parachutes, slow lighting. The sound was profound and fully immersive, like being placed inside a sonic womb. The DJs

were the same every year, a collective of Gen X sound system nerds with Detroit roots who had started No Way Back in 2007 as a way of carrying on the tradition of underground warehouse parties they had attended in the 1990s and which were threatened with extinction in the 2000s. The music was mind-bending and complex. The party had a foundation in acid techno but it moved through genres. It traveled back and forth in time. It managed to be both primal and futuristic at once. The lineages of midwestern counterculture converged there, the queers and the crust punks and the Afrofuturists and the hippies.

I had left Minnesota a long time ago but one can never really leave, and in Detroit I found a memory of the Midwest I had forgotten. It wasn't my city; the real snow that was our snow didn't start until you were west of Chicago. But the music had expanded from the Rust Belt to the Corn Belt and then beyond. We were in a city—a real city and not a conglomerate of parking lots and chain stores, or a crystalline vitrine for the rich. We were in a city that had been abandoned by finance and left for dead. On that warehouse floor I came to terms with my denatured self and the despoiled world, for this was music that came also from wreckage. It spoke of the mechanized factory floor and the circuitry of the motherboard, but the image that would not leave me was of the great biological deserts that began a few hours to the west, of the plundered topsoil and the geometric lines of Roundup Ready soybean and corn. There was no pastoral there. It was also a factory floor. Its smokestacks were crop dusters. The corporations owned it all: the land, the machines that tilled the land, the fungicides and herbicides, the crops, the very genes of the seeds. It was the future of the Amazon rainforest, it was the place that I was from, it was the food in my body. I pictured its linearity as I danced, the glossy leaves sharp enough to cut skin, their genetically engineered uniformity, their precision, which was like the precision of the music. It was the center of the country. It was at the center of us.

ACKNOWLEDGMENTS

I am very grateful to the entire team at Pantheon, especially Lisa Lucas, Zach Phillips, and Amara Balan for their trust in me and devotion to this project, and Linda Huang for the cover design, Michiko Clark and Stevie Pannenberg for the publicity and the promotion, and to my agents, Edward Orloff and Jin Auh. My deepest thanks also to David Remnick, Mike Luo, Valerie Steiker, and all the editors, fact-checkers, and copy editors at *The New Yorker*, especially Emily Stokes, who assigned and edited most of the reportage described in this book and was an unfailing advocate and friend. I would also like to thank the family and friends who gave me love, care, and places to stay in a complicated time, including my parents, Leonard and Diana Witt; my brother, Stephen Witt, and my niece, Jane; and Allison Lorentzen, Olga Romanova, Michele Hoos, Max Abelson, Michael H. Miller, Yaara Sumeruk, Martin Dicicco, Anna Lai, and Jon Caren. This book is dedicated to Emily Brochin because words don't suffice—thank you for knowing exactly what to do. Keith Gessen, Mark Krotov, Nick Bazzano, Michelle Lhooq, and Olga gave crucial feedback and corrections on the manuscript. For letting me stay in idyllic places where I could think and write, thank you to the Corporation of Yaddo and Kate Wolf, and thanks to Aurora and Seva for letting me write about the parties we weren't supposed to write about. Thanks also to Tani, Ross, Tariq, Jose, Jodie, and all the beloved friends who are also there after the sun comes up, especially Kiddo Sincere, who was there the next day too.

New York never really felt like home until I found the scene I describe in this book. I would like to express my admiration and gratitude for everyone who works in New York nightlife, and all the artists, lighting designers, promoters, bartenders, door people, and staff who put so much work into giving the rest of us a few hours of freedom and happiness. This book is a love letter to you.

ABOUT THE AUTHOR

Emily Witt has been a staff writer at *The New Yorker* since 2018. She has covered breaking news and politics from around the country and has written about culture, sexuality, drugs, and nightlife. She is the author of the books *Future Sex* and *Nollywood*. Her journalism, essays, and criticism have appeared in *n+1*, *The New York Times*, *GQ*, *Harper's Magazine*, and the *London Review of Books*.

A NOTE ON THE TYPE

This book is set in Fournier, a font designed by Pierre-Simon Fournier *le jeune* (1712–1768). In 1764 and 1766 he published his *Manuel typographique,* a treatise on the history of French types and printing and the measurement of type by the point system.

Composed by North Market Street Graphics,
Lancaster, Pennsylvania

Printed and bound by Berryville Graphics,
Berryville, Virginia

Designed by Betty Lew